P9-EAX-425

ND
2420
.S 33
Schink
Mastering color and design in
 watercolor

DATE DUE			

7
DAY
BOOK

Laramie County Community College
Instructional Resources Center
Cheyenne, Wyoming 82001

DISCARD

MASTERING
COLOR AND DESIGN
IN WATERCOLOR

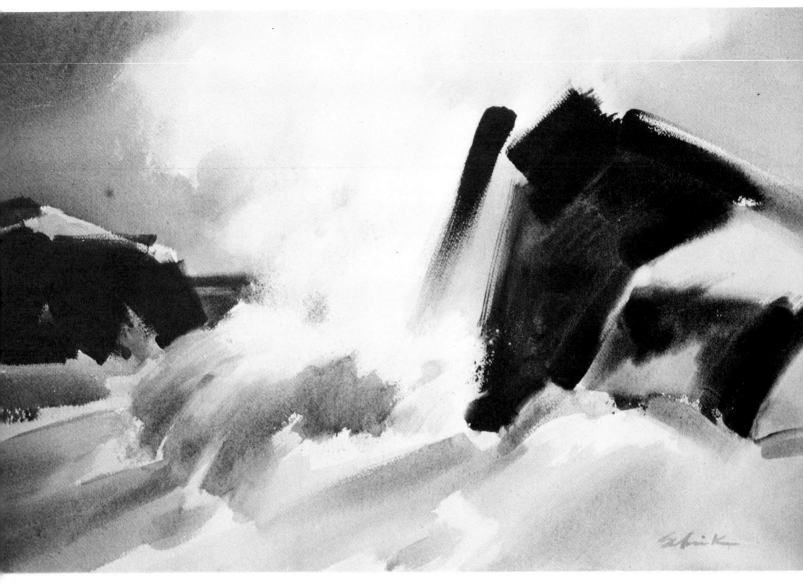

SUMMER STORM
by Christopher Schink.
Watercolor on Arches 140-lb rough paper,
24" × 38" (61 × 97 cm).
Collection of Mr. and Mrs. Carlyle Barton,
Baltimore, Maryland.

I find the longer I paint, the less conscious I am of my concept or style. How I approach a subject—the degree of abstraction or the amount of referential imagery I use—is determined by what I want to say in my painting, not by some arbitrary decision to paint in a particular style. This painting (although more representational than much of my work) is one I'm especially pleased with. It conveys in a direct and simple way the excitement I felt for this dramatic subject.

MASTERING COLOR AND DESIGN IN WATERCOLOR

BY CHRISTOPHER SCHINK

L.C.C.C. LIBRARY

WATSON-GUPTILL/NEW YORK

First published 1981 in the United States and Canada by Watson-Guptill Publications,
a division of Billboard Publications, Inc.,
1515 Broadway, New York, N.Y. 10036

Library of Congress Cataloging in Publication Data
Schink, Christopher, 1936–
 Mastering color and design in watercolor.
 Bibliography: p.
 Includes index.
 1. Water-color painting—Technique. 2. Color
in art. 3. Composition (Art) I. Title.
ND2420.S33 1981 751.42'2 80-27118
ISBN 0-8230-3015-6

All rights reserved. No part of this publication may be
reproduced or used in any form or by any means—graphic,
electronic, or mechanical, including photocopying, recording,
taping, or information storage and retrieval systems—
without written permission of the publishers.

Manufactured in Japan

First Printing, 1981

To the late Barse Miller

My deepest thanks:

To Edward Betts, whose encouragement and advice were directly responsible for my writing this book.

To Marsha Melnick, Editorial Director, and Bonnie Silverstein, Associate Editor, whose enthusiastic support and skillful direction made writing this book almost fun.

To the many outstanding watercolorists who so generously contributed their work for reproduction; and to Betty Miller for permission to use the work of her late husband, the eminent American watercolorist, Barse Miller.

And, finally, to my wife and family for understanding and, for the most part, tolerating my general grouchiness during the writing of this book.

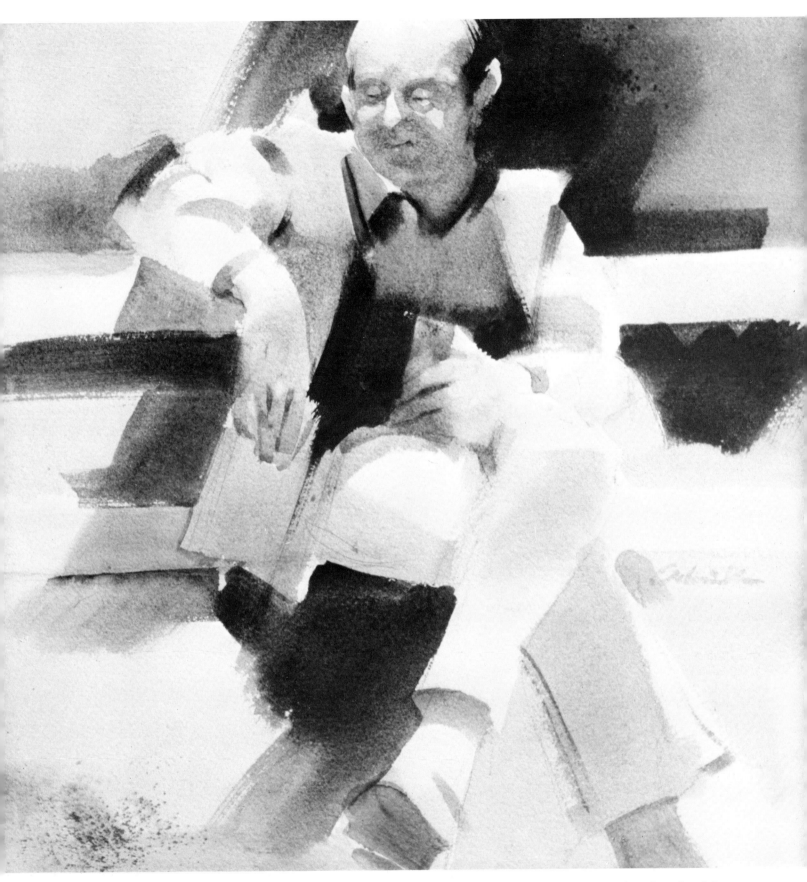

MAN IN THE PARK
by Christopher Schink.
Watercolor on Arches 300-lb cold-press paper,
22" × 30" (56 × 76 cm).
Private collection.

I've always enjoyed painting people and the occasional figurative piece that I do serves, in part, as a pleasant distraction from the problems of abstract design. I find, however, that a figurative work requires as much thought and planning as does any of my less representational paintings. In this painting my primary interest was in capturing the gesture and expression of this isolated figure, but I spent as much time planning the overall color and design as I did rendering the figure.

RANGEMARK ROCKS AND SEA
by Christopher Schink.
Watercolor on Arches 300 lb rough paper,
22″ × 30″ (56 × 76 cm).
Collection of the artist.

There are some places to which painters feel a natural affinity and Rangemark, the summer home and studio of the late Barse Miller, is one such place. Located on a remote part of the rugged Maine coast, it possesses great natural beauty and offers a variety of inspiring subject matter. I find the shapes and patterns of its dramatic shoreline particularly exciting. *Rocks and Sea* is my attempt to capture some of that excitement.

CONTENTS

INTRODUCTION

When I first began teaching water-color workshops, I noticed that most of the students I encountered had developed enough control of the medium to produce a technically competent watercolor. That is, they could paint a boat, barn, or still life without making too many mistakes. But it was apparent to me that organizing these subjects—their color, value, and form—into an expressive and cohesive design, one that conveyed their response to their subject, was what gave them difficulty. This book is a direct outgrowth of that teaching experience.

STAGES OF ARTISTIC DEVELOPMENT
As an artist you go through three basic stages of development. As a beginner you have the greatest interest in gaining some control of the medium. In other words, just getting the paint to stick to the paper is an overriding concern, and producing a technically competent watercolor is a major achievement. At this stage, whether you have organized the color and design of your painting in an orderly or expressive way is of little importance. Unfortunately, some watercolorists never advance beyond this initial stage but continue to concentrate entirely on developing technical skills. Mistaking virtuosity for substance, they become better and better at saying less and less.

The second stage of artistic development begins when you recognize that control of the medium or even virtuosic technique will not produce an effective or satisfying watercolor. You then must learn to develop the skill to organize your painting into a clear, cohesive design. So at this stage, your primary concern is in producing not only a competently rendered watercolor but also a convincing design. The skill to do this is acquired through practice and understanding.

It isn't until you have acquired an understanding of color and design and a control of the medium that you can begin the third stage of development, the point at which you can combine your knowledge and skill to express your personal interests, ideas, and feelings in an imaginative and creative way. If you practice and study, technique and design will become second nature. Your primary concern now is in producing an expressive work of art.

WHO THIS BOOK IS FOR
This book is directed primarily at painters in the second or third stage of their development—painters who need to learn how to more effectively organize their paintings. Unlike technique, which is mastered through imitation, this skill is acquired through understanding. When you're first learning to paint, you may find it helpful in developing your technique to duplicate step-by-step a demonstration or painting you admire. But once you've acquired some proficiency in the medium, you will discover that there is little value or satisfaction in slavishly imitating the color, design, or concept of another artist. It is not through imitation but by an understanding of the principles of design— how color, value, form, and movement

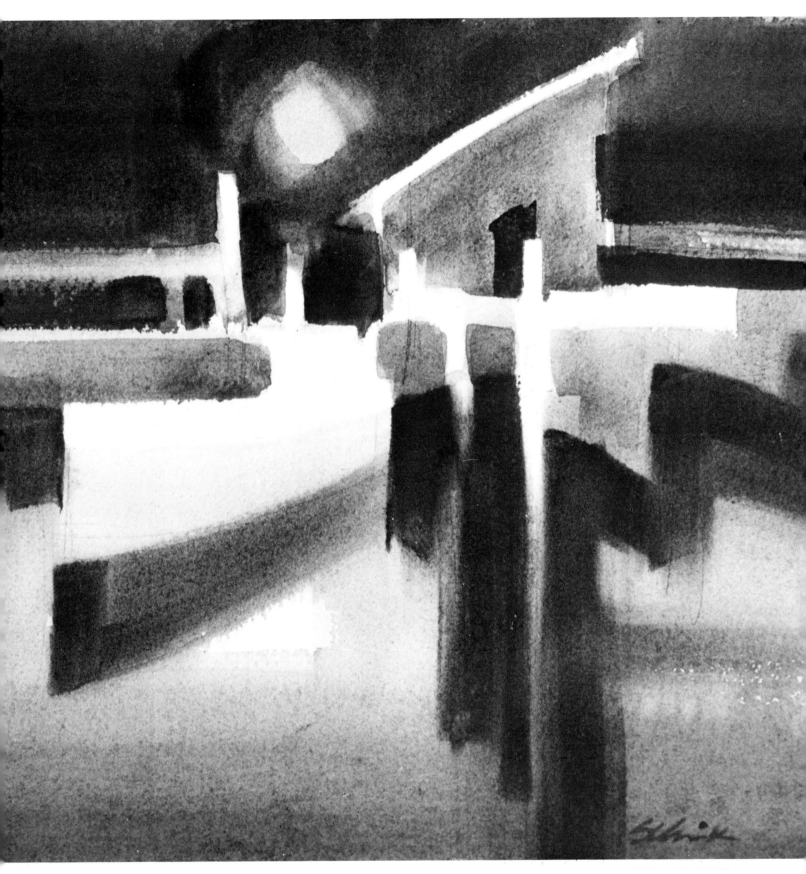

SUMMER HARBOR
by Christopher Schink.
Watercolor on Arches 300-lb rough paper,
14" × 21" (36 × 53 cm).
Collection of the artist.

I'm usually more interested in capturing the mood or expressive qualities of a subject than in reporting its surface reality. In *Summer Harbor* I've eliminated all incidental detail—the nets, bait signs, and sea gulls—and emphasized the shapes, value patterns, and color that, for me, convey the mood and atmosphere of a quiet harbor at dusk.

are organized—that you will gain the ability to produce a convincing and original work of art.

I'm fully aware of the problems involved in writing about principles of design. There is always the danger of being either confusingly vague or, at the other extreme, inflexible and dogmatic. I realize that in any creative process there are as many variables as there are constants, and that in producing an original or innovative work of art, you may break as many rules as you follow. But I believe, nonetheless, that there are certain fundamental ideas that should be recognized and understood by every painter. Whether you choose to follow them or break them is part of the creative process.

A WORD ABOUT TECHNIQUE

Watercolor is not an easy medium to control, and without control it would be impossible to convey your ideas, interests, and feelings. But I know of no other medium in which painters are so obsessed by technique. Many watercolorists never view a painting from any farther away than six inches, and their first question is invariably "How did you do that?" followed by "What kind of brush did you use?" This intense interest in technique is certainly understandable: To gain some control of the medium requires an enormous amount of practice, but technique is nevertheless only a means to an end. A skillful rendering of a confusing design, prosaic subject, or unoriginal concept will only result in a bad painting.

This is not a book on watercolor technique. In fact, in this book I assume you have already developed some proficiency in the medium. Although I include several chapters on basic painting methods, these deal as much with the expressive use of pigment qualities as with the mechanics of painting. I've also avoided the usual list of tricks, gimmicks, and exotic devices that are so popular with watercolorists—not because I'm opposed to an innovative or experimental approach to watercolor, but because I feel less experienced painters almost always use these devices in a superficial and contrived way. Whether traditional or experimental, your technique should be an integral part of your concept and design. In short, you can't save a badly designed or conceived watercolor by throwing salt at it!

ON THE QUESTION OF STYLE

Like technique, color and design are expressive tools. The way you use them—your style or approach to a subject—is a matter of personal choice. You may enjoy, for example, working in a fairly realistic manner, one that conveys a sense of real space, volume, and surface detail. Or you may prefer to see your subject in a more abstract way, one that emphasizes the graphic qualities of your subject. The choice is entirely up to you, but the style you choose to work in should reflect your interests, ideas, and feelings.

It was not my intention in writing this book to promote or endorse a specific style of painting, and certainly not my own. It should be evident from the paintings I've included that I enjoy and appreciate a variety of different approaches. My favorite painters include Degas, Rauschenberg, Sargent, Avery, Turner, Diebenkorn, Bonnard, and Matisse—certainly a varied group.

The paintings I've selected for this book, however, do have one thing in common: they are all based on a visual experience, idea, or theme that the artists have interpreted in a consistent and cohesive way, in a style or approach that is recognizably their own. They all have transformed their subjects or motifs into personal and expressive works of art.

DEVELOPING A PERSONAL CONCEPT

Although the emphasis of this book is on the use of color and design, I don't underestimate the importance of content and concept. What you have to say and the way you say it are the elements that distinguish your work from thousands of other equally well-designed and executed paintings. Finding an imaginative and personally satisfying concept is an essential part of your development as an artist.

Most painters begin by consciously imitating the work of an instructor or painter they admire. Their sole objective is to produce a painting that looks like someone else's—"an Andrew Wyeth" or "an Edward Betts." All artists go through this imitative period when they first begin painting but, unfortunately, some never leave it. Like repertory actors, they continually change costumes: this week they're Rex Brandt and next week Dong Kingman.

Your own style will begin to develop when you recognize that

painting *like* somebody is less important than having something personal and imaginative to say—that concept follows content. You may still be influenced by other painters, but it will be in a less direct way—an unconscious borrowing of an approach that effectively conveys ideas similar to your own. Your style evolves from a need to communicate. It will be different from the styles of other painters because your ideas, interests, and feelings are different. For example, I work in a fairly abstract style, not because I feel abstract painting is in some way superior to realistic painting, but because I find it the most direct way to convey the qualities of a subject that excite me—the movement and pattern of colors and shapes. The way I paint is not the result of an arbitrary decision to adopt a particular style. It is part of a gradual evolution that I'm sure will continue as my interests and ideas change.

The way you paint should reflect your personal response to the world around you. When you know what you want to paint and why you want to paint it, when you recognize what it is that interests and excites you, your own personal style will emerge naturally.

HOW THIS BOOK WORKS

I'm sure you have already spent a few minutes thumbing through this book and have discovered it is not a typical "How To" or "Christopher Schink Paints a Watercolor" book. There are no step-by-step demonstrations of the way I think you should paint clouds or the foliage on sycamore trees. The instruction and illustrations do reflect, to some degree, my interests and tastes, but they are not simply *my* solutions to the problems of designing a painting. I've tried to present the fundamental concepts of color and design in a way that will be useful to any painter regardless of his approach or style. My object is to help you gain a better understanding of how color and design can be used in a personal and expressive way.

I've divided this book into two major sections—Design and Color—and subdivided them further into thirty lessons. Each chapter presents a general concept or principle of color or design, expounds on it, then suggests how it can be applied in a practical and personal way to your own work. To illustrate the application of these concepts, I've included paintings by

other artists as well as myself, in styles ranging from highly realistic to almost totally abstract. Each lesson concludes with a critique in which I've tried to pose questions that will help you judge how effectively you have used each concept in your own work.

HOW TO USE THIS BOOK

I know from my own experience that you won't immediately sit down and read this book from cover to cover. You'll probably start by thumbing through it looking for paintings that appeal to you. And you may stop occasionally to read a caption or paragraph that seems interesting. However, the written material and illustrations I've included were not intended as a random sampling of painting concepts and styles. To use this book most effectively, you should approach it in a fairly systematic way, beginning at the start of each major section—either Design or Color—and reading each lesson in order. I've organized these sections to duplicate the steps you'd normally follow in planning and painting a watercolor.

I'm sure you are already familiar with some of the concepts I've included—most painters, for example, are aware of the importance of value organization—but with further investigation you may find a more practical approach or a new solution to the problems of color and design. If you're unsure what value a particular lesson may have for you, you might start by answering the questions in the Critique section at the end of each one. I've included them to help you judge how fully you understand the preceding principles and how effectively you have applied them in your own work.

Even if you have the time and energy to read this book cover to cover without interruption, you won't gain full benefit from it. It's far too long and comprehensive to be assimilated in a single sitting. A more practical approach is to read it in sections, two or three lessons at a time. It can serve as both a reference and a guide—an "easel-side companion"—to help you plan, organize, and analyze your paintings.

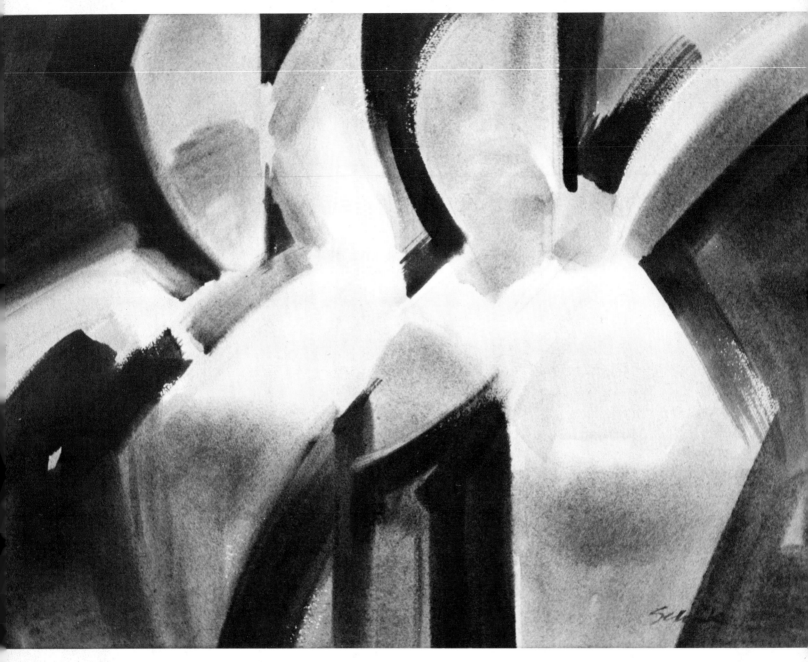

KUMQUATS
by Christopher Schink.
Watercolor on Arches 300-lb rough paper,
22" × 30" (56 × 76 cm).
Collection of the artist.

While I enjoy the stimulation of new and exciting sights that traveling brings, I have found that the subject or idea for a painting may be no further away than my backyard. For instance, this painting was based on the rhythmic forms of the foliage of a kumquat tree located just outside my studio window.

DESIGN

At times most painters (and I include myself) find the diversity and complexity of the landscape overwhelming. What to paint, the viewpoint to take, and how to organize your color and design in an expressive way are a few of the questions you face at the start of every painting. You won't find the answers to these questions in tired formulas or by mindlessly moving your brush. Nor can you rely entirely on your intuition and enthusiasm to provide you with a clearly organized design. To design a painting you must not only feel, you must *think*.

This section deals with the thinking part of painting—how to consciously organize, plan, and analyze your own painting. By recognizing and understanding how the elements of design—value, shape, movement, and so forth—function in a painting, you will be able to employ them in a lucid and expressive way.

SELECTING A SUBJECT

I often begin my workshop critiques by asking each painter to describe the subject or inspiration for his painting. Predictably, the answers are as vague and confused or as direct as the paintings they describe. This demonstrates an important idea: knowing *what* you want to paint and *why* is the most basic consideration in planning a watercolor. Every subsequent design decision—the elements or qualities to retain or eliminate, emphasize or subdue—will be determined by your selection and focus.

Most of us enjoy the seashore or the open countryside and are delighted when we have the opportunity to paint them. However, we may enjoy them for very different reasons and respond to them in entirely different ways. Your paintings and approach should reflect these differences. The subjects you choose and the way you interpret them should be a personal expression of your interests, ideas, and feelings.

FINDING A SUBJECT

When searching for a subject, begin by following your intuition. If some area catches your eye or you sense the possibility of a painting, stop and look around. For example, there is a small harbor located a few minutes from my home that is loaded with exciting subject matter. When you find such an area, spend a few minutes exploring it. Get out of your car and walk to the end of the pier or the other side of the harbor. Take your sketchbook and leave your painting gear behind. (If you're encumbered with equipment, like most watercolorists, you'll falter after fifteen feet and paint the first thing—or worse, everything—in sight!) Fully explore the area. Look under the pier or inside the boat. Look up. Look down. Be selective. You can't include everything and make a direct, expressive statement.

In the first photograph the camera has captured a multitude of interesting elements: the shadows and patterns of the hulls and dock, the play of light on the middleground boats, the silhouette of a half-finished boat against the sky, the late afternoon quietude of a small harbor—but no single element predominates. Look for a specific element, quality, or condition that interests you and spend a few minutes examining it.

IDENTIFYING YOUR INTEREST

Artists often are described as having a "painter's eye"—the ability to find in the ordinary and commonplace imaginative and personal subjects. This skill is less a matter of selection than of direction and focus—the recognition of some particular quality or condition that can be creatively translated into paint. It is important to identify these qualities before you begin painting. You must know not only what you like, but *why* you like it. Any one of many qualities—color, value patterns, shapes, movements, texture, or expressive mood—could be the inspiration and basis for an effective painting. The quality you decide to emphasize will determine the direction and focus of the work. A painting without a personal direction or focus, no matter how interesting or heroic the subject, will be merely an inventory of visual facts.

In the second photograph we have a more selective view of the boats in the harbor, one that offers any number of painting possibilities. The play of color in the sail covers, the seesawing movement of the sails and hulls, the pattern of the sails as they recede in space, the quiet mood of moored

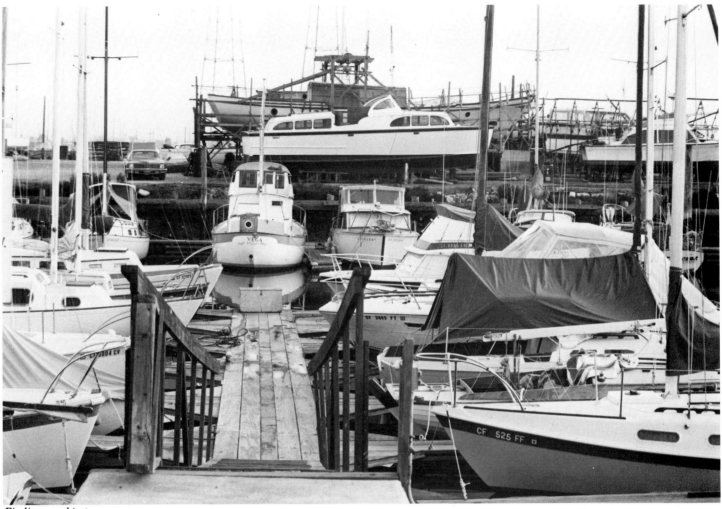

Finding a subject.

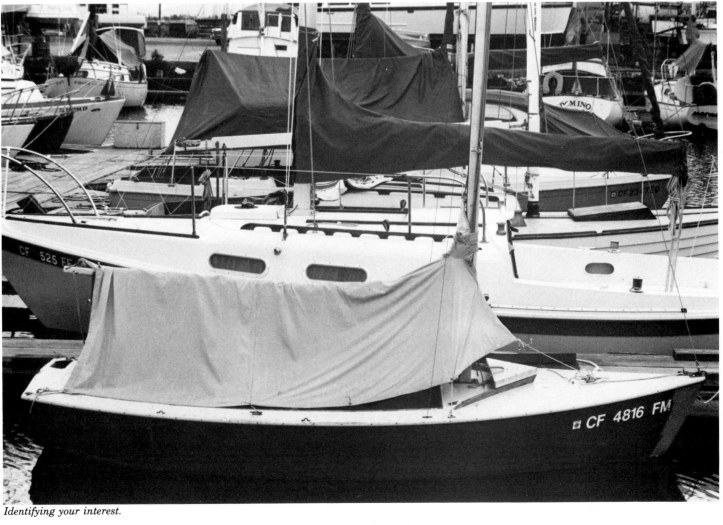

Identifying your interest.

boats in the late afternoon light—each idea, alone or in combination, could be the basis for an effective painting. But again you must be selective. You can't say it all in one painting! And a long-winded, fact-filled painting will have less impact than a simple, direct statement.

APPLYING THESE IDEAS
You may find it easier to recognize what interests you than why, but spending a few minutes contemplating your subject may help you identify your interest. Search for the distinguishing aspects of your subject that make it particularly appealing to you, such as its color, shapes, or mood.

Though you're in the business of painting, not writing, verbalizing your specific interest may help. In your sketchbook or on the edge of your board, write down what it is you like about your subject. Keep your notes simple; you aren't writing poetry. As you plan and execute your painting, continually refer to the notes. All your design decisions—what you retain or eliminate, emphasize or subdue—will be based on them.

CRITIQUE
Has your subject been painted before, and if so, does it need to be painted again? Inexperienced painters will often select (consciously or unconsciously) a subject they've seen painted before or may choose a subject because "it looks like a watercolor." There is, of course, nothing wrong with painting boats and barns,

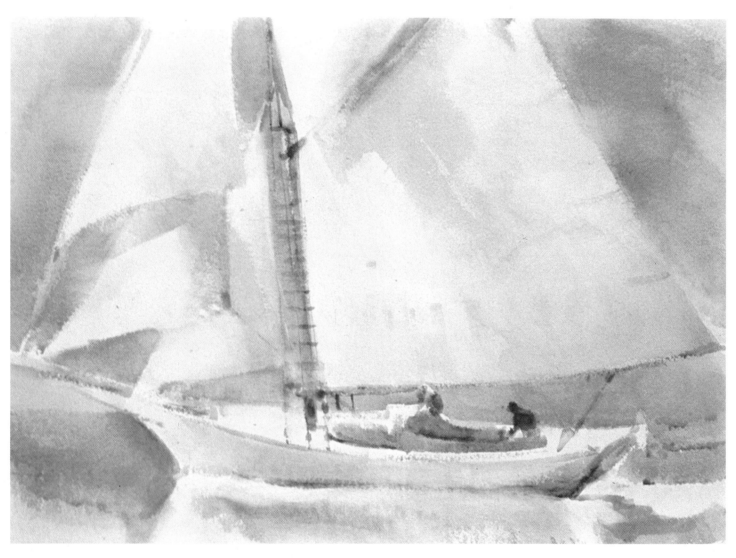

FRIENDSHIP SLOOP
by Barse Miller, N.A., A.W.S. (1906–1973).
Watercolor on Arches 300-lb rough paper,
22" × 30" (56 × 76 cm).
Private collection.

Friendship Sloop is painted with the brevity and the directness that characterized all of the late Barse Miller's work. Though he was a master yachtsman and intimately acquainted with boats, he rarely selected them as subjects. His interest here is not in accurately describing a boat, but in capturing an atmospheric and evocative mood—a large sailing boat seeking shelter in a fog-enshrouded harbor. He has accomplished this by organizing the color and design in a way that emphasizes the expressive qualities of his subject.

Selecting a subject and, more important, identifying your interest in it are the first steps in planning a watercolor. What makes this painting a distinguished work is not the subject (boats are common fare for watercolorists), but the artist's recognition and interpretation of a highly evocative mood.

but only if they have some special meaning for you or you can interpret them in a personal, creative way. The next time you select a subject, ask yourself, "Does this need to be painted? Does it need to be painted again? And what personal insights or imaginative treatment can I bring to it that will distinguish it from thousands of other similar paintings?"

Is your interest or idea clearly conveyed? A confused or fragmented painting is often the result of a loss of direction. After painting for several hours, it's easy to become distracted by peripheral elements—the grass in the foreground or those little shacks on the hill. Write down your first impression and, no matter how long the painting takes, concentrate on conveying it. Eliminate or subdue any element or quality that detracts from your primary interest.

Have you chosen too many or conflicting interests? In your enthusiasm for an area, you may try to paint too much—like a colorful fishing boat reflected in the quiet water of a harbor with an old fisherman in the stern mending nets in front of a confusion of shacks and seafood restaurants silhouetted against a stormy sky filled with geese heading south. If this scenario sounds familiar, try in your next painting to limit your subject and interest to one or two ideas. If you're excited about several things, paint the one you find most interesting and make sketches of the others for future use.

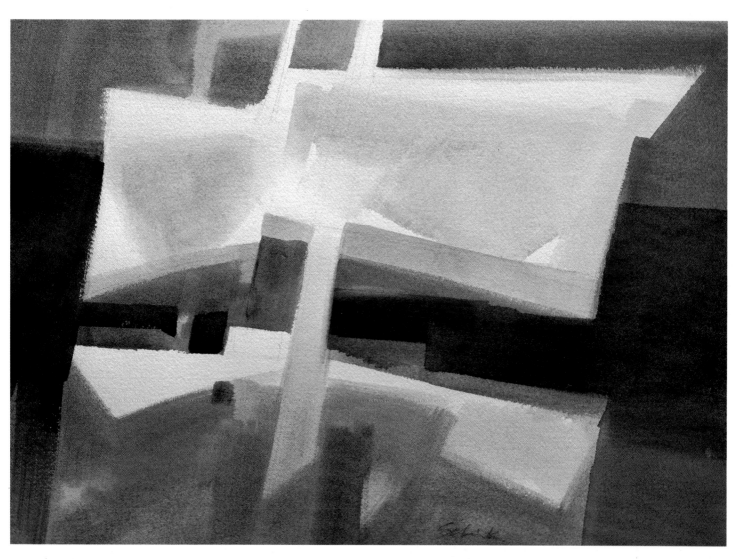

SAIL PATTERNS NO. 4
by Christopher Schink.
Watercolor on Arches 300-lb rough paper,
22″ × 30″ (56 × 76 cm).
Collection of the artist.

Sail Patterns No. 4 is one of a series of paintings based on subjects found in a small harbor near my home. The color, forms, and atmosphere of this area have made it an ideal locale, providing me with the subjects and inspiration for many of my paintings. When searching for subject matter, I begin by exploring an area with sketchbook in hand. When I sense a possible subject, I spend a few minutes analyzing it to determine what it is specifically I like about it and why. Often I write these responses in my sketchbook to serve as a guide while planning and executing my painting. Here I have selected one of the many boats in dock, but my primary interest was in the interesting shape and dramatic movement of its sail cover. Therefore, all my design decisions were based on this specific interest.

SELECTING A VIEWPOINT: DISTANT AND MIDDLE

Your pictorial viewpoint—the point from which you view your subject—should be chosen to reinforce your expressive aim. It should be determined not by where you parked your car or how far you can carry your equipment in one load but by what you want to express in your painting. Your personal response to a subject is reflected as much in the viewpoint you select as in the color and design you employ to convey it.

As you wander around your subject, you may find a number of interesting viewpoints—close or distant, high or low. Each will reveal a different aspect of your subject and convey a different message. Choosing a viewpoint that conveys your interest in or reaction to your subject is a simple way to create a direct and effective painting—well worth the effort of carrying your equipment that additional fifteen feet! Let's consider the expressive possibilities of two potential choices, a distant viewpoint and a middle one.

DISTANT VIEWPOINT

The distant viewpoint has had a long tradition in landscape painting, particularly with watercolorists, who have used the transparency of the medium to create a sense of space and atmosphere. When viewed from a distance and at ground level, the landscape usually falls into undulating horizontal bands that convey an expansive open quality. Also, with distance, contrasts in linear movement, color, and value are reduced, resulting in a more passive, harmonious design.

You may find this lack of tension both an advantage and a disadvan-

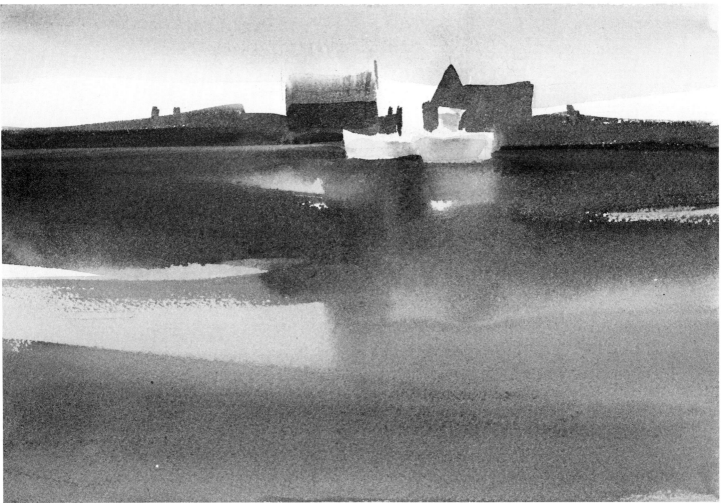

Distant viewpoint.

tage. While the elements of your subject can be seen in simpler, more easily related forms, they can also become static and dull. When you use a distant viewpoint, large areas of sky or earth may need to be reproportioned or animated with color and shape to create interest. Raising or lowering the horizon line can be a useful device for shifting the focus and proportions of your painting.

In the distant viewpoint (page 20), I have emphasized the horizontal movements of the water, land mass, and sky in order to convey the quietude of a small harbor at dusk. I also moved the horizon line up to create a more interesting distribution of shapes.

MIDDLE VIEWPOINT

As we drive our cars, walk in the city, or explore the countryside, we see the world, more often than not, from a middle viewpoint. It offers us the greatest amount of information and is ideal for picture postcards and snapshots. But for paintings, the middle viewpoint, especially when used by inexperienced artists, can be prosaic and predictable. The major disadvantage of a middle viewpoint is its equal distribution of shape, interest, and focus.

In the middle viewpoint shown below, the building, boat, sky, and water are similar in size and visual force. Despite the abundance of information, no single element predominates to focus our interest or hold our attention. This is because the middle viewpoint is intrinsically indiscriminate. To be effective, it must be combined with a strong personal concept and design.

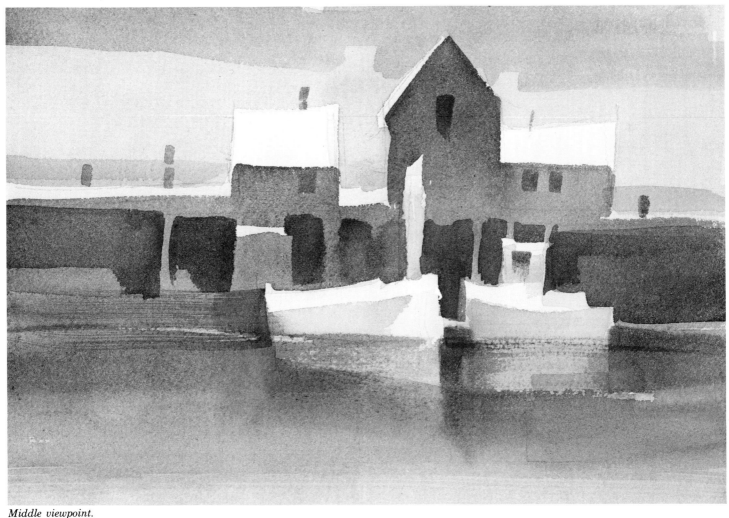

Middle viewpoint.

APPLYING THESE IDEAS

Once you've selected your subject and identified your interest, you must look for a viewpoint that will reinforce them. For example, if you wanted to convey the lonely quality of a farm isolated in the countryside, you would choose a distant viewpoint. To suggest the activity of a busy boat dock, you would probably choose a middle viewpoint. If you wanted to emphasize pattern and movement in the foreground, you would look for a higher viewpoint. If the scale or height of your subject were your main interest, you would choose a lower viewpoint to eliminate distracting foreground elements.

You don't always have to move to get a different viewpoint. If you feel distant farm buildings might be more effective from a middle viewpoint, you don't have to slog through a half acre of mud to paint them! You can simply stay where you are and enlarge them in your painting. And, conversely, if you want to create a distant viewpoint while working in tight quarters without moving to the far end of the parking lot, just reduce the size of your main subject and expand the surrounding areas.

THE WAVE NO. 3
by Phil Dike.
Watercolor on paper,
22" × 30" (56 × 76 cm).
Collection of E. Gene Crain.

Phil Dike is unarguably one of the masters of American watercolor. In his painting, *The Wave No. 3*, he has taken a traditional subject and viewpoint and transformed them into an inventive and hauntingly evocative design. The landscape when viewed from a distance and at ground level forms a series of horizontal bands that suggest an open, expansive quality. Also, at a distance, contrasts in value, color, and movement are reduced and the effect can be both harmonious and dull. Here, Dike has animated the large passive areas of sky and foreground by introducing simple but imaginative forms and subtle variations in value and color. He has used color, design, and viewpoint to reinforce the expressive qualities of his subject.

CRITIQUE

Was your viewpoint chosen for convenience or communication? Do your viewpoints convey a specific quality or idea? Or do you simply set up in any convenient place in the hope something will turn up? Remember: an interesting or expressive viewpoint is a simple and fundamental design device—one of the few afforded photographers, who are unable to significantly change the color, value, or shape of their subject. Don't trade an interesting viewpoint for convenience or a good parking place.

Did you select a distant viewpoint because you wanted to include more objects in your painting? If you find yourself continually backing off from your subject in an attempt to include unrelated, peripheral elements—an old tractor on the far right or a gnarled oak way to the left—you're probably producing more than your share of disorganized and fragmented paintings. A distant viewpoint is most effective when used to reinforce a specific quality or condition: for example, early light over a city or patterns in a field. If you find some isolated element especially interesting, use it as the subject for another painting with a close or closeup viewpoint, but leave it out of this one.

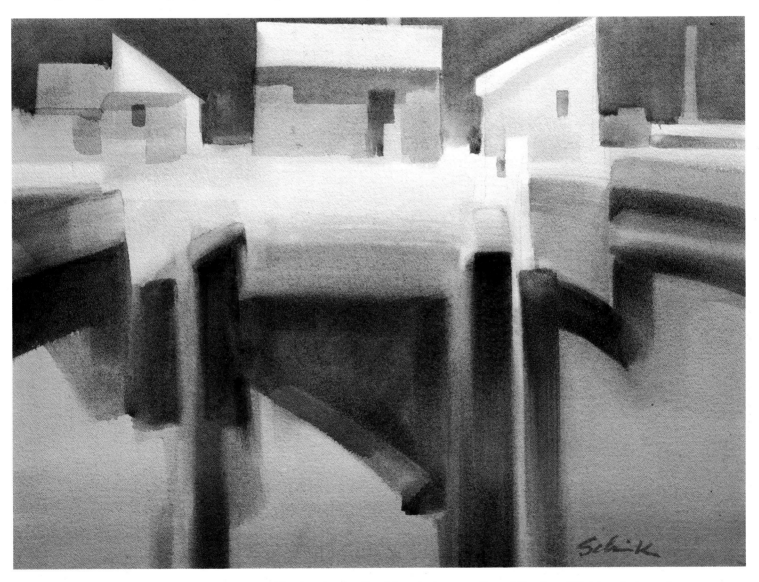

PROSPECT HARBOR
by Christopher Schink.
Watercolor on Arches 300-lb rough paper,
22" × 30" (56 × 76 cm).
Collection of Ellen Collins,
San Francisco, California.

The inspiration for this painting was the subtle play of light and atmosphere on a group of buildings in a quiet Maine harbor. My actual viewpoint when sketching the subject was considerably farther away, but to emphasize my primary interest—the pattern and color of the buildings—I used a middle viewpoint. To convey the atmospheric quality of the gray violet light, I used a series of transparent glazes.

For a middle viewpoint to be effective, it should be used in combination with a personal concept (as it is here) or organized to focus attention on a specific element, quality, or condition. When used in a conventional way or to describe an indiscriminate collection of objects, it can be as predictable and prosaic as a painted picture postcard.

SELECTING A VIEWPOINT: CLOSE AND CLOSEUP

In my workshop critiques I find it surprisingly easy to identify the areas or elements that truly interested each painter because they're always painted with enthusiasm and feeling, a sincere personal response to the subject. Unfortunately, they're also often surrounded by large areas of uninspired and unnecessary paper and paint, areas that neither relate nor contribute to the focus of the painting. In such paintings, the elements treated with selectivity and thought may occupy as little as 15 percent of the entire surface.

One means of avoiding this imbalance (and the tedious business of filling in vast areas with marsh grass or shrubs) is to move closer to your subject. This will enable you to eliminate extraneous elements and focus on important areas or qualities.

CLOSE VIEWPOINT

The close viewpoint is a useful format for painters working in a representational style as well as with a more abstract concept. Moving closer to the subject eliminates peripheral distractions and directs the viewer's attention to the primary elements of the painting. It also offers more possibilities (as illustrated here with the two boats from the preceding lesson) for the dynamic interplay of shapes and movements than a distant or middle viewpoint. While the close viewpoint makes for more exciting design possibilities (often a primary concern of more abstract painters), it also presents several problems. A closer viewpoint creates more acute linear perspective—especially evident in buildings—resulting in strong diagonal movements that can be

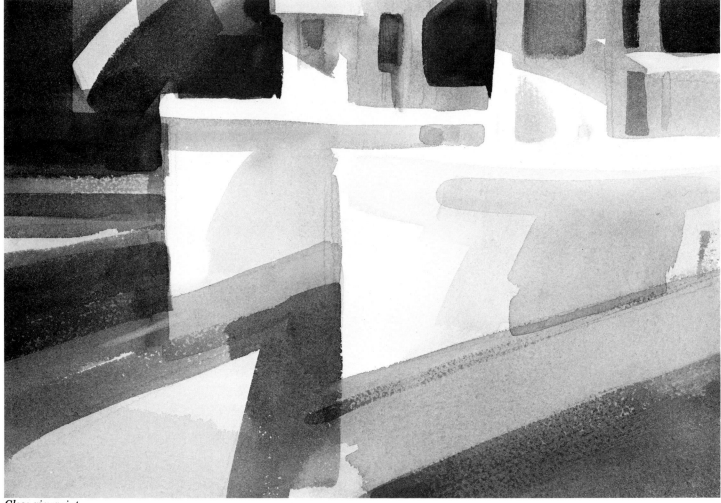

Close viewpoint.

difficult to organize and unify. Moreover, because of the restricted number of things included, the opportunities for repetition of color and value can be limited.

CLOSEUP VIEWPOINT

While the close viewpoint may include a few nearby objects in addition to the subject, the closeup view moves even closer to the subject. A closeup viewpoint is intrinsically personal and selective, a direct reflection of the artist's vision and response to his world. This world may be contained

in an area no larger than a few square inches or feet and it may hold objects no more prepossessing than a clam shell, a gnarled branch or, as illustrated here, a rusty prop and rudder. And yet it may serve as the inspiration for a painting as fully developed and expressive as any based on a grander view.

The closeup viewpoint is especially appealing to contemporary painters whose interest is principally in the relationship of color, value, and form. It offers within a limited or shallow space the opportunity for a dynamic

interplay of these elements. When greatly enlarged, commonplace objects are less easily recognized. This change of scale creates an ambiguity that emphasizes the abstract quality of the painting's design.

APPLYING THESE IDEAS

Before settling on a middle or distant viewpoint, try moving closer to your subject. If you normally look for subject matter and inspiration from the top of a hill or the front seat of your car, try for a change to limit your viewpoint. When you find an area or

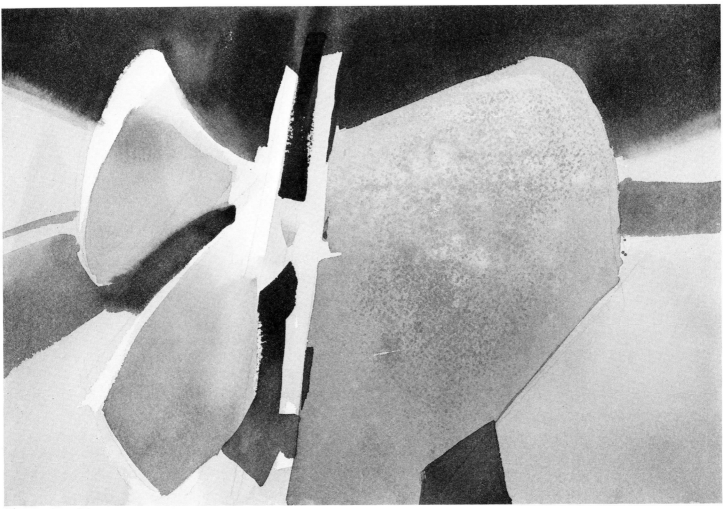

Closeup viewpoint.

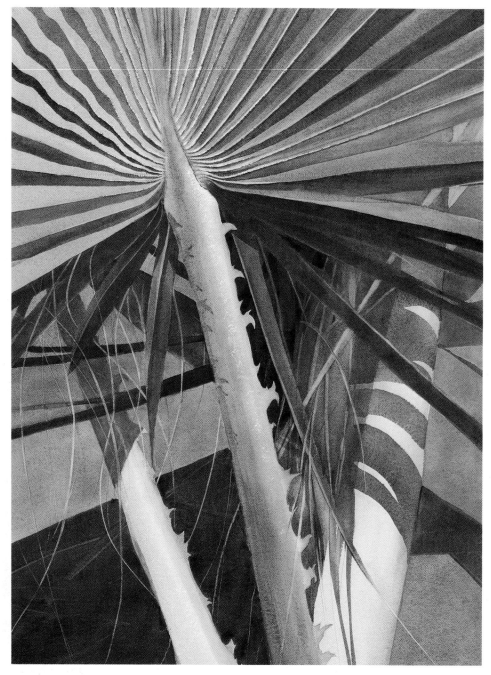

PALM PATTERNS NO. 36
by Edith Bergstrom.
Watercolor on Arches 300-lb rough paper,
22" × 30" (56 × 76 cm).
Collection of Hallmark Cards, Inc.

The color, pattern, and movement of palms, common trees in southern California, have provided artist Edith Bergstrom with the inspiration for a series of imaginative paintings. Here she has selected a close viewpoint that emphasizes the dramatic movement of the trunk and fronds and eliminates all peripheral elements (including, in this case, a delightful Victorian house). Though she has handled this subject in a seemingly realistic way, it is her selective viewpoint and strong design that transforms this common subject into a highly personal and startlingly effective painting.

element that might be interesting, move closer and examine it from several angles. Look for an expressive and imaginative viewpoint, rather than a conventional one. The close and closeup viewpoints will not only provide a different view of your subject but also different design possibilities. You might consider these differences when selecting your next viewpoint.

If you're distracted by peripheral elements, bring along a small rectangular framing window, say 2" × 3" (5 × 7.5 cm), cut from a piece of paper or mat board, and use it to frame your subject. Or make a frame with your fingers. Use this device to limit and focus your view and make several sketches employing different viewpoints—close and closeup, high and low. Don't be afraid to make your primary interest large. It is, after all, what you want to say in your painting. It's far easier to eliminate unrelated and extraneous elements than to redesign or subdue them.

CRITIQUE

Was your closeup viewpoint chosen for its expressive possibilities or for its eccentricity? The possibilities of subjects viewed from a closeup position may seem limitless—light shining through the bottles in your spice rack, the silvery texture of an old fence, the sinewy curves of a gnarled tree. But remember, your viewpoint should be based on a genuine interest in your subject. It should reflect a sincere response to the world you live in, not a desperate attempt to be novel. Sincerity is what distinguishes creativity from eccentricity.

Have you used the close or closeup viewpoint to emphasize the dynamic interplay of positive and negative space? Or have you simply created a study or vignette of some isolated element? An effective way to eliminate distracting peripheral elements is to close in on an area or element and enlarge its image in your painting. However, the shape, color, and value of the remaining areas of negative space should be designed to enhance the large positive elements. If these supporting areas are ignored, the painting becomes simply a study or vignette, with the visual interest concentrated entirely on some isolated element.

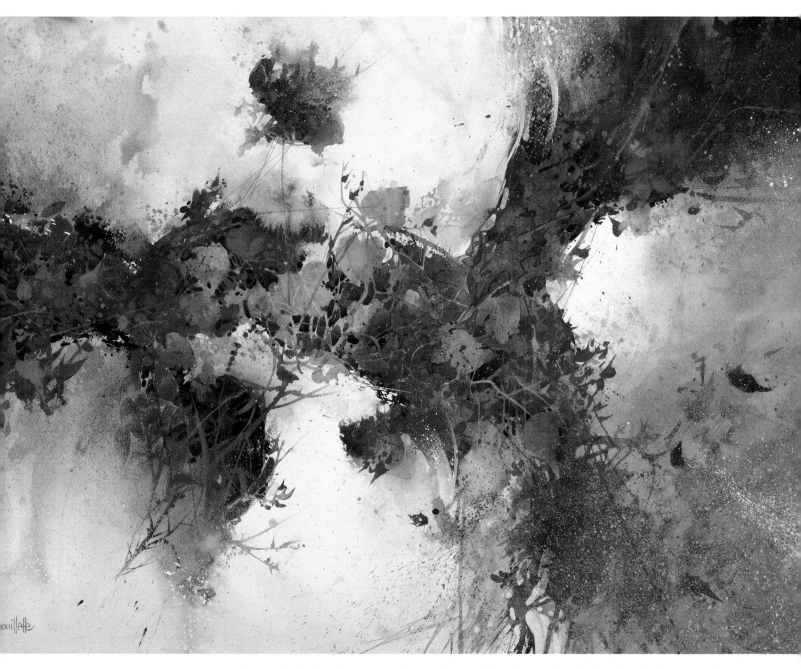

THAWING OUT
by Al Brouillette.
Watercolor on Arches 300-lb rough paper,
21" × 29" (53 × 74 cm).
Collection of Diane Gerard,
Morristown, New Jersey.

A simple subject seen from a closeup viewpoint can be the inspiration for a painting as fully developed and expressive as any based on a grander view. The subject of this almost abstract painting by Al Brouillette was nothing more than a few perennial violets emerging through a patch of sleet, but by taking a closeup viewpoint emphasizing the dramatic play of value, color, and form, he has created a painting as striking and evocative as any with grand vistas of snow-capped peaks.

The closeup viewpoint is especially appealing to the contemporary painter whose primary interest is in the form and design of a painting. It provides the opportunity for the dynamic interplay of color, value, and form within a limited or shallow space.

LESSON FOUR

DESIGNING POSITIVE AND NEGATIVE SPACE

What distinguishes a painting from a study or sketch, making it a complete statement rather than an anecdote, is its use of the entire surface in an overall design. In a painting, both positive and negative areas are designed and balanced. In a study, sketch, or vignette, attention is given only to the space occupied by the subject. The design of the remaining space or supporting areas is not considered. It is simply left. Therefore, when planning a painting, you should give as much attention and thought to the proportion and shape of the supporting or negative areas as you would to the design of your primary or positive elements. An inspiring subject seen from an interesting viewpoint may produce an informative study but not necessarily an effective painting.

DEFINING POSITIVE AND NEGATIVE SPACE
Positive and negative space are terms commonly used to describe the role of areas or objects in pictorial space. Solid positive elements, usually the subject of the painting, are surrounded by more open negative areas. For instance, in the first illustration, the fruit and bottle would be considered positive elements and the tablecloth and drape, no matter how decorative, would be called negative space. In a typical landscape, say a rural scene, the barn and buildings would be the positive elements, and the foreground field, distant mountains, and sky would be the negative space. Normally the areas of positive space are made the central focus of

the painting; however, it is possible to shift the focus of a painting to the negative space. For example, a dramatic or colorful sky can be the predominant element in a design.

DESIGNING POSITIVE AND NEGATIVE SPACE
By balancing the proportion and shape of positive and negative areas, you can make the entire surface of your design visually active. This is most easily achieved by enlarging the size of the positive elements.

In the second example, the numeral 5 on the right represents a primary or positive element in the proportions normally used in a sketch or middle viewpoint. It is surrounded by a large area of inactive negative space and is clearly the dominating force in the design. On the other hand, the numeral 5 on the left has been enlarged to extend past the edges of the design. The negative space has been greatly reduced and divided into three smaller elements that are at least equal in visual force to the positive area.

It is not always possible to enlarge the positive elements of a painting. For instance, a middle or distant viewpoint depends on a large proportion of negative space. However, there are several ways to make the negative space an interesting component of a painting's overall design. You can divide or subdivide it in an interesting way, you can grade its color or value, and you can add texture or surface decoration to it. Any or all of these devices can be used to create a better visual balance between the pos-

itive and negative areas of your painting.

FRAMING THE SUBJECT
If you have difficulty seeing and organizing positive and negative space, try several sketches before you begin painting. You can start, as in the third illustration, by drawing primary elements and surrounding areas in simplified shapes. Then move your borders in, using a line to frame the design. Concentrate on the shape and proportion of the negative space. Don't worry about cropping positive elements if doing it will make the negative space more interesting.

Here the roof of the building on the left protrudes past the edge, dividing the negative space into two interesting shapes. Where larger monotonous negative areas are unavoidable, try subdividing them into more unusual shapes. For example, the foreground here could be made more appealing by dividing it into shapes that echo the movement of the roof line.

APPLYING THESE IDEAS
You may, in fact, be more sensitive to the interplay of positive and negative space than you realize. I know a number of painters who regularly test their completed paintings with "L" mats (two mat corners held together to form rectangles of varying sizes), reducing the outer dimensions until they find an effective design. With particularly unsuccessful paintings, they may even resort to scissors, cropping edges until they have a dynamic design—sometimes only six inches square! These devices are nothing

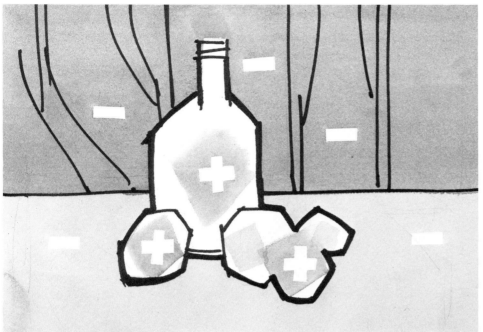

Defining positive and negative space.

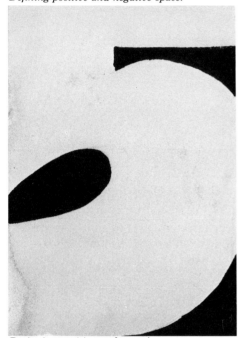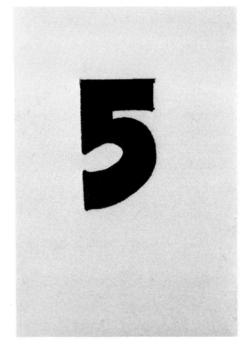

Designing positive and negative space.

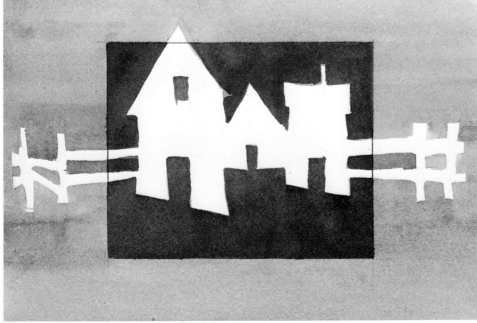

Framing the subject.

more than belated and unconscious attempts to adjust the balance of positive and negative space. The disadvantages are obvious: a loss of impact from a reduction in size and a waste of expensive paper. It is far better to design and apportion negative and positive areas from the very beginning.

CRITIQUE

Have you faded the edges of your painting or used a vignette to solve your spatial problems? If you normally start a painting by concentrating on and defining the positive elements and then, as your interest and inspiration flag, fade or "fudge" the edges, you're missing the opportunity to create a dynamic design. In your next painting, concentrate on designing the negative space first. Do several sketches and be sure to draw a border to define your negative space. Without a border, it's impossible to judge the shape and proportion of supporting areas. Remember: well-designed negative areas will enhance the positive elements, making an even more forceful design.

Do you rely principally on texture or surface decoration to make your negative areas interesting? Filling large uninteresting areas with bushes, shrubs, and busy brushstrokes usually indicates a lack of preplanning, a desperate attempt in the last stages of painting to animate negative space. You should use texture and surface decoration sparingly, as part of a thoughtfully conceived overall design—not as an afterthought.

HAWK
by Shirley Porter.
Watercolor on Rives 140-lb paper,
21" × 29" (53 × 74 cm).
Collection of the artist.

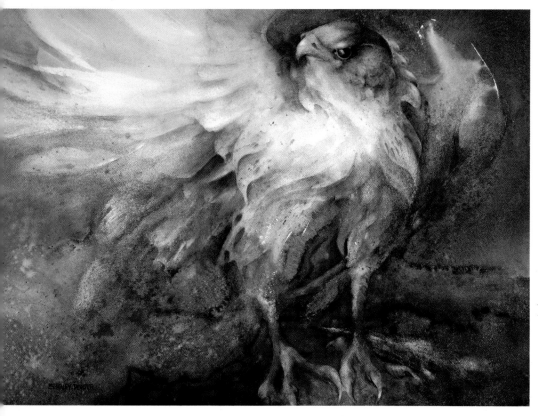

This handsome painting by Shirley Porter is one of a series she has done on birds. What distinguishes it from a mere study or sketch is its use of the entire surface in an overall design. By greatly enlarging her primary interest—the hawk—and reducing its supporting area—the negative space—she has created a dynamic design in which positive and negative areas are equally interesting in shape. Her skillful use of value contrast and texture make the painting all the more exciting.

When designing a painting, you must give as much attention and thought to the proportion and shape of supporting areas as you do to your primary or positive elements.

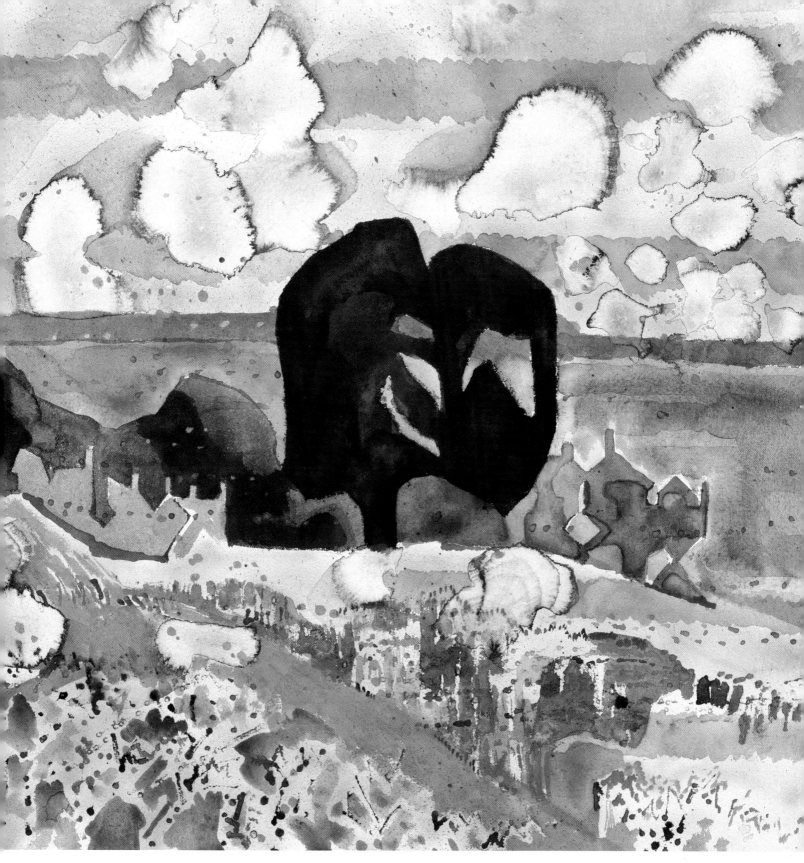

IRISH LANDSCAPE
by Keith Crown.
Watercolor on paper,
23½" × 32" (60 × 81 cm).
Collection of E. Gene Crain.

You could hardly call Keith Crown's landscapes realistic, but they are as evocative and descriptive as anything done in watercolor. By drawing from the landscape any elements (including those behind, below, or above him) and transposing them into highly imaginative forms, he creates a painting that conveys his unique response to his subject.

In *Irish Landscape* he has animated the negative space in his design—the sky and foreground—by the use of color contrast, division, and texture, to produce an exciting overall design. The proportion and design of negative or supporting areas in a distant landscape are as important as those done from a middle or closeup viewpoint.

APPLYING THE PRINCIPLES OF DESIGN

For an inexperienced painter, designing a satisfying watercolor may seem more a matter of guesswork and luck than conscious planning. In fact, many design decisions are made intuitively. However, there are several basic principles that can be useful in organizing the graphic elements of a painting. There are three basic qualities present in the underlying structure of every creative work: unity, variety, and contrast. Whether carefully considered or intuitively applied, all three are essential. In later lessons I will discuss the specific application of these principles, but to begin, let's examine these basic concepts in general terms.

UNITY

A painting must have unity; it must be organized as a harmonious and cohesive whole. A painting composed of a multitude of singular and contrasting parts, will be chaotic or disturbing. In the first illustration, no single element or quality predominates the design and there is an absense of unity. Individual elements may be attractive or interesting but when combined make a disunified design. Unity is achieved when the elements of a painting share some common quality—color, value, shape, or movement.

CREATING UNITY THROUGH REPETITION

Unity is achieved by repetition. When an element or quality is repeated, it creates by its recurrence a visual rhythm. It becomes the dominant element or, in a sense, the theme of a

An example of disunity.

Creating unity through repetition.

Creating variety within unity.

Introducing contrast.

design. In the second sketch, the diagonal movement of the sail has been repeated to create the simplest form of unity. Other elements have been eliminated or subdued, and the regular movement of the sail form dominates the design. Any graphic element—value, color, and so forth—can be repeated.

CREATING VARIETY WITHIN UNITY

Repetition leads to unity and, if continuous and unvaried, to monotony. In the illustration here, the unrelieved regularity of the sail forms creates a unified but boring pattern. A painting should contain variety within its unity. Elements or qualities that are related but not identical will create interest without disturbing the harmony of the design. The sail and boat forms in the third sketch vary in size and position to create a pattern that is rhythmic but less predictable and more interesting.

INTRODUCING CONTRAST

Contrast is created when a dissimilar element or quality is introduced into a harmonious unified design. Contrast serves two purposes: to emphasize by antithesis the dominant qualities of a design and to direct the viewer's attention to important areas or qualities. For example, a dominantly red painting will seem even warmer when a small area of green is added. A dark painting will appear darker when a small area of light is introduced. And your eye will be attracted to these areas of contrast.

In the fourth example, the circular

shape of the sun contrasts with the sail forms and is repeated in minor variations in the shadows on the sails and patterns in the water. Contrast can be subtle or strong depending on the expressive intent of the painting. Isolated or singular contrasts can be made more compatible by repetition and variation.

APPLYING THESE IDEAS
The principles of design are applicable in every stage of the design process from designing linear movement and shapes to organizing values and color. The concepts of repetition, variation, and contrast are useful whenever you're faced with a design decision. In the following projects I

refer to these concepts. They are helpful in developing a sensitivity to the relationships in the graphic elements of a painting and understanding how a painting is constructed. I'm not suggesting, however, that you approach every painting as if it were a second-year art school design problem. (That will invariably result in a contrived, unimaginative painting.) I would hope, instead, that you develop an awareness of how each element of your painting functions in terms of the overall design and how these elements can be altered and modified to improve that design.

If you have difficulty seeing your painting as a design and are primarily concerned with reproducing

the surface reality of your subject, try viewing your painting from a different perspective. Turn it sideways or upside down. While the oft-repeated dictum that a good painting reads well from any direction is only partially true, viewing your painting from different directions is useful in assessing its design. You can suspend, at least momentarily, your interest in the red barn, the rusty tractor, and the gnarled tree and judge whether you have effectively created a sense of unity, variety, and contrast.

CRITIQUE
Are you relying on nature to provide you with a good design? Nature can provide the inspiration or the idea

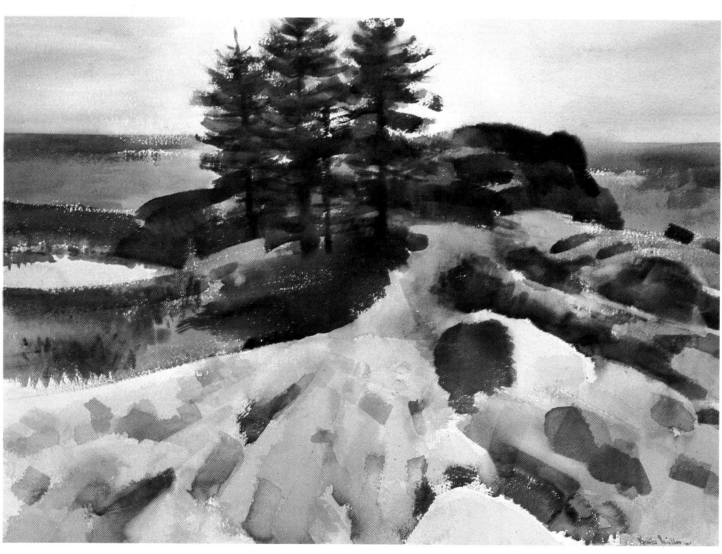

RANGEMARK
by Barse Miller, N.A., A.W.S. (1904–1973).
Watercolor on Arches 300-lb rough paper,
21" × 29" (53 × 74 cm).
Collection of Mrs. Barse Miller.

This direct and forceful landscape by the late Barse Miller clearly illustrates how the elements of design—color, value, shape, movement, and so forth—can be organized to create a sense of unity, variety, and contrast.

Although seemingly realistic, this painting is the result of a carefully planned and organized design. Before he started painting, Miller spent several hours over the course of a summer studying the subject. He has created a sense of unity by repeating similar hues (varying from violet to warm pink), values (ranging from light to middle), and movement (generally horizontal with some radiating diagonals). For contrast, he has used the dark green vertical trees, playing them against the long horizontal movement of the water and the light, warm sky.

for a painting, but not in an order or form that will clearly convey your response to it. To do that, you must rearrange, alter, and organize your subject matter. You must design your painting. If you have difficulty departing from your subject and seeing your painting as a personal and expressive design, remember, the effectiveness of your painting is based on how clearly it conveys your reaction to nature, not on how accurately it reproduces it.

When painting, do you regularly stand back and assess your design? Unity, variety, and contrast are abstract qualities and difficult to judge; however, standing back from your painting helps. I find that most painters, whether experienced or inexperienced, have a good sense of design, but I'm continually surprised at how long some painters will work before standing back and assessing the results. When they do, it's often too late! To avoid wasting precious hours and paper, get into the habit of standing back from your painting at regular intervals and thinking about your design.

Are you sensitive to where contrasts occur? We've all had the experience of pulling out an old painting and discovering some distracting part—a distant, out-of-tune red barn or a dark fence post in the corner—that we previously had been unaware of. Misplaced or overly strong contrasts can destroy the unity of a painting or misdirect its focus. Strong contrasts in color, value, movement, or shape must be thoughtfully planned to draw the viewer's eye to the most important areas or qualities. When doing your next painting, stand back and note what first attracts your eye. Judge whether contrasting elements emphasize or detract from your primary interest.

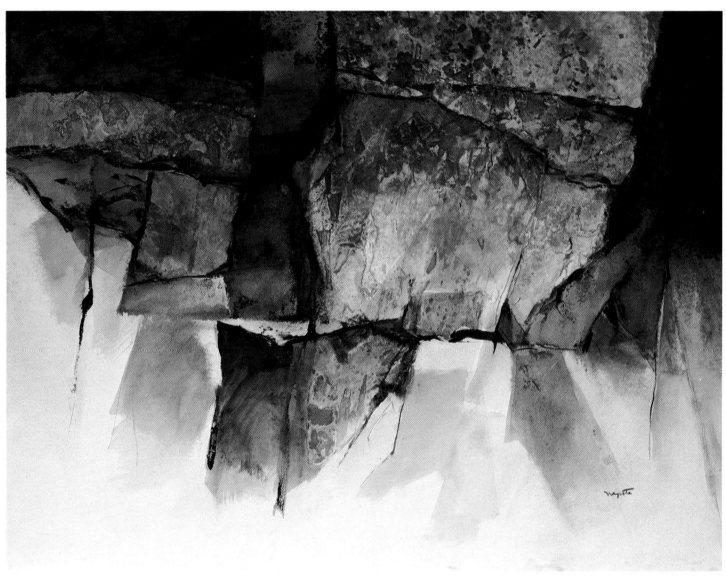

WEATHERED ETERNAL CLIFF
by Alexander Nepote.
Watercolor collage with ink
on mounted paper, 30" × 40" (76 × 102 cm).
Collection of the artist.

This handsome painting by Alexander Nepote was based on sketches he made while exploring the Southwest. His subject is nothing more than a barren cliff face, but by selecting a closeup viewpoint he found in the shapes, colors, and textures of this unprepossessing subject the inspiration for a powerful, almost abstract design.

Whether abstract or realistic in concept, a painting should convey a sense of unity, variety, and contrast. Here, Nepote has introduced the warm hue and diagonal movement in the area in the upper left as contrast to the predominantly light, cool, vertical and horizontal design.

DESIGNING LINEAR MOVEMENT

Drawings and paintings exist on two-dimensional surfaces—that is, they are flat. Although line is essential to drawing, in painting the artist uses variations in shape, color, and value to create painted symbols that suggest the actual subject. These symbols can be fully developed and detailed, as in more representational work, or simplified and abstract. In either case, their movement and direction can be designed to reinforce the expressive intent of the painting. For example, several horizontal bands of color can evoke the vast, expansive quality of a landscape. And strong diagonal movements can be used to suggest activity such as trees in the wind or boats in a storm. Through the associations it conveys, linear movement can evoke a consistent emotional response from the viewer. It can be designed to form the underlying structure of a painting.

Although line in a painting serves principally as an embellishment, in the preliminary planning stages, line can be a useful tool. In a preparatory sketch, the edge or dimension of a shape to be painted can be described by a line. Then its direction and movement can be designed to create associations that contribute to the expressive qualities of a painting.

Descriptive linear movements fall into four general categories: horizontal, vertical, diagonal, and curvilinear. Each evokes a different response.

HORIZONTAL AND VERTICAL MOVEMENT

Lines moving in horizontal and vertical directions have great stability. They relate directly to their surroundings—the painting's edge, its frame, and the wall on which it hangs. Horizontal movements evoke a feeling of restful calm and suggest the landscape, sky, earth, or ocean, and the horizon. Vertical movements suggest the presence of humanity and nature within the landscape and evoke a feeling of strength and stability. Horizontal and vertical movements are often the predominant element of a landscape's design.

DIAGONAL MOVEMENT

Lines moving in a diagonal direction suggest change and excitement in nature, because we associate diagonal movement with activity—people working, boats at sea, or trees leaning in the wind. Diagonal movements create a feeling of tension (or even chaos, when they are conflicting and dissimilar). Diagonals are also often used to provide contrast in a predominantly horizontal and vertical design. When diagonals form the primary movement of a design, dissimilar diagonals may have to be made parallel to create a sense of unity.

CURVILINEAR MOVEMENTS

Lines used in curvilinear movements suggest the human figure, rolling hills, or moving water. Curvilinear movements can be active or passive, depending on the activity of the line. An arc is a strong visual force in a design, drawing the eye inward toward its center. In a predominantly curvilinear design, curves work best

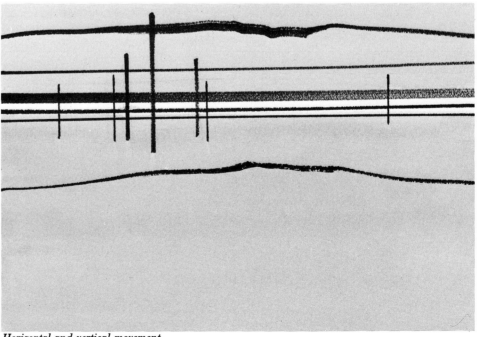

Horizontal and vertical movement.

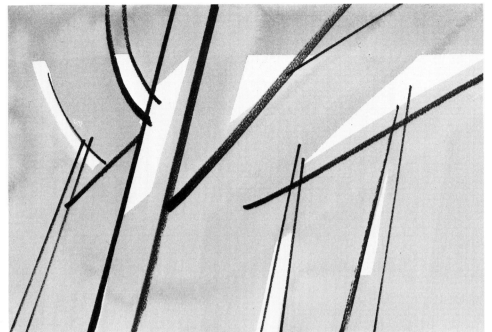

Diagonal movement.

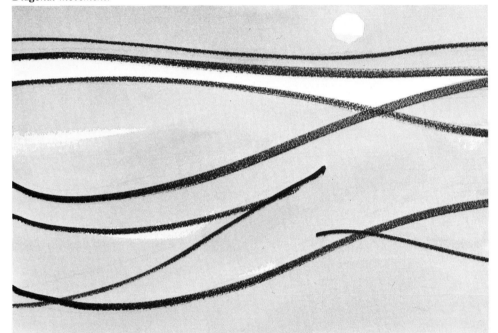

Curvilinear movement.

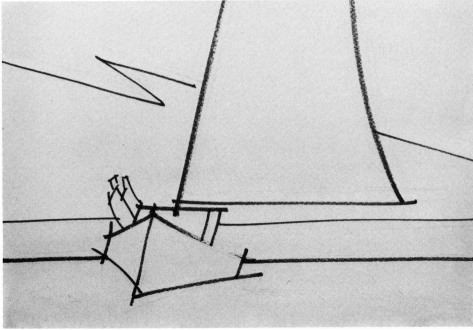

Organizing linear movement.

when they are arranged to encircle areas of focus.

APPLYING THESE IDEAS

To organize the linear movements, start by drawing the outer dimensions of your chief interest. In the last sketch, the mast, sail, and hull were drawn first. I eliminated all detail and tried to find and repeat the major movements that would reinforce my reaction to the subject—the diagonal of the boat heeling in the wind. Repeating this diagonal movement created a sense of unity.

Next I looked for secondary movements—the long horizon line and the sweeping line of the cloud. Your eye will follow long, uninterrupted movements, so these should be placed near areas of special interest. Here I positioned the horizon line to lead your eye to the boat and figures. Longer movements in less important areas, such as the line of the cloud here, can be broken by fading or subduing contrasts in value, or by crossing the line with minor countermovements, or by "jogging" or "squiggling" the line. Strongly contrasting countermovements should be reserved for areas of special interest. Here the reverse diagonal of the figures (repeated in the far edge of the sail) counters the predominant diagonals of the mast and boat. This becomes the area of major focus.

Do several of these sketches, keeping in mind the expressive quality you wish to convey. Select the design that is best. You will use it as the underlying structure for the next step in the design process, designing shapes.

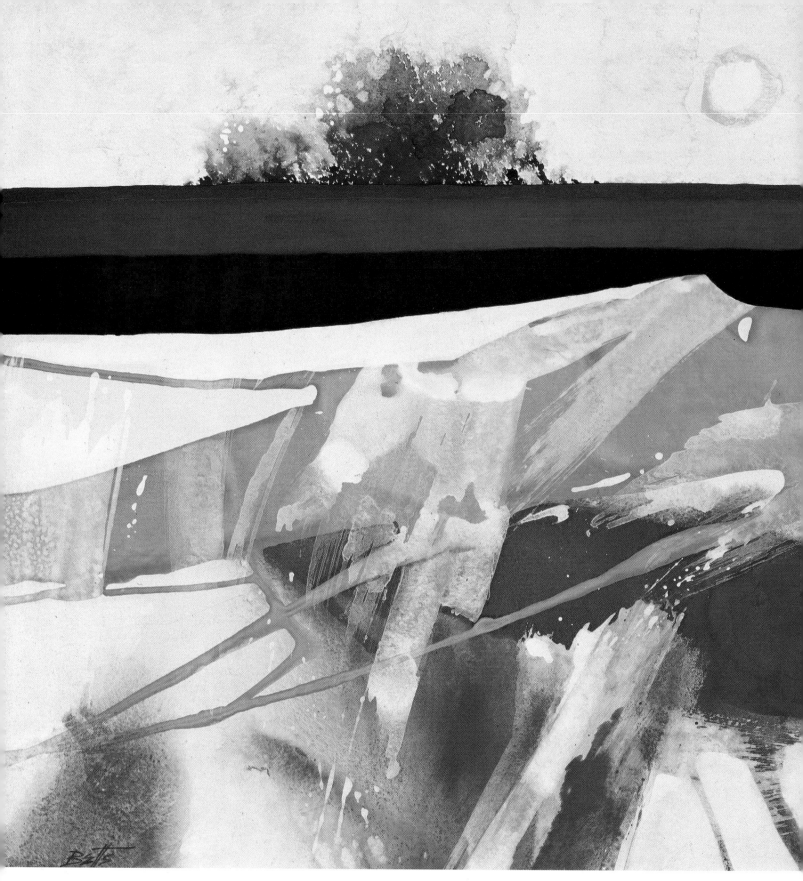

WINTERSHORE
by Edward Betts, N.A., A.W.S.
Casein on paper, 22" × 29" (56 × 74 cm).
Courtesy of the Midtown Galleries,
New York City.

Edward Betts has created with the simplest of forms an expressive and highly evocative painting. Without including a single seagull, boat, or fisherman, he has captured the still, ominous mood of a winter seascape through linear movement and color. By emphasizing a strong horizontal movement, he has suggested the sea, and against this he has used the more active, curvilinear wave form for contrast. These movements are echoed in the sun and gestural forms in the foreground. The predominantly cool color scheme is accentuated by the horizontal band of intense red and the attenuated yellow of the sky. Because of its strong forms and expressive movement, this design would work equally well as the basis for a more realistic painting.

CRITIQUE

Does the linear movement of your design reinforce the expressive intent of your painting? You may have been attracted to a subject for one quality but while painting unconsciously emphasized another, which resulted in an incongruous or discordant movement. For example, you might have wished to capture the quietude of a rural scene but instead mistakenly allowed the diagonals of the barn's busy roofline to be the dominant linear movement. In designing a painting, don't hesitate to alter, subdue, or eliminate any element that detracts from your expressive intent.

Do you have difficulty translating your linear sketches into successful paintings? Remember: a linear sketch is only the first step in the design process, and the information it provides is limited. All shapes, values, and color must be thoughtfully planned before you start a painting. To paint a successful watercolor based solely on a line drawing requires great presence of mind and a lot of luck—commodities not always available!

CROWDED ROOM
by Norma Auer Adams.
Watercolor on Arches 140-lb rough paper,
21" × 29" (53 × 74 cm).
Collection of Bud Thon,
Palo Alto, California.

In her painting, *Crowded Room*, Norma Auer Adams has used a recurrent and almost monotonous vertical movement to create a powerful and evocative design. She has also implied the presence of human forms by using contrasting curvilinear movements. These culminate in a single isolated area of light that provides focus and interest. Linear movement can be employed as an expressive element in the underlying structure of a painting. Different qualities or moods can be suggested by emphasizing specific linear movements—horizontal, vertical, diagonal, or curvilinear. Countermovements can be used to create contrast and interest.

LESSON SEVEN

DESIGNING AND COMBINING SHAPES

A painting is not made up of lines nor is it composed of objects—barns, boats, and trees. Instead it is made up of shapes—areas of paint that vary in size, form, color, and value to create an expressive design and, in representational painting, to give the illusion of objects, space, and volume. Translating subject matter into simple, interesting shapes and combining these shapes to form an integrated design are fundamental steps in the design process.

MAKING SHAPES INTERESTING

For a shape to be interesting, the direction and movement of its edge must be both rhythmic and varied. For example, in the first sketch, the movement at the edge of the tree on the left-hand side of the painting is rhythmic, but because of the unvaried repetition, it is also monotonous. On the other hand, the tree shape in the second sketch is more interesting. Its movement is equally rhythmic, but it is also varied and less predictable.

Not all shapes in a painting need be equally interesting. Depending on the expressive intent of the painting and the role of each shape in the overall design, some shapes may be simple and passive, and others complicated and active.

COMBINING SHAPES

A painting is composed of a variety of shapes that have been integrated to create a sense of unity, variety, and contrast to form a unified and expressive design. A shape may be interesting in itself, but when combined with other shapes may prove to be weak and ineffective. Therefore, in

A monotonous shape.

An interesting shape.

designing a painting, shapes must be considered in relation to each other and to the design as a whole.

To create an integrated design, shapes can be varied in a number of ways: through their general direction, their size, and the activity of movement at their edge. The general movement of shapes is determined in the linear design plan of your painting.

In the third example shown here, diagonals (the predominant movement) are used to describe the jutting rock forms, and they move in a generally parallel direction. The verticals and diagonals of the trees and the long horizontal are countermovements that create contrast and focus. The size of the rock forms and trees (positive elements) and the foreground and sky (negative elements) have been varied to create interest, since equal-sized shapes seem uninteresting and monotonous. In addition, the progression from large to small creates a sense of space and depth.

Complicated or active shapes attract attention and therefore should be used in areas of focus or interest and in contrast to simpler, more passive shapes. Here the busy movement of the tree shapes contrasts with the quieter rock forms.

APPLYING THESE IDEAS

When you're on location and faced with a complexity of subject matter, you may find it difficult not to think of your subject as a collection of things—a boat, the dock, two fishermen, and so forth. In order to translate diverse elements into an integrated design, you must learn to

suspend, at least initially, your interest in the reality and detail of your subject. You must learn to visualize your subject as an arrangement of shapes and patterns.

The easiest way to accomplish this is to make a sketch in which you have reduced the elements of your subject to the fewest and simplest forms. You can base your sketch on the diagram of linear movement you made earlier. Avoid details in your sketch—windows, seagulls, busy shadows. Instead, describe each element in terms of its largest, simplest form and concentrate on designing the shape and movement of its outer edge. Be conscious of how positive shapes affect the negative areas surrounding them. Look for patterns—light moving from roof to roof or masses of dark trees— that can be used to connect fragmented areas. Above all, don't feel compelled to adhere to the exact shapes of your subject. Redesign! The world is filled with funny barns and awkward trees that are better left unpainted. In a painting every shape, from the slimmest shadow to the grandest mountain, must be thoughtfully proportioned, placed, and designed.

Combining shapes for expressive design.

CRITIQUE

Are many of the shapes in your painting dull and monotonous? The repeated use of a similar arm movement or brushstroke will produce a monotonous or uninteresting shape. You can avoid "lumpy" mountains and "quilted" trees by painting each shape as a whole, concentrating on designing and varying its edge. Don't allow your arm and your brush to design your painting. Use your mind and your intuition.

Have you included or emphasized an unnecessary or incongruous shape without considering its purpose in the design? Before you start to paint, analyze the shape of each element of your subject and its role in your overall design. For example, you may have placed a tractor or some equally active shape on the outer edge of your design because that's where the farmer parked it. This won't work. If an object is distracting, or unessential, move it, subdue it, or eliminate it. The farmer won't care!

In your enthusiasm for the positive shapes of your subject, have you neglected the design of your negative areas? Your greatest interest will probably be in the positive elements of a subject. But remember: for a painting to be effective, its entire surface must be thoughtfully proportioned and designed. Don't neglect the negative areas. If you're in the habit of carefully designing the positive shapes and half-heartedly filling in the negative ones, in your next painting try to concentrate on designing the negative shapes first. Think of them as a setting—a stage on which the positive shapes will shine.

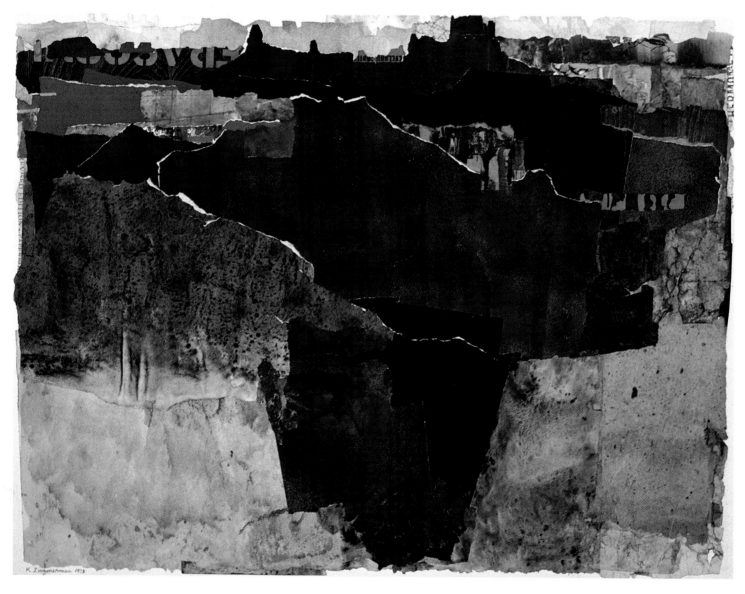

NIGHT CANYON
by Kathleen M. Zimmerman.
Watercolor collage on paper,
24" × 30" (61 × 76 cm).
Collection of the artist.

Kathleen Zimmerman combines an imaginative use of the medium with a strong sense of design to produce works that suggest rather than slavishly duplicate the landscape. Her principal interest is in the shape and movement of landscape forms seen from a distant viewpoint. To convey this interest, she uses a collage technique—tearing and cutting painted paper into naturalistic forms. By varying the size, direction, and edge of these forms, she has created an interesting and expressive design with an economy of means. To this strong underlying structure, she has added just the suggestion of texture and detail.

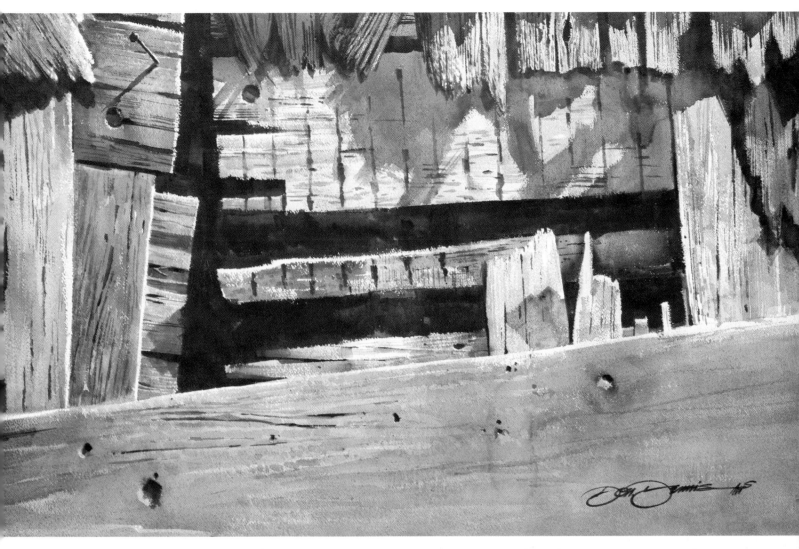

WEATHERED ABSTRACTION
by Don Dennis, A.W.S.
Watercolor on Arches 300-lb rough,
24" × 38" (61 × 97 cm).

Don Dennis's mastery of the medium is clearly evident in his painting *Weathered Abstraction*. But it is not his virtuosic brushwork or convincing reproduction of texture that make this painting so effective; it is his skillful organization of shape and pattern. He has transformed an ordinary subject into an exciting and forceful design. The texture and detail are simply embellishments.

Translating subject matter into simple, interesting shapes and combining these shapes into an integrated design are fundamental steps in the design process. Without them, a painting becomes nothing more than a disorganized collection of surface decoration and detail.

ORGANIZING VALUES

If watercolor is new to you, you may wonder why watercolorists seem so preoccupied with values—the darkness or lightness of a painted area. In opaque media such as gouache or oil, darks and lights can be painted in any order. But transparent watercolor must be painted in a systematic, subtractive process, working from light to dark. Light areas are attained by leaving the paper white or slightly tinted. In other words, they're painted (or located) first and their exact form is described by the contrasting darker areas surrounding them. They're not added; they're left. For that reason, the placement and organization of lights, middle values, and darks have to be determined at the very outset of the painting process.

The term *value* is used in painting to describe how dark or light an area is regardless of its hue (color) or intensity (brightness). A good way to visualize values is to imagine how your subject or painting would appear in a black and white photograph. Squinting also helps—I know a number of myopic painters who have no trouble seeing values.

The range of values that can be reproduced in watercolor extends from the white of the unpainted paper to the darkest pigments. There are, of course, an unlimited number of intermediate steps between these two extremes, but for purposes of discussion and to simplify the planning and painting process, this range can be divided into five even steps: light, middle light, middle, middle dark, and dark (see value scale at right).

A painting may contain a full range of values from white to black or only a portion of them, say, the first three steps: light, middle light and middle. But a full range of values is necessary to convey the illusion of deep space and volume. Paintings with a limited range of values will seem flatter and shallower in space.

PLACING LIGHT VALUES

Your first consideration in planning and painting values is the placement of lights. Light value areas have a visual force equal or superior to darks. While dark areas absorb light and appear to contract, light areas reflect light and seem to expand. You must design and position light areas with care and not as afterthoughts. Keep them away from the edges and on or near areas of importance. Here I've placed my lightest values on the roof and side of the boat (my primary interest) and have tried to design simple, interesting shapes (sketch 1). You may not want to make the pure white of the paper your lightest value, and with many subjects it's not even possible. But remember: the lighter the first step, the greater the opportunity in later stages for value range and contrast. You'll also find it easier to subdue or darken a light than to reclaim it.

PLACING MIDDLE VALUES

Once the position and form of your light areas have been established, the middle lights and middle values can be broadly painted. In the preceding stage, I painted around the lights with a large, simple middle-light wash, eliminating any unplanned lights in supporting areas. Here I planned and painted my middle values as a large simple shape, further defining the light and middle-light areas (sketch 2).

Middle-value areas (middle lights and middle values) are the predominant component of most paintings. They form the stage on which the value extremes (lights and darks) can interact. Plan your middle-value areas as large, simple passages that will unify the design. Use them to build a strong understructure and avoid anticipating detail, texture, or darks. That will come later.

PLACING DARK VALUES

In a watercolor, the middle darks and darks are positioned and applied last. They are the final notes on the value scale. When placed near or adjacent to lights, they create a contrast which attracts the viewer's attention and interest. By their weight and density, they emphasize the transparency of lighter areas.

A value scale.

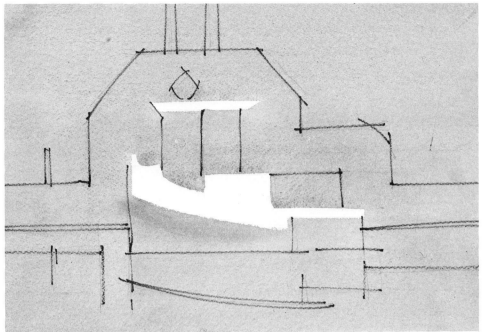

Placing light values.

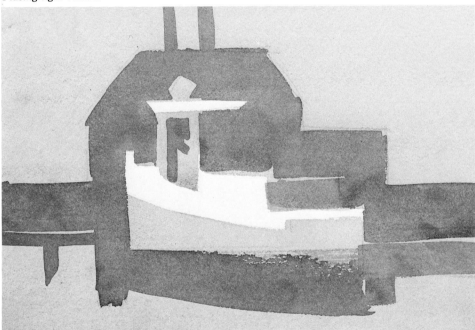

Placing middle values.

Reserve the greatest contrast for areas of primary interest. That is, place your darkest values near or adjacent to important lights. In the third example, I've placed my darkest value in the background shape to contrast with the light on the prow of the boat. Design and position darks as carefully as you would lights or bright colors like cadmium red, and don't just daub them in everywhere. Secondary darks can be repeated throughout the design to create movement and unity or to describe middle-value forms, but avoid placing strong, distracting contrasts in unimportant areas.

REASONS FOR ORGANIZING VALUES
Values in a watercolor are organized for several reasons. One is to create a sense of unity, variety, and contrast in a painting, by drawing attention to the area of importance and enhancing the expressive intent of the work. Values are a powerful design device. Passages of light or dark will move the viewer's eye through the painting, areas of similar value will unify a design, and contrasting areas will focus the viewer's attention.

Values are also organized to simplify the painting process. When the values of a painting are preplanned, it's possible to proceed directly from light to dark with little or no backing and filling (repainting and patching) of areas. Instead, full attention can be focused on developing design relationships. Moreover, by systematically painting from light to dark, it's possible to maintain greater control of the medium. Most accidents occur when

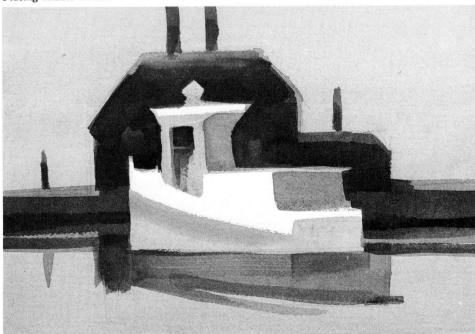

Placing dark values.

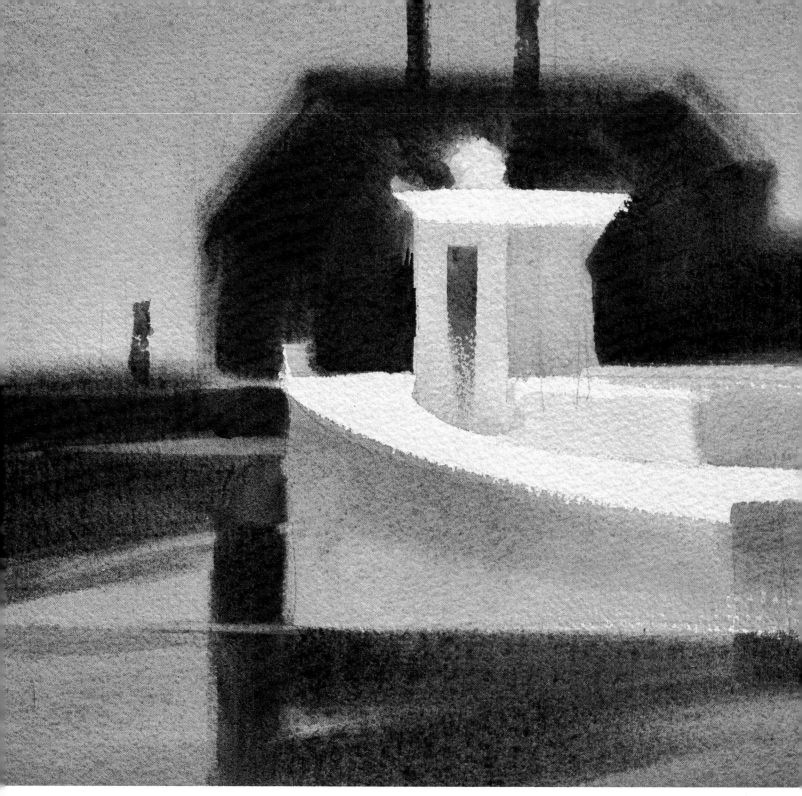

OHIO TUG AND BARGE
by Christopher Schink.
Watercolor on Arches 300-lb rough paper,
10" × 15" (25 × 38 cm).
Collection of the artist.

I did this painting as the final step in my value demonstration and completed it in less than thirty minutes. While there is nothing admirable in painting fast (or slow, for that matter), it does demonstrate how, with a carefully organized value plan, you can confidently proceed through a painting, giving attention to color and shape as well as value relationships. And by systematically working from light to dark, you can maintain greater control of the medium. In addition to contrasts in value, I've used alternations in hue and color temperature to create variety and interest. By playing dark against light and warm against cool, I've created a simple but effective design.

values are painted out of sequence and drying areas are disturbed with paint that is too wet.

APPLYING THESE IDEAS

As you may have already discovered, beginning a watercolor without a preconceived value plan invariably leads to confusion or failure. Deciding which areas or elements will be dark, which will be light, and where the greatest contrasts will occur must all be done before you begin painting.

Developing a small value sketch in which you can test the placement of lights, middle values, and darks, and then systematically following this sketch when you paint is a far better procedure. You can use your earlier sketch of shapes as the basis for a value study, but be sure to fully shade in every area. Don't rely on line to separate elements. In planning a painting, try to be conscious of value relationships—of light against dark—rather than of the objects themselves.

It's also possible to create a highly effective painting using a limited range of values, so you may wish to restrict the values in your design for expressive reasons. Paintings done in a high key (the lightest three value steps), middle key (the middle three value steps) or low key (the darkest three value steps) depend mostly on contrasts in color, shape, or texture for interest and focus. However, the illusion of space and volume is lessened in a painting with restricted values. Instead, the emphasis in such paintings is usually on their decorative or design qualities.

CRITIQUE

Are your lights a planned part of your design or are they simply left over? You may have developed the habit of beginning your painting with middle-value washes, proceeding to darks, and leaving lights only where you run out of paint or ideas. If so, your paintings will probably seem fragmented and diffused. In your next painting, begin with large middle-light washes, and plan to place your lights in important areas.

Are your middle values dark enough? Middle-light and middle values are difficult to judge, and painting them accurately takes practice and experience. In the early stages of your painting, your first two value steps may appear solid and strong when compared to the white of the paper. But when darks are added later, the middle and middle-light values will seem to lighten and weaken. If your darks seem to jump off your painting, you've probably misjudged your middle values. In your next painting, try checking your values against a value scale or apply a small area of strong dark early in the painting and "key" or relate your lighter washes to it.

Do the greatest value contrasts in your painting occur on or near areas of interest? Squint at your painting. Are there strong dark and light contrasts occurring in unimportant places? Strong contrasts away from areas of interest or on the edge of a painting will distract the viewer or draw his eye out of the painting. You can easily subdue these problem areas by shifting their value or softening the edge between contrasting areas.

LESSON NINE

REVERSING VALUES

You are probably already aware of how important value organization is to the success of your painting, but you still may not realize how values may be shifted and rearranged to significantly strengthen the design of your painting. Shifting values means that you won't have to spend hours futilely searching for a subject with just the right value arrangement, but that any subject you find interesting or inspiring, regardless of its value relationships, can be reorganized to make an effective painting. For example, if you're excited about an old church but are about to reject it as a painting subject because there is no light on the steeple, don't. Just shift the light to the steeple and reorganize the values accordingly. By shifting values you can make an exciting subject into an exciting painting.

WHEN AND HOW TO SHIFT VALUES

Values are shifted for several reasons: (1) To create a clear contrast between important elements in your subject and their surrounding areas. (2) To reduce contrast in distracting or less important areas. (3) To combine and enlarge visually weak or fragmented areas. (4) To place the strongest contrasts of dark and light in the areas of greatest importance.

The placement and movement of light should be a primary consideration when planning a watercolor. Because light attracts the viewer's attention, it can be used to direct and focus interest on any area or element

of your subject. And while the photographer is restricted by the direction and intensity of his subject's light source, the artist can shift the light in a painting in any direction—from left to right, foreground to middleground to background, and high to low.

Sometimes moving a light or emphasizing a dark is all that's necessary to produce a good design. However, some subjects may require more extensive reorganization. The most obvious way to alter the value relationships of any subject is to *reverse* the major areas of light and dark. By transposing values, dark or shade areas can be made light and interesting, and vice versa.

ALTERING VALUES BY REVERSAL

The first illustration is an example of the kind of subject you might encounter when painting outdoors. So you may assess the effectiveness of the overall design, I have eliminated line and texture and have simplified value and shapes in the sketch. But the subject presents several typical problems in value organization:

1. There is no light or contrast on the important elements (the buildings).

2. There is a large monotonous passage of middle, middle-dark, and dark values (the buildings and near hills) running through the center of the design.

3. The lightest values occur at the edge of the design.

In the second sketch, these problems

have been corrected by reversing the major light and intermediate values to make a more effective design. The roof and middleground are now the lightest values and, for contrast, the adjoining areas—the near and distant hills—have been made the darkest values. The dispersion of light in the sky and foreground has been reduced by shifting those areas to a slightly darker value. This is just *one* solution. You can make any number of equally effective value plans.

APPLYING THESE IDEAS

While the methods for shifting values are simple enough, applying them on location may sometimes prove difficult. When faced with an exciting subject, your first impulse is to simply duplicate what's there—light for light, dark for dark. But remember: unless the actual values of your subject are essential to the painting, you can shift and rearrange them in any way that improves the design. Simply because a farmer has painted his old barn dark brown (he probably got the paint on sale!) doesn't mean you must do the same in your painting. It can be made light, middle, or whatever value will work to make an effective design.

Test the effectiveness of your design in a series of sketches, each with an alternate value plan. Draw a border around each sketch in proportion to the format of your painting. Keep the sketches small (especially when working with pencil), say 2″ × 3″ (5 × 7.5 cm) and avoid linear detail. They

Typical unaltered value arrangement.

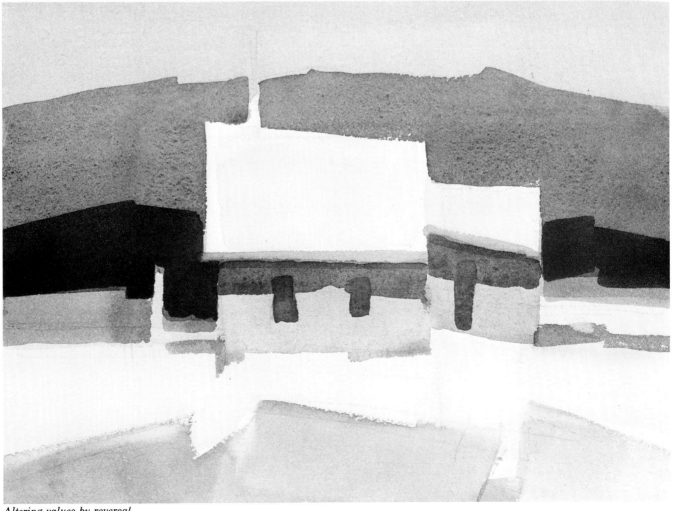

Altering values by reversal.

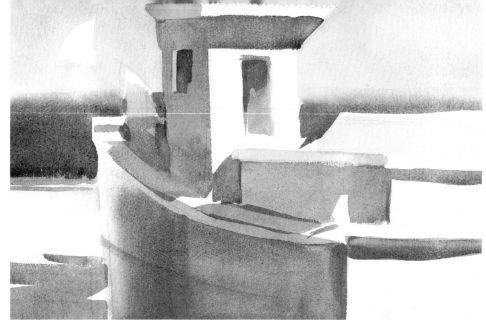

Value Sketch.

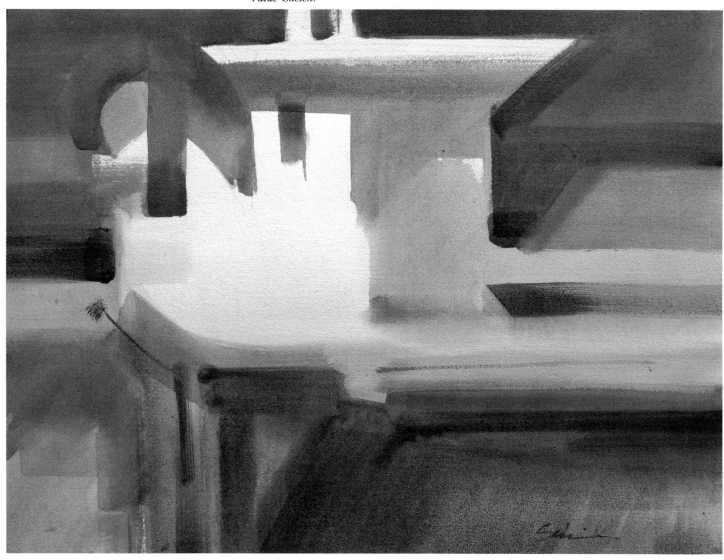

PETE'S HARBOR SERIES NO. 7
by Christopher Schink.
Watercolor on Arches 300-lb rough paper,
20" × 28" (51 × 71 cm).
Collection of the artist.

In the value sketch of the actual subject, the light comes from the right rear, illuminating the stern of the boat and the back of the cabin. The sweeping movement toward the bow—my major interest—is broken by shadow, and large unimportant areas of light and middle dark draw your eye to the edge and corner of the design.

In my painting (admittedly more abstract than the sketch), I have reversed values and shifted the direction of the light source to the left to illuminate the sweeping line of the bow and the side of the cabin. These two important elements are now the lightest values in the design and are in strong contrast to the slightly darkened background. Values have been modified in the lower right and left corners to reduce distracting contrasts. By shifting and transporting values, I was able to direct the interest and focus of the painting to the area and elements I felt were most important.

should be experiments in value organization, not finished drawings. Work in a simplified value range using, at most, five steps from light to dark. And fully shade every area. Unresolved or confused areas in a sketch won't disappear when transferred to a painting. They'll become larger and more noticeable.

Do several of these sketches before you begin painting. Try different combinations, reversing and moving lights and darks until the contrast and focus of your design is on the areas or elements you feel are most important. Select from these the

sketch that most effectively conveys your interest or idea. It will serve as a value guide while you paint.

CRITIQUE

Did you do several fully developed value sketches before you began painting? In your enthusiasm for your subject, you may be tempted to scratch a few lines in your sketchbook and begin painting without fully exploring alternative plans. Don't. You should develop at least three or four value sketches before you begin painting. It will be time well spent. Often the most effective design evolves from several preliminary attempts and is

radically different from your original sketch.

Have you shifted values to create a melodramatic rather than an expressive design? Values should be altered to improve the design, but not to the extent that the expressive qualities or original inspiration for the painting is completely altered or lost. You can introduce light and contrast into a dull subject without resorting to miraculous beams of light, changes of weather, or worse, seasonal changes. Such obvious, artificial devices result in unconvincing or just plain corny paintings.

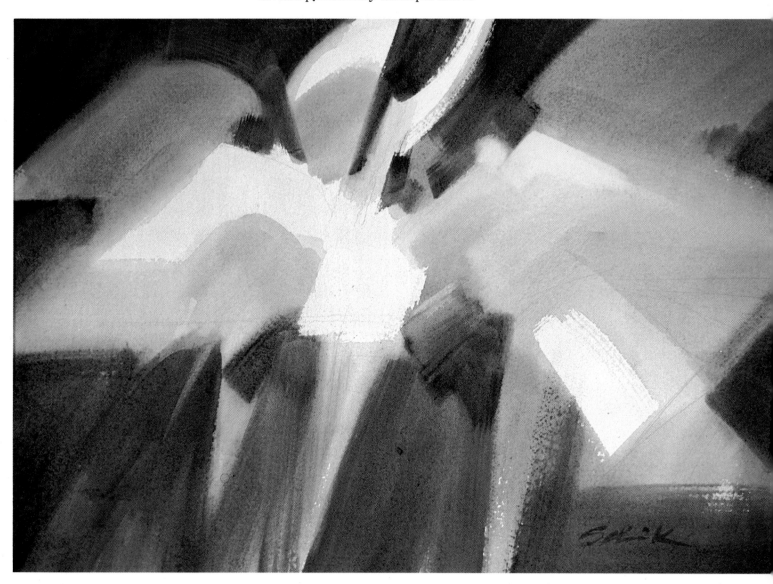

CYCLAMEN NO. 5
by Christopher Schink.
Watercolor on Arches 300-lb rough paper,
14" × 21" (36 × 53 cm).
Collection of Mr. and Mrs. Paul Strasburg,
Brooklyn, New York.

The placement and movement of light should be a primary consideration when planning a watercolor. Because light attracts the viewer's attention, it can be used to direct and focus interest on any area or element of your subject.

The inspiration for this painting was an arrangement of flowers my wife had put in our living room. I was intrigued by the shape and movement of the flowers, but found that most of them were either in shadow or silhouetted against a light window. In my painting, I reversed the actual value relationships of my subject and arbitrarily placed light in areas that would focus attention or emphasize the shape and movement of the plant.

LESSON TEN

GRADING AND ALTERNATING VALUES

Both gradation and alternation make it possible to transform a monotonous or static subject into an animated and dynamic design.

The term *gradation* refers to a smooth transition—in value, color temperature, intensity, or hues—without lines or boundaries. It is a device particularly well suited to watercolor because of the medium's fluidity, which makes smooth transitions from light to dark or warm to cool easily achieved. The phenomenon of gradation, a gradual shift in value, is often seen in nature. For example, against dark, low foliage the base of a telephone pole may appear light, but its upper section, which is silhouetted against a light sky, will appear to gradually shift in value and become darker. These are optical illusions created when your eye attempts to distinguish specific elements. Your eye will also follow gradual movements from light to dark in large areas such as the sky.

The term *alternation* refers to the rhythmical repetition of several tones at various intervals. Alternation can be used as a device to break up large areas or long movements in a single value, which can be dull or static. For example, by silhouetting a group of dark buildings against a light sky, you will clearly establish their position in pictorial space, but the resulting design will be static and uninteresting. By breaking up some of the values—making some buildings light against a dark part of the sky, and keeping others dark against a light sky—you can create a varied, dynamic surface. You could also enliven the static spatial relationship and uninteresting value pattern of a row of dark tree trunks seen against a light forest background by subtly alternating the value relationship of trunks and background from light against light to light against dark. In fact, many contemporary artists use this device to create a sense of spatial ambiguity, "pushing" and "pulling" the elements of their subject backward and forward within a limited pictorial space.

GRADING AND ALTERNATING VALUES FOR INTEREST

The lack of value contrast, a static quality, makes the first sketch in this lesson uninteresting. For example, the similarity in value between the building on the right and its surroundings makes that area both monotonous and confusing. Also, the foreground and building on the left combine to make a single uninspired shape. In fact, in most areas, the alternation of values—dark against light—is weak or non-existent.

In the second example, values have been shifted by gradation and alternation to create a more dynamic design. The roof of the building on the right has been gradated to contrast with the sky and the supporting wall, which has been gradated in the opposite direction. The value of the building on the left has been shifted from light at the top to dark at the bottom to contrast with the tree and foreground. Both the sky and foreground have been animated with gradated washes.

APPLYING THESE IDEAS

The basis for gradation and alternation already exists in nature. All you need to do is find and emphasize—or invent—these value transpositions in your subject. Be conscious of how each area relates in value to its surroundings. Important areas that lack contrast or static areas can be alternated or gradated in value to create interest.

To do all this in your head or while you're painting would be almost impossible, so make several value sketches before you begin painting. If you use a pencil, make sure it's soft. To blend the pencil strokes, rub shaded areas with your finger to simulate the plastic quality of paint. Try several combinations, reversing the direction of gradations and alternating values. Try for smooth gradations and don't shift the value within any element more than a half step or so. For example, a white barn could be gradated from light to middle light for contrast.

Keep your sketch simple. Don't rely

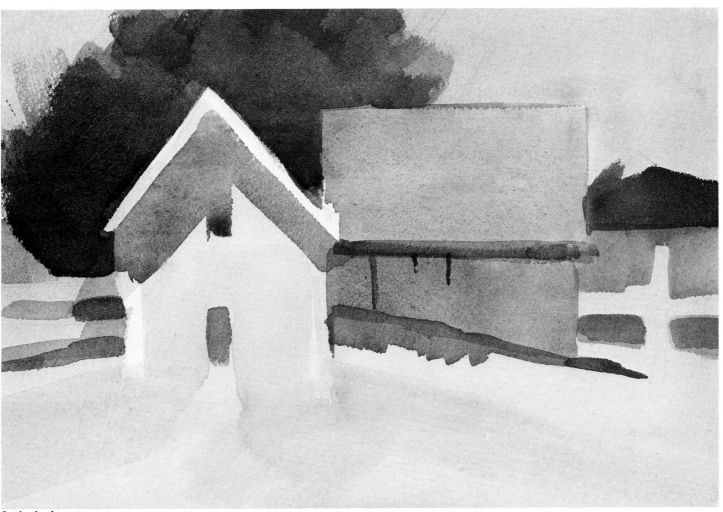

Lack of value contrast.

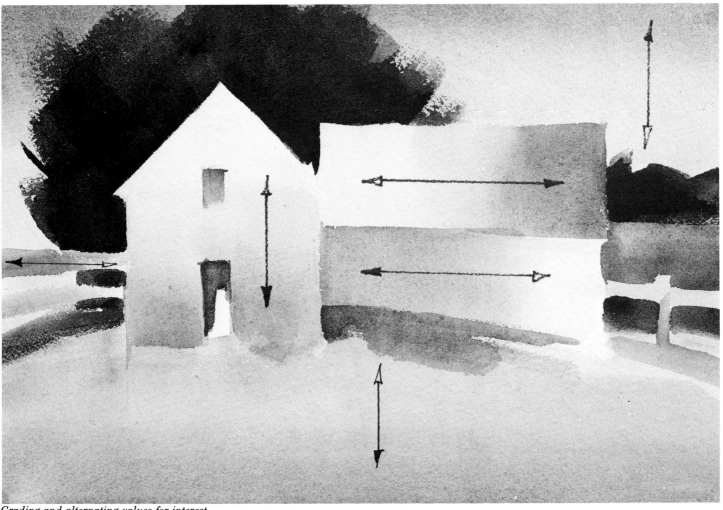

Grading and alternating values for interest.

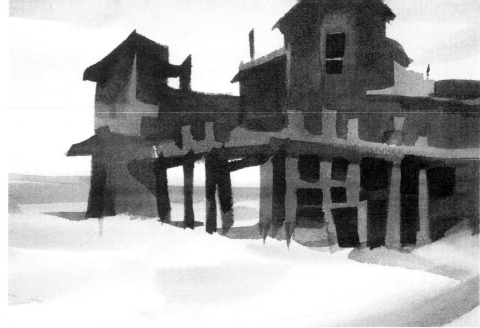

Value Sketch.

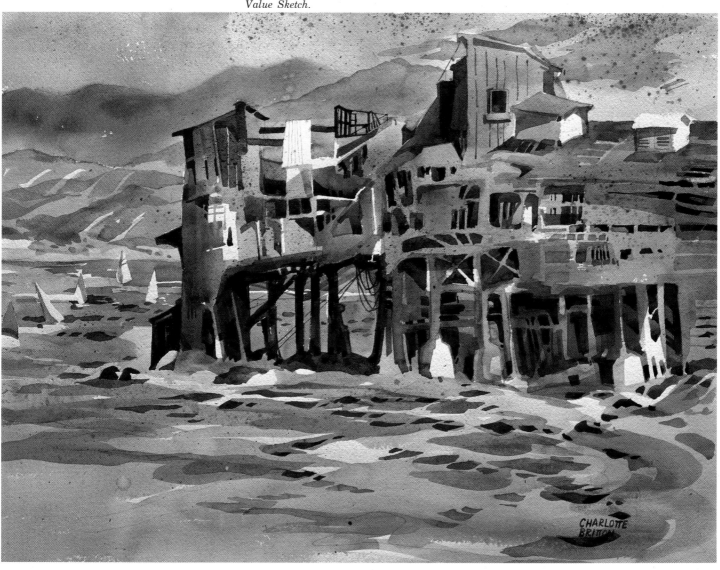

MONTEREY WHARF
by Charlotte Britton.
Watercolor on Arches 140-lb rough paper,
22" × 30" (56 × 76 cm).
Collection of Mr. and Mrs. Richard R. Crass,
Atherton, California.

Charlotte Britton has used alternations and gradations in value to suggest the lively, active quality of her subject and has emphasized these qualities with confident and energetic brushwork. By repeatedly shifting values—light against dark and dark against light—she has created a design that conveys her response to this subject. A more accurate rendition of its values would probably be less exciting. For example, in the value sketch that accompanies this painting, I've painted the same subject lighted from the rear. The similarities in value in both the buildings and dock and the sky and water give the design a static, two-dimensional quality. By alternating values, Charlotte Britton has created an expressive and dynamic design.

on line to separate elements. Instead, alternate values—dark against light and vice versa. Think of your design as a checkerboard or a bas relief in which dark and light areas alternately advance and recede to create an exciting painting. Place the strongest contrasts on or near the areas of primary interest, but don't neglect secondary areas. Work out a value plan for the entire painting. When you're finished, select the sketch that most effectively conveys your response to the subject. It will serve as a guide for your painting.

CRITIQUE

Have you animated or fragmented your design? While gradation and alternation can effectively activate a static design, they can also disturb the unity and spatial integrity of a painting. If shifts in value in an element are too abrupt or extreme or transitions in value too rapid, the sense of volume and space of a subject will be exaggerated or disturbing. If you already have a tendency to fragment your painting with numerous value changes, use gradation and alternation sparingly. Keep to flat simple value plans.

Does an animated, active design accurately convey your response to your subject? Some subjects are better expressed with a quieter, more passive value plan. For example, the feeling of a solitary boat at dusk might best be conveyed with a simple, closely related value pattern. On the other hand, the activity of a busy afternoon harbor scene could be captured with a more dynamic play of values through gradation or alternation. If you enjoy doing exciting, active paintings, be selective. Look for exciting active subjects.

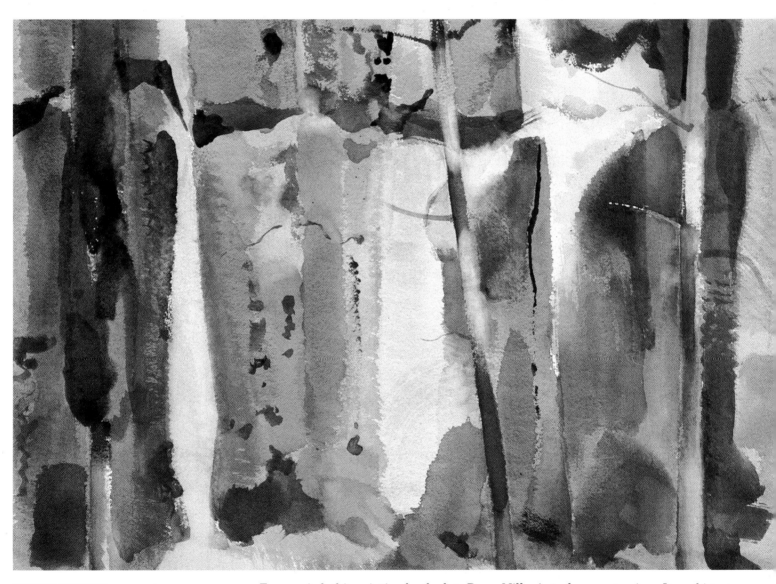

ROMAN QUARRY
by Barse Miller, N.A., A.W.S. (1904–1973).
Watercolor on Arches 300-lb rough,
21" × 29" (53 × 74 cm).
Collection of Mr. and Mrs. Knox Farrand,
Los Angeles, California.

To my mind, this painting by the late Barse Miller is truly a masterpiece. It combines an airy, almost lyrical quality with a directness that characterized all of Miller's work. By the subtle shifting of values, he has created a design that is both sensitive and lively. To avoid the static effect of dark trees against a light background, he has alternated their value relationships—light against dark, then dark against light. (Note how the tree in the right middleground shifts in value.) Many contemporary painters use alternations and gradations of value to create a sense of spatial ambiguity, "pushing" and "pulling" the elements of their subject backward and forward within a limited pictorial space.

COMBINING VALUES

We have seen how values can be varied and contrasted through reversal, gradation, and alternation. But it's not always necessary or even desirable to separate every area or object in your painting by value contrast. In fact, one of the simplest ways to unify a design is by *combining* adjoining areas of similar value to make larger, more forceful shapes and patterns. For example, the scattered, multivalued forms of a group of farm buildings can be transformed by combining their many different values into a single, unified, interesting shape that will attract and hold the viewer's attention. Fragmented areas of light and shadow can also be consolidated into simple value patterns and arranged to direct the viewer's eye through the painting.

Values are combined to simplify and strengthen a painting's design. Shifting values or combining areas are, in one sense, forms of repetition—unifying devices. They are employed in secondary or supportive areas to create a dominance of value. In areas of importance, fragmented or isolated elements are combined to create clearer contrasts.

The way you combine values depends to a great degree on how you see your subject. If you visualize your subject as a collection of things—light on one side, dark on the other and filled with surface detail—then combining values will be difficult. To make it easier to combine values, think of light and shadow as your subjects. Observe how they move across the elements you've selected, illuminating some, obscuring others.

Note the value patterns created—the interplay of light and shadow—and design and emphasize these movements. They'll help strengthen and unify your painting.

CHIAROSCURO

For centuries, painters have used the movement of light and dark (called *chiaroscuro*) as a design device. Light, as it moves over a subject, consolidates diverse elements into simple patterns. Shadow and shade merge, and the visible edges of objects moving into the shadow are lost. The viewer's eye is led through the painting by passages of light and dark with "lost-and-found" edges and stops only at areas of importance, where sharp contrasts have been developed.

The first sketch illustrates how values can be shifted and combined to create passages of light and dark. Contrasts between the building and the sky have been reduced and edges have been "lost" to allow light to circulate through the painting. Shadow and shade have been combined to make large, simple shapes.

COMBINING AND SHIFTING VALUES FOR UNITY

The second sketch illustrates the kinds of value problems you might encounter when painting on location. Distracting value contrasts are dispersed throughout the design, and isolated areas of light and dark compete for attention. Because of abrupt alternations in value, the form and position in pictorial space of the boats and dock and buildings are confused

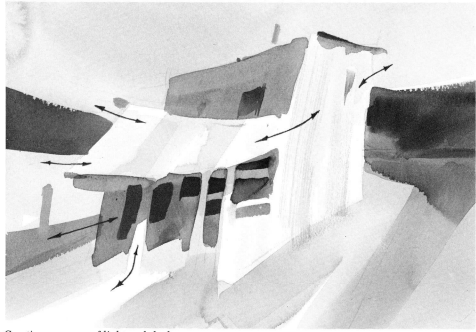

Creating passages of light and dark.

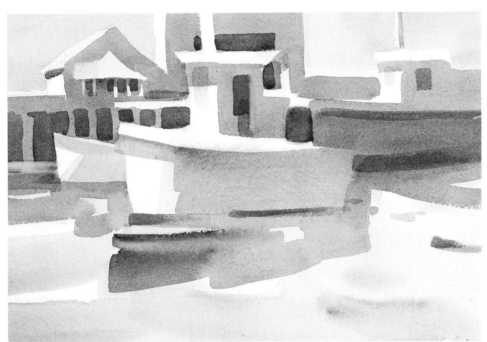

Typical on-location problems.

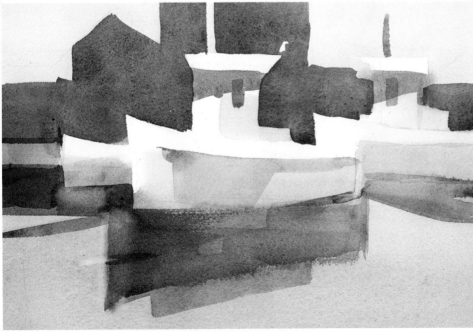

One solution.

or lost. There is a sense of disunity.

In the third sketch, the values have been shifted and combined to make a more cohesive design. Light has been used to unify the foreground boat forms into a simpler, more forceful shape. The background buildings and dock have been made a uniform medium dark, eliminating detail and distracting value contrasts. The water and reflections in the foreground have been reduced to a simple, two-value pattern. An increased sense of unity and solidity has been achieved by combining values.

APPLYING THESE IDEAS

Combining values and developing movements of light and dark while painting is difficult—you almost always "lose" more edges than you find! So before you begin to paint, make several preparatory value sketches. Begin them by designing the linear movement and shapes of your subject matter. Then, once you've established their general direction and position, ignore them and think only of the *movement of light and shadow* as your subject. Don't feel compelled to model each individual object, but look instead for large movements of light and dark. Where these movements are interrupted, shift and modify the values you observe so that the circulation of light and dark is uninterrupted. Where contrasting areas are fragmented, move and combine shapes to create larger, more forceful forms. Don't be afraid to be arbitrary. A simple, forceful design will be more convincing than an accurate rendering.

Value Sketch.

LOG FLOAT
by Christopher Schink.
Watercolor on Arches 300-lb rough paper,
21" × 29" (53 × 74 cm).
Collection of the artist.

This is my second try at painting this subject, three logs lashed together to make a float. I was excited by the contrast in color between their rich, warm bases and cool, violet sides and the dynamic shape and pattern they made.

In my first attempt (long since relegated to the junk pile but approximated above in my value sketch), I gave too much attention to modeling the log forms and to duplicating the shadow pattern. Light areas and strong value contrasts were scattered throughout the painting. The design had neither unity nor focus. In this second painting, I have combined the shapes and values of these fragmented areas to create more interesting patterns and a more cohesive design—one that conveys my interest and excitement in the subject.

Select as a guide for your painting the sketch that best conveys your interests or ideas. Following it, you can quickly and confidently express in paint your response to the subject.

CRITIQUE

In an attempt to capture detail or texture, have you lost the sense of form and space in your subject? If you like working realistically, but find your paintings have more incidental detail than unity of form, you should spend more time planning values before you paint. By shifting and combining values, you can create a simple understructure of lights and darks strong enough to support elaborate detail or texture.

Is your painting filled with small, "stringy" lights and darks? How does your painting read from a distance? Does it have a clearly defined and cohesive value pattern? Or does it disintegrate into a multitude of small, busy lights and darks? If the values in your painting seem weak and diffuse, remember that a painting is normally viewed from eight to ten feet. At that distance, small or intricate lights and darks will appear thin and weak. You can strengthen and unify the forms of your subjects by shifting and combining values to create larger, more forceful areas of light and dark.

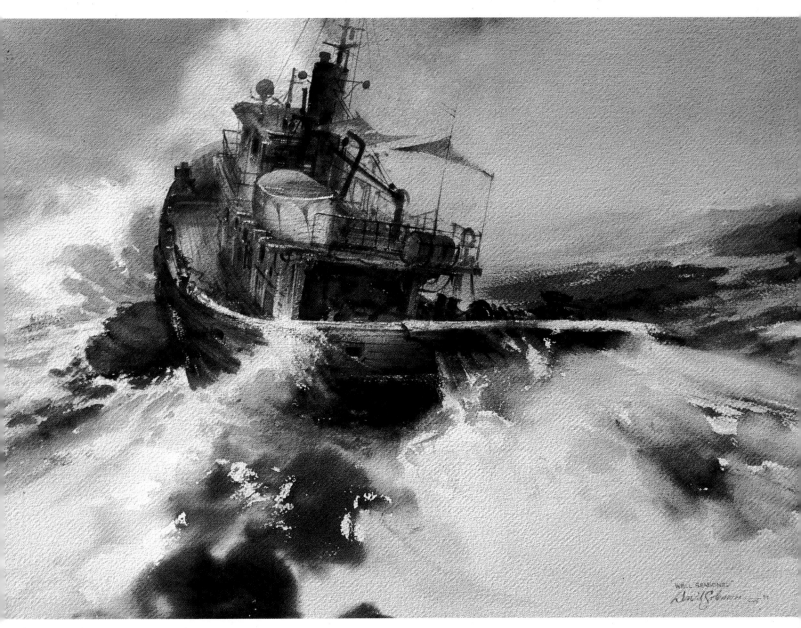

WELL-SEASONED
by David Solomon.
Watercolor on Arches 140-lb rough paper,
22" × 30" (56 × 76 cm).
Collection of George Clohessy,
Laguna Beach, California.

In this striking painting, David Solomon has created a design that clearly conveys the drama of his subject. By combining values into long uninterrupted passages of light and dark, he leads your eye to his primary interest, the tug. Although representational in style, the value pattern, movement, and form in his design would make an equally effective abstract. (Try viewing the painting sideways.) You can use movements of light and dark as well as "lost-and-found" edges to unify your design and direct the viewer's attention to areas of importance where sharper contrasts in value have been developed.

COLOR

There is no other element of design that is as exciting or as confusing as color. What pigments to select, how to combine them, and when and where to use them are perplexing questions every painter faces. Since each of us perceives and responds to color in a different way, the answers to these questions would seem to be simply a matter of personal taste. Although some painters restrict their palettes to a few pigments they find appealing, or rely on pre-mixed colors and formulated combinations they know will work, by doing this they limit the possibilities of using color in a creative and personal way. The pigments you select and the way you combine them should allow you to expand rather than restrict your expressive range.

This section deals with the problems of color selection, mixing, application, and organization. It explains how pigments can be selected and organized in a logical and systematic way, and how they can be combined to produce the widest range of hues and consistencies. This section will also help you understand how color functions in a design and how it can be used as an expressive element in your painting.

LESSON TWELVE

DEFINING THE PROPERTIES OF COLOR

Because of physiological and psychological differences, each of us perceives and responds to color in a different way, and these differences make any discussion of color difficult. There are, however, a number of commonly accepted terms that are used by painters to describe the properties, interactions, and relationships of color that constitute a basic vocabulary of color. A knowledge of these terms is essential to an understanding of how color works.

If you are already familiar with these terms, you might take only a few minutes to review the definitions. But if they're new to you, then you should spend some time studying them. They are essential to describing how color can be mixed, combined, modified, and altered.

HUE

The term *hue* (or chroma) is commonly used to describe the *type* of light (the specific area of the color spectrum) reflected off an object or area. The hue is what most people think of as the name of a color. In the first sketch (page 62), the hue of the house is orange, the hue of the grass

is green, and the hue of the roof is violet.

VALUE

The term *value* is used in painting to describe the *amount* of light reflected off an area, its degree of lightness or darkness, regardless of its hue or intensity. In the second example you can see that the house and roof are different in hue and intensity but close in value. A simple way to visualize values is to imagine your subject or painting as a black-and-white photograph.

INTENSITY

Intensity (or saturation) is the term used to describe the relative brightness or dullness of an area or object, regardless of its hue or value. For example, in the third sketch the house, roof, and grass are more intense on the left than on the right, although they are the same general hue and value. The intensity of pure pigments can be reduced by the addition of complementary or neutral pigments or by diluting them with more water.

COMPLEMENTS

Complements are hues that are exactly opposite each other on the color

wheel. For example, the complement of red is green and the complement of orange is blue. If complementary hues are mixed, they will produce a gray or neutral hue. The fourth sketch is a simple color wheel showing primary and secondary complements.

NEUTRALS

A *neutral* hue is one that is quite low in intensity. The gradual addition of a complement or black or white to a pure pigment will make it progressively less intense until it finally becomes neutral. In the next example, the intensity of the hues on the left has been reduced by the addition of the complementary hues on the right. The resulting hues in the middle section are *neutral*.

WARM AND COOL TEMPERATURES

Warm and *cool* are comparative terms used to describe the relative temperature of a hue. For example, the hue French ultramarine (a slightly purple blue) is obviously cooler than cadmium orange. But compared to cobalt blue, the ultramarine would be considered warmer because it contains some red.

Hue.

Value.

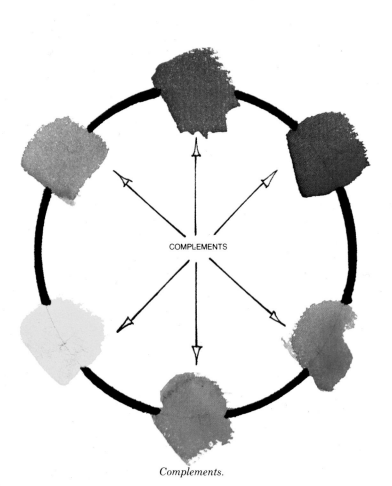

COMPLEMENTS

Complements.

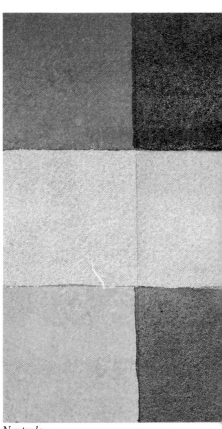

Neutrals.

Intensity.

Warm and cool.

VALUE SCALE

A *value scale* is an even division of the values that can be reproduced with pigment. It extends from white (pure paper) to black (a combination of the darkest pigments). As you can see in the scale below, I have divided the values into five even steps—light, middle-light, middle, middle-dark, and dark. These graduations are used in the book to describe values.

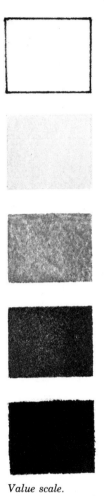

Value scale.

DEVELOPING A SENSITIVITY TO COLOR

When they see a painting with particularly attractive or expressive color, laymen and inexperienced painters often assume that the artist must have some magical talent, a unique color sense that they lack. There are, of course, people who are inherently sensitive to subtle color nuances, just as there are people with perfect pitch (a sensitivity to changes of tone in sound). Both are wonderful gifts, useful for matching wallpaper and picking out tunes on the piano. But possessing a sensitivity to color or sound will not assure an artist an exhibition at the Metropolitan Museum of Art or a recital at Carnegie Hall. There is, in fact, little evidence of any great colorist producing fully developed works at an early age. Certainly Turner and Van Gogh turned out their share of drab, brown paintings during their early years. Most painters develop a sensitivity to color and the skill to handle it through study, observation, and practice.

It therefore should be reassuring to know that your sensitivity to color will increase with experience and practice and that the more you paint, the more you will see. In time, objects you previously perceived as dull or gray will suddenly be filled with color and you will be able to distinguish subtle differences in hue and value. Moreover, with practice, you will be able to employ color in a creative and expressive way.

CRITIQUE

Do you confuse intensity with value? If you have trouble distinguishing intensity from value, remember that intensity denotes the amount of pure pigment or saturated color contained in an area, regardless of value or hue. For example, the color of a well-watered lawn is more intense than the color of a neglected one, though both are the same in hue (green) and value (light-middle). The best way to judge intensity (and hue) is to look quickly at your subject or painting and make an immediate assessment. When you stare continuously at an area, the color rods in your eye become fatigued and their sensitivity is reduced. For that reason, staring or squinting works best in judging values.

Do you have trouble remembering the color wheel? The color wheel is a simple device, but one that is basic to color mixing. If you can't immediately recall the complement of each primary and secondary, you should take a few minutes to memorize the color wheel. You might find it helpful to draw one on your painting board or on the cover of your sketchbook and use it as a reference when mixing colors.

LESSON THIRTEEN

SELECTING A BASIC PALETTE

Most student palettes are composed of an accumulation of pigments recommended by various teachers or they are filled with colors the students found attractive when browsing in their local art store. Rarely do they represent a selection based on an understanding of the principles of color mixing.

Pigments in a basic watercolor palette should be selected for three reasons: hue, permanence, and pigment consistency. I therefore begin my watercolor clinics by suggesting a basic palette, a selected group of pigments that will be useful to every painter. The pigments on this palette were not chosen arbitrarily, nor do they represent merely a collection of my favorite colors. Each was selected for its hue, permanence, and pigment consistency to provide the greatest range of color-mixing possibilities. Many of the pigments on this list were suggested to me by the late Barse Miller, a master colorist.

This is a limited palette in the sense that it contains only essential pigments—pigments in a hue or consistency difficult or impossible to mix. The majority are primary hues. There is a limited number of secondary and neutral hues. Many of the pigments popular with watercolorists—such as Payne's gray, Hooker's green dark, burnt umber, and sap green—have

not been included. Equivalents of all of these can be mixed using the pigments listed below. The palette I recommend is as follows:

Cadmium Red
Winsor Red
Alizarin Crimson
Rose Madder Genuine
French Ultramarine
Cobalt Blue
Winsor Blue
Cerulean Blue
Viridian
Winsor Green
Winsor Yellow
Aureolin
Cadmium Yellow
Cadmium Orange
Yellow Ochre
Indian Red
Burnt Sienna

HUE

Hue is obviously the most important consideration when selecting pigments. The hues in this basic palette were chosen for their position on the color wheel to provide the greatest number of mixing possibilities. Several of these hues are unattractive in their pure form, but indispensable ingredients in a multitude of useful combinations. For example, viridian and Winsor green appear raw and unnatural when used straight from the tube, but combined with other hues,

they produce an unlimited number of attractive and useful greens. The position of each primary, secondary, and neutral hue relative to the absolute primaries is shown on the color wheel on page 66. All primary pigments contain small amounts of one or both of the other two primaries. These are shown in parentheses. For example, French ultramarine (R) is a blue containing a small amount of red.

PRIMARIES

Primaries are those hues (red, yellow, and blue) that cannot be made by combining other hues. A perfect primary, by definition, would be one that contained neither of the other two primaries. Because there are no true or perfect primaries available in pigment form, for a full range of color mixing it is necessary to include, at the very least, the two pigments that are the closest on each side to the true primary. For example, there are a number of reds available to watercolorists, but no true red. They all contain either a small amount of yellow (cadmium red, Winsor red) or blue (rose madder genuine, alizarin crimson) or both (Indian red). In order to mix a full range of secondaries containing red, it is necessary to include both a yellow-red and a blue-red. The relative position of each primary pigment is shown on the color wheel.

CADMIUM RED · WINSOR BLUE

NEUTRAL HUE (GRAYED PURPLE)

The "wrong" primaries make a neutral secondary.

WINSOR GREEN · ALIZARIN CRIMSON

NEUTRAL GRAY

Combining complements produces a neutral.

ALIZARIN CRIMSON · FRENCH ULTRAMARINE

INTENSE PURPLE

The "right" primaries make an intense secondary.

SECONDARIES

Secondary hues are produced by combining two different primaries, and most secondary hues can be attained by mixing the primaries listed in this basic palette. However, a few secondary hues are included in this palette (cadmium orange, viridian, Winsor green) because they possess an intensity or pigment consistency impossible to duplicate with primary combinations.

Selecting the Right Primary. To mix a secondary hue—say, purple—you combine two primaries, red and blue. But you must choose these primaries with care because not every red and blue on your palette will make an intense purple. For example, when cadmium red is combined with Winsor blue, the resulting mixture is not an intense secondary but a gray, neutral hue. The explanation for this is simple: both cadmium red and Winsor blue contain some yellow, the complement of purple.

How Complements Work. Remember: the addition of its complement (the hue exactly opposite on the color wheel) to a hue will gray it, making it less intense. For example, here two complements—a red and a green—have been combined, resulting in an almost totally neutral gray. But you don't have to add a great amount of its complement to neutralize a hue. Even small amounts of a complement will reduce its intensity.

How to Select Primaries to Make Intense Secondaries. To mix an intense secondary, you must select and combine the two primaries closest on the color wheel to the desired hue. For example, here I've combined alizarin crimson (a red containing a small amount of blue) and French ultramarine (a blue containing a small amount of red) to make an intense purple. The reason for the intensity of the mixture is that neither of the primary hues selected contain yellow— the complement of purple.

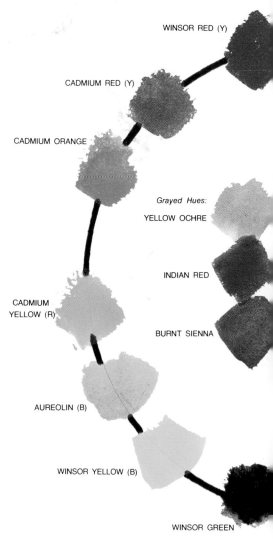

WINSOR RED (Y)

CADMIUM RED (Y)

CADMIUM ORANGE

Grayed Hues:
YELLOW OCHRE

INDIAN RED

CADMIUM YELLOW (R)

BURNT SIENNA

AUREOLIN (B)

WINSOR YELLOW (B)

WINSOR GREEN

The color wheel shows prima

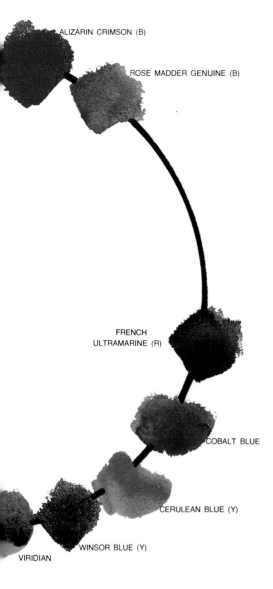

ALIZARIN CRIMSON (B)

ROSE MADDER GENUINE (B)

FRENCH
ULTRAMARINE (R)

COBALT BLUE

CERULEAN BLUE (Y)

WINSOR BLUE (Y)

VIRIDIAN

nd secondary complements.

NEUTRALS

You may have noted the absence of many of the popular neutral hues—such as burnt umber, neutral tint, Payne's gray, and Davy's gray—and modified secondaries and tertiaries—such as sap green and Hooker's green dark. It has been my experience as a teacher that few students have difficulty mixing "dirty" browns or grays, so buying them in a tube seems an unnecessary expense! Instead, if you've come to depend on one of these popular commercially mixed hues, you'll discover that it's possible to easily mix its equivalent with this basic palette. For example, here I've combined aureolin and alizarin crimson with a small amount of French ultramarine to produce a warm dark almost identical in hue, value, and intensity to burnt umber.

Disadvantages of Commercially Mixed Neutrals. Neutral hues are made by combining the three primaries (and, in some cases, black) in varying amounts. For example, here I've mixed a Payne's gray hue using aureolin, alizarin crimson, French ultramarine, and Winsor blue. Because a ready-mixed gray or neutral already contains all three primaries, any hue added to it will contain the complement of one of its components. It is therefore difficult to modify or vary a commercially mixed hue without some loss of intensity. On the other hand, mixing your own gray gives you more control. Knowing its components, you can modify it to any intensity you wish as you're preparing it.

Mixing Variations of Popular Hues. Sometimes, to avoid graying these commercially premixed hues, painters use them directly from the tube—for example, a sap green field with Hooker's green dark trees under a Payne's gray sky. But you don't need to bother with all these extra colors. Using the basic palette, it's possible to make equivalents of these popular hues and a thousand other hues, varying each to capture the color and weight of your subject or inspiration. You can do this by mixing them, not by squeezing them from a tube. For example, here I've made a sap green by combining aureolin and Winsor green, with a touch of alizarin crimson to neutralize it.

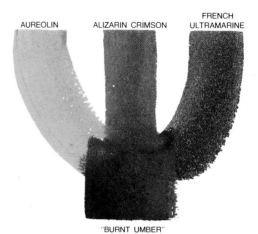

AUREOLIN ALIZARIN CRIMSON FRENCH ULTRAMARINE

"BURNT UMBER"

A burnt umber hue can be mixed.

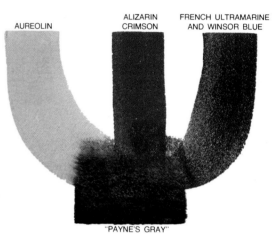

AUREOLIN ALIZARIN CRIMSON FRENCH ULTRAMARINE AND WINSOR BLUE

"PAYNE'S GRAY"

A Payne's gray hue can be mixed.

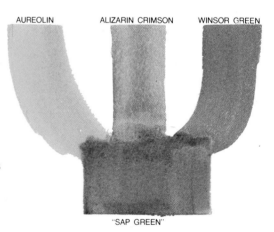

AUREOLIN ALIZARIN CRIMSON WINSOR GREEN

"SAP GREEN"

A sap green hue can be mixed.

PERMANENCE

Though the myth persists, there are few artist-grade pigments available today that are truly fugitive. The paints I use and recommend are produced by Winsor & Newton, an English firm long recognized as the manufacturers of the highest quality artist's materials. However, many other manufacturers produce pigments of comparable quality in the more common hues—such as phthalo blue and green, viridian, burnt sienna, yellow ochre, alizarin crimson, and so forth. So you should feel free to use any pigment the manufacturer recommends as permanent. Remember, no matter how stable its composition, every pigment will suffer some adverse effects when subjected to extremes of light, temperature, or moisture. But under normal conditions, all the pigments listed here can be classified as permanent and durable.

Less Durable Pigments. Some pigments popular with watercolorists are less durable and should be avoided or used with caution. They are:

Hooker's Green Light
Sap Green
Prussian Green
Gamboge
Crimson Lake
Violet Carmine

Fugitive Pigments. The few remaining fugitive pigments are:

Van Dyke Brown
Chrome Yellow
Chrome Lemon
Mauve
Carmine
Rose Carthame

These and the various colored inks should be used only in paintings intended for commercial reproduction, where preservation of the original artwork is not a consideration.

APPLYING THESE IDEAS

You may be reluctant to abandon some of your favorite pigments that are not included in this basic palette. Their use may be limited, but it is predictable to you—and there certainly is no guarantee of immediate success with the pigments I've suggested. In fact, you'll probably feel confused or tentative when you first attempt to use them. However, with practice and familiarity, you'll soon develop the skill to mix these pigments in the fullest possible range of color. And as we proceed, you'll realize why they've been selected as part of a basic palette.

To lay out your palette, you'll need a palette with enough individual wells to accommodate the seventeen pigments listed here, and with a mixing area that has the capacity to hold large washes. I use Morilla's "Holbein 1000," a large (and somewhat expensive) folding palette made of enamelled metal, but the John Pike and Jones plastic palettes are reasonably priced and seem to work well.

Start with a clean palette and lay out your pigments according to their position on the color wheel. It doesn't matter which primary you start with, but keep them in order. That way you'll be able to easily identify relative color temperature and hue of each pigment. For example, you'll know that the dark blue closest to red is French ultramarine, not the cooler Winsor blue. In addition, you'll have fewer problems with distant or complementary hues running together and contaminating each other. Squeeze a generous amount of pigment (at least half a small tube) into each well. I know it's expensive, but you can't paint without it!

A good way to conserve paint is to put your palette away dirty. By washing your palette *before* you begin painting (not *after*, when pigments are still soft), you'll avoid sending good pigment down the drain. Before you begin to paint, sponge your dried, dirty palette with a little water to revive hardened pigments. Be sure to replenish any pigments that are low and remember to start each painting with a full palette of clean, soft pigment.

LESSON FOURTEEN

UNDERSTANDING PIGMENT QUALITIES

If you've had some experience with watercolor, you'll know that although watercolor is considered a transparent medium, not all watercolor pigments are equally transparent. Nor do they all possess the same pigment intensity or tinctorial (staining) power. Watercolor pigments range from the most delicate, transparent hues to heavy, opaque, sedimentary pigments and powerful, translucent stains.

You may have already discovered (with ruinous results) the vast difference between a sedimentary pigment such as French ultramarine and a powerful stain like Winsor blue. Despite a similarity in appearance, their intensity (Winsor blue is forty-five times stronger than French ultramarine!), pigment consistency, and effect on other pigments differ greatly. They are not interchangeable. A promising painting can be ruined by an out-of-tune electric blue sky or a large passage of muddy dark. Because of such differences in strength and consistency, you may be confused as to where and when to use a specific pigment.

The first step in organizing pigments is to identify and learn the specific properties of each hue and group it according to its general characteristics. As I explained earlier, each pigment in my basic palette was chosen for its hue, permanence, and pigment consistency. Since we have already discussed hue and permanence, let's now examine the differences in their consistency.

Pigments can be divided according to consistency into three groups: transparent nonstaining, opaque sedimentary, and staining pigments.

TRANSPARENT NONSTAINING PIGMENTS

Transparency is a desirable and attractive characteristic of watercolor. Pigments that impart a clarity and depth of tone are particularly useful and even more so if they are also nonstaining. Nonstaining pigments can be applied in transparent layers (glazes) without sullying or staining the other pigments they contact. And because they don't stain the paper, they can be lightened or removed without ill effect. The following pigments on my palette are transparent and nonstaining.

Rose Madder Genuine is a delicate, slightly bluish red made from the madder root. It is extremely transparent, with almost no hiding power. It does not work well for mixing darks or in combination with stains, but it is useful for subtle, transparent glazes.

Aureolin (cobalt yellow) is the only nonstaining, reasonably transparent yellow available. It is cooler than cadmium yellow (leaning more toward green) and, unlike the opaque yellows, it can be used to warm darker hues without significantly affecting their transparency.

Cobalt Blue is a fairly transparent, middle-value blue that is close in hue to a perfect primary. It can be used to mix both greens and violets, but it is too light to make strong darks. Because of its transparency, it can be used in glazes to create the illusion of atmosphere or shadows.

Viridian (verte emeraude) is a very transparent bluish green. It is an intense, pure, secondary color containing more blue than yellow, but no red. It can be used in combination with yellows and reds to make a great variety of natural greens in almost any value or intensity.

Burnt Sienna is a fairly transparent, grayed orange. It is the least neutral of the darker earth colors and can be combined with other hues without a significant loss of intensity or transparency. However, it should not be thought of as a substitute for yellow or orange.

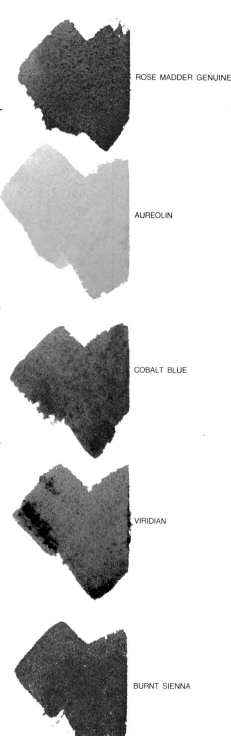

ROSE MADDER GENUINE

AUREOLIN

COBALT BLUE

VIRIDIAN

BURNT SIENNA

OPAQUE SEDIMENTARY PIGMENTS

Opaque colors are dense, nonstaining, sedimentary pigments that obscure much of the paper or underlying pigment. Opaque pigments are effective in conveying weight and density but work less successfully in glazes. Although they are not stains, their weight makes them difficult to remove when dry.

Indian Red is a grayed earth red with enormous hiding power. It can be mixed to make natural browns of great density and weight in the middle-light to middle value range. It is not a stain, but because of its great weight, it is hard to remove when dry.

Cerulean Blue is a chalky, slightly greenish blue with strong hiding power. Because of its weight and sedimentary nature, it works well when used in the wet-in-wet method. At full strength, it is only middle light in value and, therefore, not a good choice for darks.

Yellow Ochre is a slightly grayed, warm, earth yellow with good hiding power. It is an excellent substitute for cadmium yellow and is used extensively in landscape painting. Because of its opacity, it cannot be used to make darks without a visible loss of their transparency.

Cadmium Orange is an extremely intense true orange. It is an essential secondary because its intensity and purity of pigment cannot be attained by mixing. It possesses strong hiding power and can be used in combination with viridian and Winsor green to make rich greens.

Cadmium Yellow is an intense, warm (leaning toward red) yellow. It possesses strong hiding power and is best used in the early stages of a painting. Because of its opacity, it cannot be used to warm middle-value or dark hues without a significant loss of their transparency.

Cadmium Red is a very intense yellowish red with strong hiding power. Despite its intensity, at full strength it is only a middle-value hue. If preferred, one of the other closely related cadmiums, such as cadmium red deep or scarlet, can be substituted.

French Ultramarine is a warm (leaning toward red), middle-value blue. It has fair hiding power and, at full strength, appears deceptively dark. It will lighten when dry, often creating unexpected opacity or chalkiness.

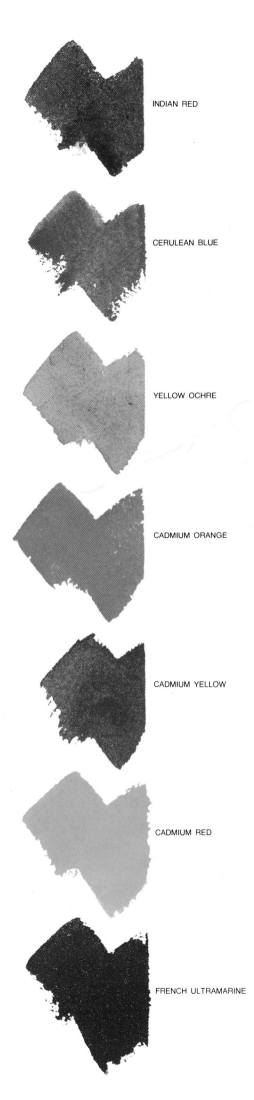

INDIAN RED

CERULEAN BLUE

YELLOW OCHRE

CADMIUM ORANGE

CADMIUM YELLOW

CADMIUM RED

FRENCH ULTRAMARINE

STAINING PIGMENTS

There is a group of pigments with phenomenal strength of tone and tinctorial power that will stain not only the paper, but also any other pigment they contact. For the most part, this is a disadvantage. Once applied, they cannot be easily altered or removed. When used as a glaze, they will stain the underlying layers of pigment and destroy their color vibrancy. Transparent stains can be used to achieve deep, intense darks.

Winsor Blue (phthalocyanine, Thalo, or monastral blue) is a cool (leaning toward yellow), transparent dark blue with enormous power of tone, an intensity rarely seen in nature. It is a strong stain and will affect any other pigments it contacts.

Winsor Red is a slightly warm red (tending toward yellow) with only moderate transparency, but having enormous strength of tone. It is a staining pigment that has a tendency to spread in wet passages. It is too opaque and light in value to work well for darks.

Winsor Yellow is an opaque, slightly greenish yellow. It is very light in value, but has enormous intensity. It should be used in the early stages of a painting. Because of its lightness and opacity, it does not work well in middle-value and dark mixtures.

Alizarin Crimson is an exceedingly transparent, slightly bluish red. It has great intensity and a beautiful clarity of tone. It is dark in value and its transparency and intensity make it an excellent choice for dark mixtures.

Winsor Green (phthalocyanine, Thalo, or monastral green) is a very intense, transparent green with strong staining power. It is slightly bluish and appears unnatural in its pure state. For landscape painting, it must be modified with yellows and reds.

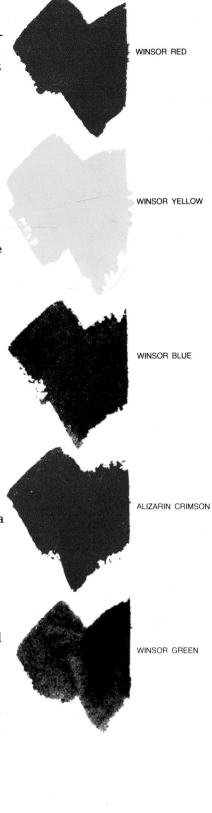

WINSOR RED

WINSOR YELLOW

WINSOR BLUE

ALIZARIN CRIMSON

WINSOR GREEN

APPLYING THESE IDEAS

In my workshops, I've encountered innumerable painters who possess a strong feeling for design and form, but who have little or no knowledge of pigment characteristics and consistency. In the heat of inspiration, they reach for a blue—any blue—with total indifference to its consistency or effect on other pigments. Their paintings could be aptly described as inconsistent. Their successes are rare because a knowledge and understanding of pigment characteristics is necessary for successful color mixing.

You should be able to identify the hue, value, intensity, and consistency of each of the pigments on this basic palette. Studying the list of individual characteristics is helpful, but you will find your skill in using this palette can best be developed by application and practice.

Here are some practical ways to familiarize yourself with these pigments: Start by trying out each of these pigments on a large practice sheet. If it's clean, the back of an old painting will do. Group them according to consistency—transparent nonstaining, opaque sedimentary, and stains. Now paint a stripe of each ranging from full strength to a light tint, and label each one. Note the relative value and intensity of each pigment.

When your first stripes have dried, you can glaze over parts of them with washes of different pigments. Overlapping pigments of different groups will help you assess their opacity or staining power. Also try intermixing pigments from different groups to see how specific pigments will affect each other when combined. Don't be afraid to experiment—you're building a color vocabulary.

A helpful way to identify and remember the general characteristics of each pigment is to label them on your palette. You can write on the outside edge of most palettes with a pencil. If this doesn't work, use masking tape and a marking pen. Mark each pigment according to its general characteristics: *T* for transparent nonstaining, *O* for opaque sedimentary, and *S* for stains. Be sure your marks are clearly visible. If you're on location in the heat of inspiration and you reach for a dark blue marked *S*, you'll know in time it's that deadly Winsor blue!

LESSON FIFTEEN

MATCHING TRANSPARENT PIGMENTS TO SUBJECT

As we have seen, the pigments on my basic palette fall into three groups: nonstaining transparent, opaque, and staining. Each of these groups differs in appearance, intensity, and consistency, which can be an advantage or a disadvantage. By matching pigments with similar characteristics to a specific subject or desired effect, you can create a convincing and harmonious surface quality—one that conveys a verisimilar sense of either atmosphere, weight, or power. Conversely, if the pigments in a painting are selected and combined arbitrarily, without regard to weight or consistency, the results can be disturbing: a floating, weightless barn, an out-of-tune neon sky or an opaque, impenetrable shadow. Therefore, pigments should be selected and mixed to match not only the hue, value, and intensity of a subject, but also its weight and consistency.

The transparent nonstaining pigments—aureolin, rose madder genuine, cobalt blue, viridian, and burnt sienna—have a delicacy and clarity of tone that is particularly attractive. But if they are to be used effectively in a painting, they must be matched to subjects with similar qualities. Because of their transparency, these pigments are ideal for conveying the illusion of atmosphere, space, and light—important elements in landscape painting. They have the airy, ethereal quality we associate with the glowing, atmospheric watercolors of Turner. They are most effective when used to describe such typical subjects as: early morning light on a harbor; the light, reflection, and shadows of boats in water; or the pearly iridescence of flesh tones. Because they are nonstaining as well as highly transparent, they can be combined in mixtures or applied in individual glazes that will neither obscure nor stain the underlying paper or paint. (We will discuss method of application in more detail in Lesson Sixteen.)

TRIADS—PRIMARY EQUIVALENTS
The late Barse Miller further organized each pigment group into triads of the three primaries: yellow, red, and blue. Among the five transparent, nonstaining colors, the primaries are: aureolin (yellow), rose madder genuine (red), and cobalt blue. These pigments are almost perfectly matched in intensity and consistency, and can be combined without concern for one overpowering the other or for a loss of transparency. Because the triad pigments range in value from light to middle (viridian and burnt sienna are somewhat darker) and have little weight or density, they are too transparent and light to be used for subjects with much weight or mass or to make substantial darks. However, they can be combined to make a great variety of hues for lighter subjects or to establish a transparent, atmospheric underpainting. Also, rose madder genuine (at full strength) can be mixed with cobalt blue or viridian to produce a cool, middle-value shadow tone that is convincing.

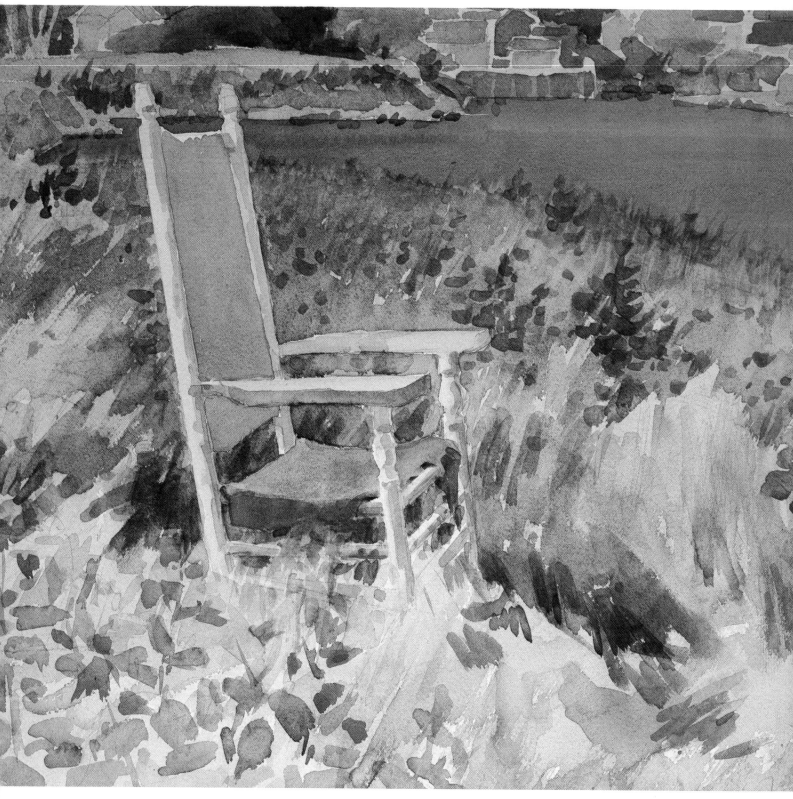

LAST OF THE SEASON
by Barbara Osterman, A.W.S.
Watercolor on Arches 140-lb cold press paper,
14" × 21" (36 × 53 cm).
Collection of the artist.

In Barbara Osterman's painting *Last of the Season* color, value, and pigment consistency are perfectly matched to the character of her subject. The result is a sensitive and lyrical description of a simple but engaging subject. Throughout most of the painting, Osterman has used a triad of nonstaining transparent pigments—rose madder genuine, aureolin, and cobalt blue. These primary equivalents are closely matched in intensity and consistency. They are extremely transparent and luminous and particularly effective when used to convey a sense of light and atmosphere. They also have a clarity of tone and delicacy that can't be duplicated with other pigments.

DOUBLE TROUBLE
by Judi Betts.
Watercolor on Arches 140-lb rough,
21″ × 27½″ (53 × 70 cm).
Collection of Hjalmar Breit, III,
New Orleans, Louisiana.

Judi Betts' painting of two large boats in drydock, aptly titled *Double Trouble*, has a luminosity and sensitivity that is characteristic of her work. It is an excellent example of how pigment consistency can be used to convey the feeling of light and atmosphere. As the basis for this painting she has used a predominance of nonstaining transparent pigments in a glazing method—where individual washes have been applied in successive layers. The resulting passages have a subtlety and iridescence impossible to achieve by using a direct method. For contrast, she has introduced small areas of opaque or staining pigment that accentuate the atmospheric quality of her subject.

APPLYING THESE IDEAS

To match pigment qualities to your subject, spend a few minutes analyzing your subject before you start painting. Be sure to identify not only your subject, but the specific quality or condition you wish to convey. The quality you select will determine the pigments you will use. For example, if your primary interest in painting a Maine seascape is in capturing the atmospheric effect of early morning light on distant rocks and water, you would use mostly nonstaining transparent pigments. If, on the other hand, you are more interested in conveying the mass and monumentality of the rocky shoreline or the dynamic pattern of the jagged rock formations, you would select opaque or staining pigments as the principal components of your color scheme.

To reproduce the light or atmospheric qualities of a subject, start with the triad pigments: aureolin, rose madder genuine, and cobalt blue. These pigments (along with viridian) can be combined or applied in individual washes (glazes) to make a variety of light to middle-value hues that will establish the predominant transparent quality of the subject. To these, add small amounts of other pigments for middle-to-dark hues or for small areas of contrasting opacity. You can introduce any pigment on your palette into a predominantly transparent painting if you do so with restraint and a sensitivity to your painting's overall surface quality.

These pigments are not secret ingredients in a magic formula. They will not transform a badly designed or indifferently painted watercolor into a great work of art. They are merely simple devices to make you conscious of the expressive possibilities of pigment consistency and surface unity.

CRITIQUE

Do you start every painting with a phthalo blue sky or a burnt umber field? In most cases, the predominant surface quality of a painting is established in its initial washes. If you have developed the habit of starting every painting in a formulated way—with a Winsor blue sky or a yellow ochre wash—you are limiting yourself, by reflex, to a group of pigments that may not be suited to your subject. Before automatically laying down the first wash in your next painting, take a few moments to select the pigment group that will most effectively convey the weight, transparency, or intensity of your subject.

Do the nonstaining transparent pigments you've selected match your subject? The nonstaining transparent pigment group is comprised of hues that are particularly attractive and useful in landscape painting. However, they're not suited to every subject. For example, the weight and mass of a gnarled oak trunk or the power and intensity of a rusty tractor could not be conveyed with the transparent hues of rose madder genuine, aureolin, and cobalt blue. To reproduce these qualities, other pigments or pigment groups should be used.

LESSON SIXTEEN

USING GLAZES FOR TRANSPARENT PIGMENTS

The simplest, most popular method of painting watercolors is by the direct method. There you combine pigments and water on your palette and apply them directly to the dry paper, starting with the lightest areas and progressing to the darks. But there is an indirect and more easily controlled method, called glazing, that offers an alternative or adjunct to the direct method. In the glazing technique, transparent pigments are combined in a series of layered washes, each of which is allowed to dry before the next is added. The method thus permits a subtle modification and adjustment of value and hue until the desired color is obtained. The resulting passages have a depth and iridescence impossible to obtain directly.

The nonstaining transparent pigments on my palette are particularly useful for the glazing technique. Because of their transparency and clarity of tone, they can be applied in repeated layers without greatly obscuring the paper or underlying passages of paint. And, more important, they won't stain the paper or underlying layers of pigment, which would destroy the vibrant effect of a glaze.

On the other hand, opaque pigments are less effective in glazes. Repeated layers of dense pigment will obscure the paper and underlying paint, and the resulting surface will have a muddy, unattractive quality. However, a single layer of opaque pigment could be used to add weight to a series of transparent glazes. Stains,

because of their staining action, also are not suited to the glazing technique. But an underlying layer of stains can be used as an initial wash in a glaze where greater intensity is needed.

Rose madder genuine, cobalt blue, and aureolin—the triad pigments of the transparent nonstaining group—are the major components of most glazes. They are close in hue to true primaries and highly transparent. By combining them in individual washes of varying strength, it is possible to produce a great variety of subtle, transparent hues. Applied in a glaze technique, these pigments (along with viridian) can be used to establish an overall atmospheric quality or to modify areas painted with opaque or staining pigments (for example, shadows on an old barn or texture on rocks).

APPLYING THESE IDEAS
You have probably used the glazing technique before (overlapping washes in watercolor are almost unavoidable), but you may not have used transparent nonstaining pigments in a systematic approach. The technique and principles of glazing are rather simple. Let's examine the procedure.

MATERIALS
Glazing is a slow, indirect process better suited to the quiet and comfort of a studio rather than to the discomfort and distraction of on-location painting. For the glazing technique you need a stretched sheet of paper (either rough or cold-pressed), a sturdy ad-

justable easel or table, and a large (1" to 1½"—25 to 38 mm) wash brush. A good wash brush will have soft, springy hair and the capacity to hold a great amount of water. For large, broad painting I use a variety of white China bristle varnish brushes, ranging in width from 1" to 3" (25 to 75 mm). For finer work, I use a 1" (25 mm) acquarelle brush or a 1½" (38 mm) no. 22 sabeline brush.

APPLYING THE FIRST WASH
Start with a dry, stretched sheet on a board firmly set at a fifteen degree angle. On your palette or in a small cup mix one of the nonstaining transparent primaries with a large amount of water (the rule of thumb is to mix twice the amount of paint you think you'll need). Load your brush to capacity and start your first stroke in the upper left corner of your paper. Paint an unbroken horizontal band across the top of the sheet, moving steadily without retreating or fussing. When a bead has formed at the bottom of your first band, slightly overlap it with your next horizontal stroke. Repeat this process continuing to the bottom of the paper. Avoid moving or tipping your board until the wash has dried.

I painted the first wash (page 78) using aureolin. Yellow is the lightest primary and an essential component in most landscapes. To achieve the greatest transparency, it should be painted first. If greater intensity or opacity is required, a stain or an opaque pigment can be used for the first wash.

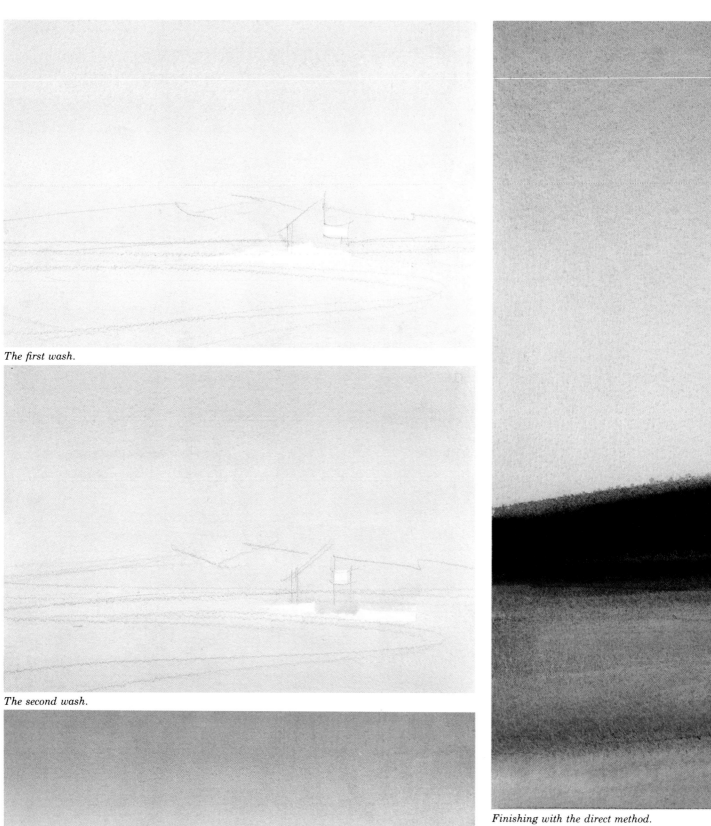

The first wash.

The second wash.

Finishing with the direct method.

The third wash.

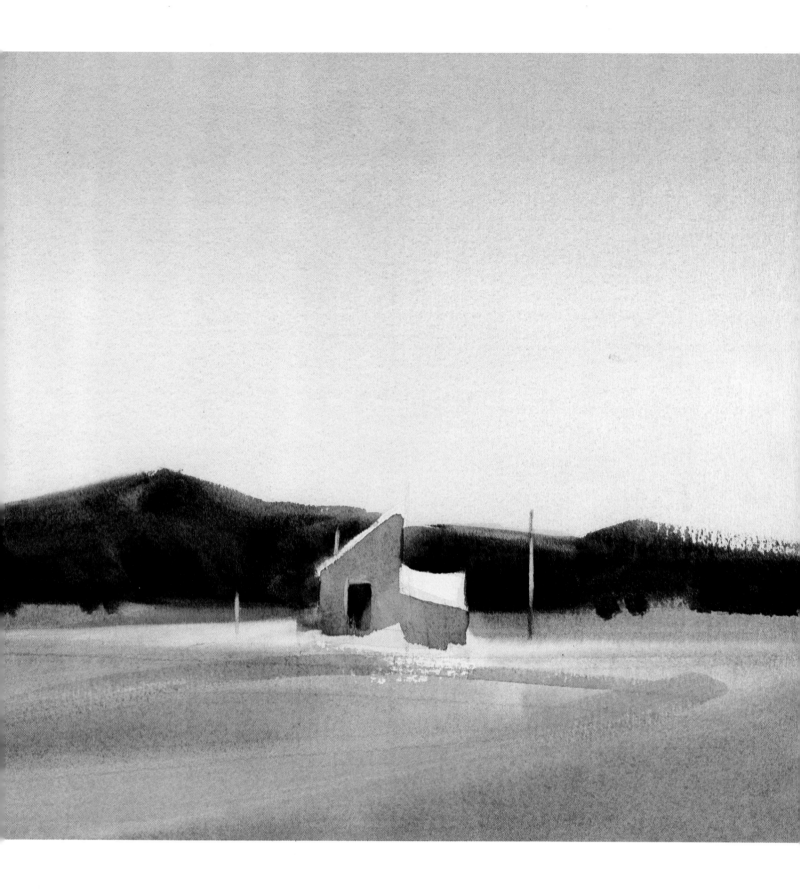

APPLYING THE SECOND WASH

When your first wash has completely dried, apply a second nonstaining transparent primary following the same procedure. With practice you'll learn to adjust the strength of these first washes to achieve the desired hue. Paint around (not up to) the edge of any planned lights you wish to leave. Your brushstrokes can go in any direction, but work quickly so you can continue the flow of your horizontal wash. Pick up any beads that have collected at the edges of these unpainted shapes with a brush that has been shaken or squeezed dry. Use the same technique to pick up puddles of wash that may have formed at the edge of your paper. If these wet areas run back into your drying wash, they'll make disturbing "fans" or "backwashes" in your glaze.

Here I've used rose madder genuine for my second wash and gradated it by progressively thinning each stroke with water. As in my first wash, I've left several simple planned shapes for my lightest value.

APPLYING A THIRD WASH

Add a third wash of the remaining primary. It should be the same value or slightly darker than the underlying washes. As in direct painting, glazes are applied in value steps from light to dark. To strengthen the value or adjust the hue of your glaze, you can add a fourth or fifth wash. A glazed painting can have anywhere from two to twenty washes, if transparent nonstaining pigments are used. After applying your final wash, note the value of your combined glaze. At most it will be a middle-light, the first step in the value scale.

Other pigments and a different technique will have to be used for middle and dark values.

Here I've added a gradated wash using cobalt blue (slightly less diluted than the other primaries) to make an atmospheric gray sky that becomes warmer at the horizon.

FINISHING WITH THE DIRECT METHOD

When the final glaze is completed, add middle values and darks using the direct method. For transparent middle values, use the primary pigments plus viridian and burnt sienna. Combine these with small amounts of opaque or staining pigments for darks or weight. Small areas of opaque pigment can be used for contrast, but don't lose the predominantly transparent quality you've created. Any pigment on your palette can be used at this stage, if it is used in small amounts for contrast or modified to appear transparent.

I finished the painting on page 79 in three simple value steps. To create a soft-edged effect, I painted the middle-light foreground before the last wash had dried, using the triad pigments along with viridian and a small amount of yellow ochre for weight. For the building I mixed a transparent middle-value gray with the triad pigments, and for the dark distant hills I used a mixture of Indian red, cadmium red, and French ultramarine. The dense opacity of the hills accentuates the transparency of the sky and building.

CRITIQUE

Is your subject predominantly transparent? If your subject is not predominantly transparent, glazing the entire paper with two or three washes will be a waste of time. Glazing can be restricted to small areas or separate elements and be done in the final stages of an otherwise direct painting. For example, to capture the transparent glow of a small boat at low tide, you would probably glaze only the boat. The surrounding mudflats would be painted directly with opaque pigments.

Does your glaze lack the vibrancy and glow associated with this technique? Your completed glaze may seem dull and lifeless for several reasons: (1) You unknowingly may have used a stain in one of your final glazes. Pigments with strong tinctorial power will stain not only the paper, but any other pigment they contact. They will destroy the effect of a glaze. If you need greater intensity, use a stain in the *first* wash and complete your glaze with nonstaining transparent pigments. (2) You have not yet introduced darks or opaque areas for contrast. An overall glaze on completion will often appear thin and washed out. Contrasting middle values and darks or small areas of opacity are needed to accentuate the transparency of the glaze. Remember: an overall glaze simply tones the paper. It is normally no more than middle-light in value, an atmospheric wash to which darker, more substantial, elements can be added.

Are your glazes always neutral and gray? A glaze—or any mixture—will be neutralized if equal amounts of complementary hues are combined. To make a more intense glaze with the nonstaining transparent triad, you must use a stronger wash of one (or two) of the three primaries.

MATCHING OPAQUE PIGMENTS TO SUBJECT

To review, the opaque sedimentaries, the second group of pigments on my basic palette, have characteristics distinctly different from the transparent group. They are rich, dense, earthlike pigments with very little transparency. They have a weight and opacity that makes them particularly useful in landscape painting when matched to subjects or effects with similar qualities. For example, the rich consistency of the opaque pigments makes them ideal choices for conveying the illusion of weight and density. When matched to subjects with substance and mass—a rock formation, an old barn, a gnarled tree trunk, a plowed field—they create a surface quality that is especially convincing.

The seven opaque pigments on my basic palette are: yellow ochre, Indian red, cerulean blue, cadmium yellow, cadmium orange, cadmium red, and French ultramarine. These pigments are similar in consistency and weight. Most are obtained from inorganic materials—minerals, ores, or sedimentary clays. They range in hiding power from the almost total opacity of Indian red to the slight transparency of French ultramarine. If applied in undiluted or in repeated glazes, they will almost completely obscure the paper. They are nonstaining, but their weight and density make them difficult to lighten or remove when dry.

TRIADS—PRIMARY EQUIVALENTS

The opaque sedimentary pigments can be further divided into primary equivalents—Indian red, yellow ochre, and cerulean blue—pigments that are perfectly matched in intensity (moderately bright) and consistency (opaque). They can be combined without concern for one overpowering the other. A more intense, but less perfectly matched triad can be made with cadmium red, cadmium yellow, and French ultramarine.

The opaque triad pigments are light to middle in value and slightly gray in intensity. When slightly diluted, they can be used for lighter value subjects, such as a silvery gray pier or a rusty plow, or heavier atmospheric effects, like that of a dense Maine fog. Applied in the first two or three value steps of a painting, they will establish a predominantly opaque surface quality.

APPLYING THESE IDEAS

You may think of opaque pigments as unattractive—the chief ingredient in "mud"—and avoid using them. And they are heavy and dense. But if they are matched to subjects with similar qualities, they can create a weight and solidity unattainable with the more immediately appealing transparent hues.

Before you select the pigments for your next painting, take a few minutes to identify the specific quality you wish to convey. Your choice may be subjective. For example, you may decide to paint an old rocking chair from a middle viewpoint using transparent pigments to capture its glowing white form in sunlight (see Barbara Osterman's painting in Lesson 15.) Or you may wish to emphasize its weatherbeaten surface and paint it from a closeup viewpoint using opaque pigments.

If conveying the weight and solidity of a subject is essential to your design, use opaque pigments as the primary components in your color scheme. You can use the triad of this group—yellow ochre, Indian red, and cerulean blue—to mix the slightly grayish hues of lighter elements, such as weathered wood, sunlit rocks, and tree trunks, or as the first two or three value steps of an underpainting that establishes a predominantly opaque surface quality.

The pigments of this opaque triad are too light, opaque, and gray to make effective darks or a full range of hues by themselves. However, they can be combined with transparent or staining pigments to make darker or more intense opaque mixtures. For example, yellow ochre and cerulean blue will produce only a light gray-green, but yellow ochre combined with viridian or Winsor green will make a variety of rich, lush greens

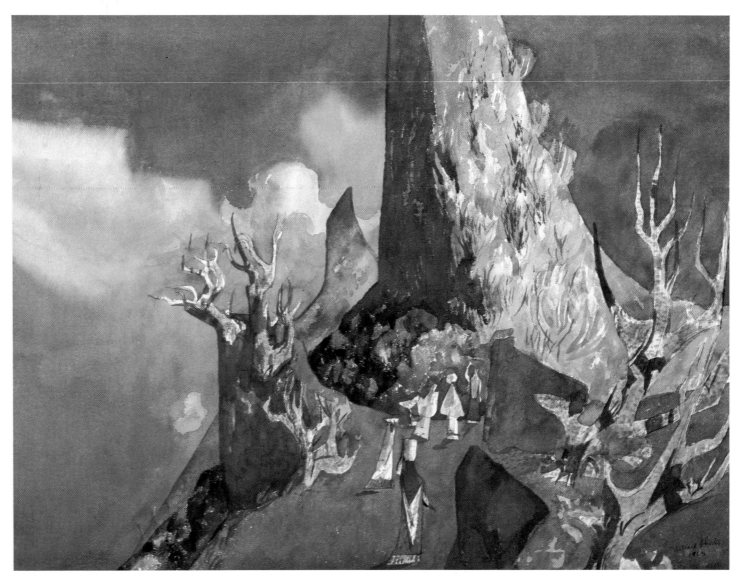

MILCUMBRE
by Millard Sheets.
Watercolor on paper,
22" × 30" (56 × 76 cm).
Collection of E. Gene Crain.

Millard Sheets is a master artist and his creative use of color, design, and technique is clearly evident in this painting. He has matched the consistency of his pigments to the characteristics of his subject to produce a watercolor that has both solidity and luminosity. The majority of the painting—the sky, mountain, and foreground—was done with opaque pigments that convey a sense of weight and density. To accentuate these qualities, he has introduced smaller areas of more intense, transparent pigment into the predominantly opaque surface. These slightly discordant notes provide contrast and interest in a harmonious setting.

GRAY HARBOR
by Christopher Schink.
Watercolor on Arches 300-lb rough paper,
21″ × 29″ (53 × 74 cm).
Collection of the artist.

Gray Harbor is one of a series of paintings I've based on the shapes and patterns of a small local harbor. It was begun on location on a cool, overcast day. My subject was a small sailboat, but my primary interest was in capturing the dense, gray-violet quality of the light that pervaded the scene. To convey this heavier atmospheric quality, I began the painting with a wet-in-wet method using a triad of opaque pigments—yellow ochre, Indian red, and cerulean blue—adding other pigments to obtain variations in hue and darker values. Back in the studio, I added several glazes of transparent pigment. To more fully appreciate how pigment consistency can be used to convey different expressive qualities, compare this painting to the one by Judi Betts in Lesson Fifteen.

that will retain an opaque consistency.

Once you have established a predominantly opaque quality, you may wish to introduce transparent or staining pigments for special effects or contrast. For example, for the shadow on an old rocking chair, which should be transparent, not opaque, you can apply a glaze of nonstaining transparent pigments over the opaque chair. Or as another example, the rocky surface of a cliff face, which could be reproduced with mixtures of yellow ochre, cerulean blue, and Indian red, will require darker stains for the contrasting value of the cracks and crevices. So long as you establish a predominant surface quality and use limited amounts of dissimilar pigments for variety and contrast, you don't have to adhere dogmatically to a single triad or group of pigments.

CRITIQUE

Are you able to convey a sense of weight and solidity with the pigments you normally use? Review your earlier paintings. Do they contain ethereal barns, floating weightless rocks, and paper-thin fields? If so, you have not matched the consistency of your pigment to the weight of your subject. Try repainting these subjects using opaque pigments to create a convincing sense of weight and a strong sense of solidity.

Have you avoided using opaque pigments because they invariably end up as "mud"? What most painters describe as mud is a large unrelieved area of neutral, middle-value paint with little or no transparency. Although a muddy passage usually contains a large amount of opaque pigment, it is not the pigment itself that makes such an area unattractive or disturbing. It is its lack of value contrast and intensity, often the result of a misjudgment of value and hue.

If you seem to produce more than your share of "mud" when using opaque pigments, concentrate in your next painting on mixing and applying the hue you want on the first try. If you can't quickly reproduce the color you want, wash out your palette and try again. Avoid combining four or five different opaque hues on your palette or in repeated washes—you'll only produce "mud."

Do you have difficulty attaining strong darks with opaque pigments? The number of darks that can be made by combining opaque pigments is limited. Most of the opaque pigments are light to middle in value. The two exceptions—cadmium red and French ultramarine—will produce a dark, neutral purple when combined. Therefore, to attain strong intense darks, you must combine the darker opaque pigments with small amounts of other dark pigments—alizarin crimson, viridian, Winsor blue, and Winsor green. If carefully apportioned, these mixtures will possess an opaque consistency that is compatible with the overall surface quality of the painting.

USING THE WET-IN-WET METHOD FOR OPAQUES

The opaque sedimentary pigments on the basic palette are most effective when used in a wet-in-wet technique. This method differs from the wash or glazing technique in that wet (or, more accurately, *moist*) pigment is applied to a wet (rather than dry) surface. Also, pigments are mixed and diluted on the paper rather than on the palette, as they are in the glazing technique.

The wet-in-wet method has several advantages: (1) It can be used on location in dry weather to avoid the disturbing hard edges that result from rapidly drying washes. (2) It facilitates the adjustment of form, value, and color relationships in the early stages of a painting. (3) It produces a predominantly soft-edge underpainting to which more defined forms can be added later, when the paper is dry, for contrast and focus. One drawback is, to be effective, the painting must be executed in a rapid, confident manner—and the results are not entirely predictable.

Because of their weight and consistency, opaque sedimentary pigments are particularly well suited to the wet-in-wet method. When applied to a wet surface, where lighter or staining pigments have a tendency to creep or wash out, opaques hold their form and body, merging with the saturated paper to form a flat, brushless surface that is characteristic of many landscape elements. Also, because they are nonstaining, they can be lightened or completely removed without destroying the white surface of the paper.

Although less easily controlled or modified, nonstaining transparent pigments and stains can also be used in a wet-in-wet method. In fact, some painters enjoy this accidental quality and employ it to create interesting or naturalistic forms.

The triad colors of the opaque group—yellow ochre, Indian red, and cerulean blue—can be used in the early stages of a wet-in-wet painting to describe lighter elements or to establish an opaque surface quality. Other opaque pigments (such as cadmium orange and cadmium red) can be combined with carefully apportioned amounts of staining and transparent pigments to make a full range of values and hues. Strong darks and shadows are applied later, when the paper is dry.

APPLYING THESE IDEAS

The wet-in-wet method requires preparation, a presence of mind and, of course, practice. Once mastered, it can be a useful means for expressive design and an indispensable technique for outdoor summer painting.

MATERIALS

For the wet-in-wet method you need a sheet of rough or cold-pressed paper and a water-resistant board. For stretching paper, a piece of plywood—either exterior grade or one treated with acrylic medium—works best, but Masonite will do.

Most wash brushes are too soft and hold too much water to be used for this technique. You'll need a stiffer brush with less water capacity. Barse

Miller used a natural bristle "sash cutter" or varnish brush, the kind found in hardware and paint stores, and I use a 1″ (25 mm) and a 1½″ (38 mm) white bristle "bulletin cutter" (made by Grumbacher). A 1″ (25 mm) sableine flat will work for half-sheet paintings.

WETTING THE PAPER

The secret of wet-in-wet painting is to maintain a uniformly moist surface. The easiest way to do this is to saturate your paper with water using a large soft sponge. Keep your board flat so the water is evenly distributed. Thoroughly wet your board and both sides of your paper. Repeat this wetting process until your paper is completely saturated and flat. Be patient. On a hot day it may take ten or fifteen minutes and half a gallon of water, but the longer you soak your paper, the longer you'll be able to paint on it.

Before painting, check the moistness of your paper. Look across the surface. It should have a soft, even, velvety quality with no unabsorbed pools of water. Test the surface with a small stroke of undiluted opaque pigment. If your brushstroke takes a feathery edge but holds its form, your paper is properly saturated.

To illustrate the correct degree of saturation, in the first illustration, I've sketched the basic forms of my subject and have applied the first layer of yellow ochre over three premoistened sections of paper. Note that the left-hand section is too wet, the middle section is properly saturated,

Wetting the paper.

Applying pigment.

Defining forms.

Completing the painting.

and the right-hand section has become too dry.

APPLYING PIGMENT

Patience is required when soaking your paper, but *speed* is necessary for painting. Be prepared—have plenty of fresh, moist pigment on your palette—and work fast! Start with your lightest opaque primary (yellow ochre in the triad pigments) and apply it undiluted. Remember: in this technique water is added to the paper, not to the paint. Use a large, moist brush (make sure it's not loaded with water), and, starting at the outside edges, work inward with large simple forms. Stay well away from any whites you might want to save. They can be more sharply defined at a later, drier stage.

Paint your next value step with opaque primary pigments. Concentrate on shape, value, and color relationships. Misjudgments can be corrected or removed with a moist sponge.

In the second illustration I painted the middle-light value step using combinations of Indian red, cerulean blue, and yellow ochre as well as small amounts of viridian and cadmium red. I overstated the value and intensity of these first steps, knowing they will lighten and lose some intensity as they soak into the paper and dry.

MAINTAINING WETNESS AND DEFINING FORMS

It is important in the first two or three value steps of a wet-in-wet to keep your paper uniformly moist. To do this, work from the outer edges in, concentrating on large shape and value relationships. Don't anticipate details or paint too long in one area. Work rapidly over the entire surface so your paper will remain uniformly moist. Watch your edges; they'll dry first. If a neglected edge or area begins to dry, repaint it with slightly wetter pigment. If your entire painting is drying too fast, revive it with a light spray from an atomizer or lift your paper and squeeze a sponge full

of water onto your board.

With the paper still in a wet condition, continue to apply and adjust the first two or three value steps. As your paper dries and the paint sets, you can begin to define more sharply the areas of primary interest with middle and middle-dark hues that contain small amounts of transparent or staining pigments.

In the third example I defined the foreground, roof edge, and dark interior using combinations of cadmium red, yellow ochre, Indian red, burnt sienna, and viridian. The contrast between the sharply defined windowframe and the softer edged peripheral areas creates a sense of focus.

COMPLETING THE PAINTING

How far you carry a painting using the wet-in-wet method is determined not only by the effect you're trying to achieve, but also by how long you're able to maintain a suitably moist painting surface. You should work rapidly to establish some middle and middle-dark areas, whether your wet-in-wet is intended as an underpainting or is simply drying faster than you anticipated. Areas of middle and middle-dark value will support any glazes, dark accents, or textural detail added when the painting has dried. They'll also provide the underlying structure of your design. Without them, later additions of dark or transparent pigment will seem to separate and float above the light soft-edged surface.

In the last example I allowed the paper to dry before adding the final washes and darks. I mixed rose madder genuine and viridian (nonstaining transparent pigments) for the gray-violet shadow. To reinforce the darks in the interior of the building, I used burnt sienna, viridian, cadmium red, and a small amount of Winsor green. To create a highlight, I lightened the edge of several boards by picking up the paint with a clean, moist brush. If you're working in a style that requires further additions of brush calligraphy or textural detail, they can be applied at this stage.

CRITIQUE

Have you avoided using the wet-in-wet method because you think it is unsuited to realistic painting? Many painters working in a highly representational style prefer the hard-edged quality of the direct or glazing method to the softer forms produced by the wet-in-wet method. Their preference is based on a common misconception: that in realistic painting every area—foreground to background, left to right—must be filled with sharply defined detail. They probably have confused realism with photography. In photography, the camera lens is able to bring every detail—from a few inches away to infinity—into focus. But the human eye can focus only on a limited area and therefore, as in a wet-in-wet painting, peripheral elements are soft-edged and vague. The contrast between sharp and soft-edge areas can be a useful device for creating convincingly realistic paintings.

Do your wet-in-wet paintings look thin and washed out? A wet-in-wet painting can look like the paint job on your old car—great when it's wet, but thin and tired when it dries. If you're usually disappointed with your wet-in-wet painting, remember: as paint is absorbed into wet paper and dries, it lightens and loses some of its intensity. To compensate for this loss, in your next wet-in-wet painting try to overstate the value and intensity of the first two or three applications of paint.

Do the darks in your wet-in-wet painting seem dull and formless? If the darks in your wet-in-wet painting don't hold their form or if they dry dull and lifeless, it's probably because you're painting them too early. Although it's important to establish some areas of middle and middle-dark value before the paper dries, it is not possible to achieve strong, vivid darks until the paper is almost completely dry. Therefore, your strongest darks should be applied in the last stages of your painting.

MATCHING STAINING PIGMENTS TO SUBJECT

The third group of pigments on the basic palette, the stains, are powerful hues that possess an intensity and color saturation far greater than the other two groups, the transparent nonstaining and opaque pigments. Their brilliance and clarity of tone make them particularly well suited to subjects—such as the powerful shining forms of a diesel locomotive or the brilliant saturated colors of a tide pool—where a sense of power or a high degree of color contrast and intensity are primary characteristics. Stains can also be used in more subjective paintings, like a stormy sea or raging forest fire, to express a sense of drama and emotion.

Because of their brilliance and intensity, staining pigments often are used by commercial artists whose principal aim is to make an immediate and arresting visual statement. However, their usefulness for watercolorists interested in reproducing the natural hues of the landscape is limited. Few elements in nature possess the intensity imparted by these powerful pigments. They are, nontheless, indispensable for capturing certain effects: the powerful shapes and patterns of machinery or industrial subjects, the dark recesses of rock forms, the dim interior of a barn, or the heavy darkness of a night scene.

The five staining pigments on my basic palette are: Winsor yellow, Winsor red, Winsor blue, Winsor green, and alizarin crimson. They are brilliant hues that are fairly equal in intensity (surpassing even the cadmiums), but varied in consistency. Winsor red and Winsor yellow are almost opaque, while Winsor blue, alizarin crimson, and Winsor green are highly transparent. All have great tinctorial power and will permanently stain the paper or any other pigment they contact. Because of their highly saturated color, staining pigments can be diluted or spread over a large area without a significant loss of intensity.

TRIADS—PRIMARY EQUIVALENTS

Two triads can be formed from this group of pigments. One is generally transparent—Winsor yellow (or new gamboge), alizarin crimson, and Winsor blue—and one is moderately opaque—Winsor yellow, Winsor red, and Winsor blue. Both triads are matched in intensity. They can be combined to achieve a full range of values and a slightly limited range of hues.

The triad pigments range in value from light (Winsor yellow) to very dark (Winsor blue). They are most effective when matched to subjects that contain strong value contrast, such as a massive crane silhouetted against the sky or a dark mountain stream bordered by snow.

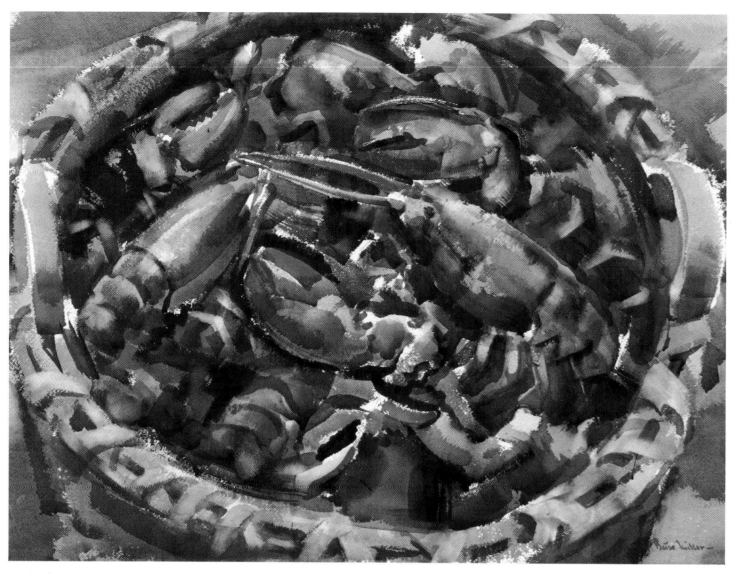

69 POUNDS
by Barse Miller, N.A., A.W.S. (1904–1973).
Watercolor on Arches 300-lb rough paper,
20" × 28" (51 × 71 cm).
Collection of E. Gene Crain.

It's hard to imagine a subject as singular and difficult as a basket full of lobsters! Yet the late Barse Miller transformed this uncommon subject into a striking design, and did it with seeming ease. To reproduce the powerful forms and strong contrast of this subject, he used a predominance of stains—Winsor green, Winsor blue, alizarin golden, and Winsor yellow, with an occasional accent of cadmium scarlet. These pigments have a brilliance and clarity of tone that make them particularly well-suited to subjects possessing a sense of power or a high degree of contrast and intensity. To convey these qualities (or a subject such as *69 Pounds*) with nonstaining transparent or opaque pigments would have been impossible or, at best, unconvincing.

Opposite page
TAOS PUEBLO
by Keith Crown.
Watercolor on paper,
30" × 22" (76 × 56 cm).
Collection of E. Gene Crain.

Keith Crown's watercolors are painted with a daring and exuberance that reflects his enthusiastic response to the landscape. In *Taos Pueblo*, painted near his summer home in New Mexico, he has captured the vast expanse and radiant color of the sky and landscape. To create this imaginative and exciting design, he has used a combination of direct and careful painting, provoked accident, and casual airbrushing. Large areas of staining pigment were used to heighten the dramatic effect. Unmodified staining pigments have a power and intensity rarely found in nature, but they can be used in more subjective color schemes (as Crown has done in this painting) to create a sense of drama and excitement.

APPLYING THESE IDEAS

On your next painting, after you have selected a subject and viewpoint, take a few minutes to identify the specific quality or effect you wish to convey. Then select the pigment group that will best describe these qualities.

If your interpretation of a subject demands a high degree of value contrast or color intensity, you will need to use staining pigments. You can use the more opaque staining triad (Winsor yellow, Winsor red, and Winsor blue) for subjects that possess weight as well as intensity—for example, colorful circus tents, a rusty anchor and chain, or an old tractor. Use the primaries to establish a predominant surface quality. For a greater variety of hue, combine them with other intense pigments. Cadmium yellow, cadmium red, and cadmium orange are compatible with opaque stains. Mix transparent stains—alizarin crimson, Winsor blue, and Winsor green—for shadows and darks.

For strong value contrast and color intensity in subjects where a sense of atmosphere or light is a primary characteristic, use the transparent staining triad—Winsor yellow (or new gamboge), alizarin crimson, and Winsor blue. For example, the lush interior of a forest, the colorful growth in a tide pool, or the reflective surfaces of fruit and bottles in a still life could be convincingly reproduced with transparent stains. For variations in hue, combine the transparent stains with the more intense nonstaining pigments—viridian, aureolin, and burnt sienna—or with small amounts of opaque pigment.

You can use these triads and pigment groups to attain a harmonious or descriptive surface quality, but don't view them as unalterable formulas because they are not. They are simply a means of organizing your palette to make you conscious of the expressive possibilities of pigment consistency. In other words, they are a useful learning device that can be altered, modified, or ignored once you develop a sensitivity to the relationships of pigment, surface, and subject.

CRITIQUE

Have you avoided using stains because of their extreme intensity? Stains are dangerous! The addition of an isolated Winsor green tree or alizarin crimson barn can effectively destroy the efforts of an entire afternoon of painting. You may be tempted to avoid or eliminate stains after having ruined several paintings with overly intense passages. While stains are not easily integrated into paintings with subtle or natural color, they are, nontheless, essential if a full range of hue, value, and intensity is to be achieved. If you have difficulty with stains, in the future try to use them either as the major component in a dynamic design or as the limited ingredient in carefully mixed darks.

Are the majority of pigments you use stains? Unless you're a colorist interested in interpreting every subject with personal and subjective color, you'll find the exclusive use of stains has several disadvantages: (1) The range of hues that can be mixed with stains alone is limited. (2) Large light areas may seem flat and dull because the clarity of tone and brilliance of these pigments are greatly diminished by dilution. (3) Most important, paintings of quiet, subtle subjects done exclusively with stains are, at best, disturbing and, at worst, flashy and superficial.

USING THE DIRECT METHOD FOR STAINS

The staining pigments on my palette are most easily controlled when applied in a simple, direct method working wet-on-dry from light to dark. Because of their light weight and staining action, they don't work well when used in a wet-in-wet or glazing technique: When applied to a wet surface (in the wet-in-wet method), they have a tendency to creep, creating unattractive edges and uncontrollable forms. When applied in successive primary layers in a glazing technique, they produce flat, neutral hues with little color vibrancy. But in the direct (wet-on-dry) method, the triads of this group, Winsor yellow, Winsor red (or alizarin crimson), and Winsor blue—can produce either an opaque or transparent surface quality with great intensity of color in a full range of values. Other pigments from the other groups can be introduced for variations in hue, and strong darks can be attained by combining Winsor green or Winsor blue with alizarin crimson.

In your first attempts at watercolor painting, you probably used the direct method almost automatically. If you were painting a sky, barn, and trees, you probably mixed a blue, a red, and a green and painted each object, one at a time, on a dry sheet of paper. This is the essence of the direct method, and of course, any pigment can be applied directly. In this basic technique, pigments are mixed to the desired hue, value, and intensity on the palette and then applied to dry paper, starting with the lightest lights and progressing to the strongest darks. By working rapidly and

directly with a minimum of underpainting and glazing, it is possible to create an exciting, spontaneous work.

There are several drawbacks to the direct method, however. Its rapid execution offers fewer opportunities for subtle adjustment of values and color and often results in a superficial painting in which busy, or even virtuosic brushwork becomes a substitute for an expressive and distinguished surface quality. In short, control is sacrificed for spontaneity with less assurance of success. Nonetheless, this quick, simple technique makes it possible to achieve an immediacy and spontaneity difficult to reach with the slower, more indirect methods.

APPLYING THESE IDEAS

Painting in a direct method with stains requires practice, a presence of mind and *a good value plan* (see Lesson Eight). With all of these, and a little luck, you can create an exciting painting.

MATERIALS

For this method you'll need a stretched sheet of rough or cold-pressed paper on a board firmly secured on an adjustable easel or table. Much of the appeal of the direct method depends on the calligraphic quality of your brushwork, so you'll want a variety of brushes. I use a 1" and 1½" (25 and 38 mm) white bristle varnish brush as well as a softer wash brush. For finer line in the later stages of a painting, I use a no. 10 or 12 pointed sable brush.

PLANNING A DIRECT PAINTING

The successful execution of a direct painting depends as much on a careful value plan as on confident brushwork. You must develop a clear, simple step-by-step value plan and adhere to it throughout the painting. Try to avoid accidents and surprises. They're an inherent part of the direct method and don't need to be invited!

PAINTING LIGHT VALUES

To maintain control of a direct painting, start with your lightest values and work systematically to dark. Apply your first washes with a large brush and keep to simple, solid shapes. Don't anticipate details or darks, but be sure to paint around any planned whites. You can't lift a stain to reclaim a white you've mistakenly painted over. Paint any yellows or warm lights you need in this first stage. If added at a later stage, they'll appear muddy and dull.

I began the first step with my lightest values, using a triad of Winsor yellow, Winsor red, and Winsor blue in various combinations. I painted the tractor first with a violet and blue-gray mixture. For the headlights, I dropped a small amount of Winsor yellow into the wet wash. When my first washes had dried, I painted the surrounding area with a rich yellow-orange made from Winsor yellow, Winsor red, and a small amount of Winsor green.

PAINTING MIDDLE-LIGHT AND MIDDLE VALUES

When your first washes have dried, paint the next value steps—the mid-

Painting light values.

Painting middle-light and middle values.

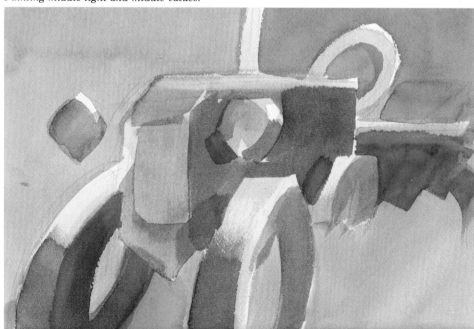

Painting middle and middle-dark values.

Completing the painting.

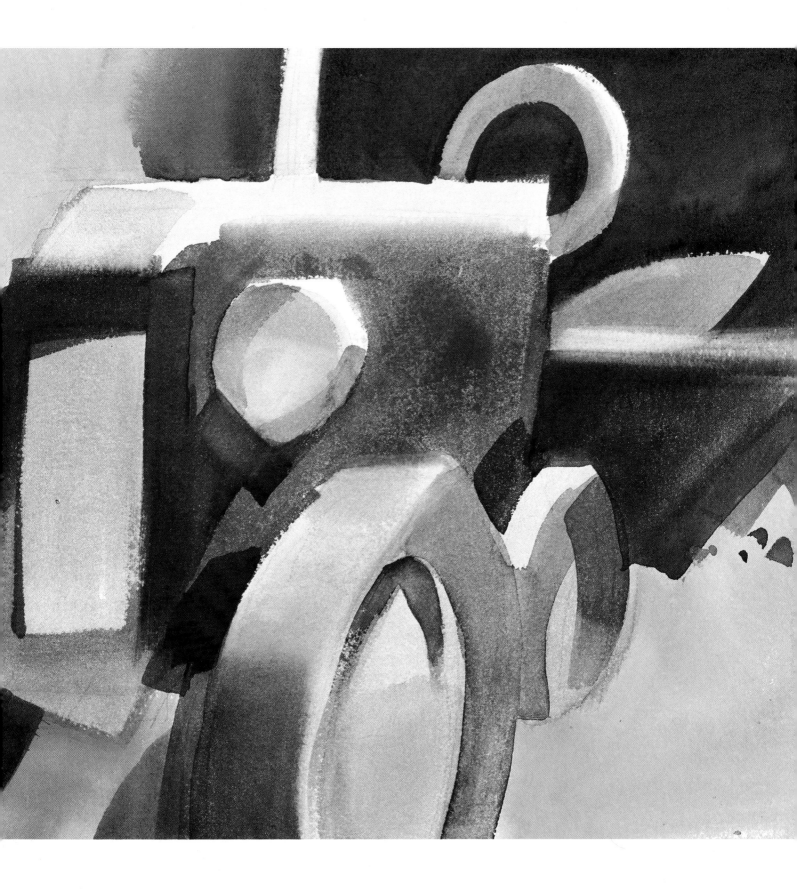

dle-light and middle value areas. Try to mix the hue you want as accurately as possible and apply it directly. Attempting to modify or alter areas painted with stains by applying repeated layers of pigment will produce a muddy, "edgy" passage. Work with a large brush and concentrate on value, color, and shape relationships. You have to paint the underlying structure of a barn before you can add the nail holes!

After my initial washes had dried, I painted the second step in my value plan using the triad pigments. The middle lights on the hood and headlights were painted first. The warm, more neutral hue of the tires was made with Winsor red and Winsor yellow with a small amount of the staining blue added. The radiator was painted with a violet and "charged" with a brushload of yellow-orange. I tried to keep these areas as simple and solid as possible.

PAINTING MIDDLE AND MIDDLE-DARK VALUES
Before painting the middle and middle-dark value steps, stand back and evaluate your paintings. Have you misjudged or neglected any areas? With the direct method and stains, last-minute modifications are usually unsuccessful. To paint with confidence, you must know where you are and where you're going.

Use a medium-sized brush to paint the middle and middle-dark areas. Be sure you have overstated the value and intensity of your light-to-middle steps. Diluted stains will soak into the paper and appear lighter and duller when dry (especially when contrasted with the undiluted darks applied in the last stages of a painting).

In the third step I painted the side of the tractor with a combination of Winsor red, Winsor blue, and alizarin crimson. I defined the form of the

lighter headlight by painting around it. I mixed warmer darks for the tires and rear of the tractor by combining Winsor red, Winsor blue, and aureolin.

COMPLETING THE PAINTING
A direct painting is completed with the addition of darks, texture, and detail. Following your value plan, paint your middle darks first using a medium-sized brush. Be conscious of their shape and edge. These middle-dark areas can't be changed or removed. Paint your darks next and keep them fairly intense. Because of their staining action, stains when mixed tend to neutralize each other, producing dull, lifeless hues. When the darks have dried, stand back and evaluate your painting, then add any necessary detail or texture using a smaller brush.

I completed my painting in the fourth step by beginning with the warm area in the upper right-hand corner. I defined the shape of the steering wheel and seat using a mixture of Winsor red, alizarin crimson, and burnt sienna. Using these same three pigments plus a small amount of Winsor green, I painted the dark areas of the tire and tractor. A few final details were added to the headlights and tires with a no. 12 round sable.

CRITIQUE
Do you seem to lose control of edges and shapes when you use stains? If you have trouble with backwashes, wandering edges, and lost forms when using stains, it is probably because you haven't developed a simple value plan or you have painted an area too soon or out of sequence. Stains have a tendency to creep when applied to a wet area. To be controlled, they must be systematically applied from light to dark following a simple value plan. Some drying time should be allowed

between each value step. If you apply stains in a rapid, random manner—a light here, a dark there—you'll end up with technicolor soup!

Do a lot of your stain mixtures end up as dull, neutral hues? If you have trouble attaining clean, intense hues with stains, it may be because you're overmixing your color. Stains work best when mixed in simple primary and secondary combinations. When they are mixed, the pigment particles in stains do not intermingle as they do with nonstaining and opaque pigments, but instead they stain each other. It is difficult to combine all three staining primaries without producing a flat, dull hue. If your subject requires a variety of subtle hues, I suggest that you start with one of the other pigment groups and use stains for darks or an occasional accent.

Do you dislike stains because of the mess they make? There is no doubt that stains are messy. They creep around your palette, contaminating other pigments and staining your mixing surface. And they stay in your brushes forever unless you wash them out immediately with soap and water. However, they are necessary for a full range of expressive color.

Here are some practical suggestions for fighting stains: (1) Squeeze only a small amount of staining pigment on your palette; for normal painting, a little goes a long way. (2) For paintings requiring a predominance of stains, use a second palette (or china dish or butcher's tray) that contains only stains. Small amounts of other pigment can be used from your regular palette. (3) Wash up when you're done. The stains on your palette (and under your fingernails) can be removed with a little cleansing powder. A thorough washing with a little plain soap should clean your brushes.

LESSON TWENTY-ONE

COMBINING THE PIGMENT GROUPS

The three pigment groups on my palette—nonstaining transparent, opaque, and staining—have distinctly different characteristics that can be used individually to create a sense of unity and harmony in a painting and in combination to create a sense of contrast. Small areas of dissimilar pigment consistency will accentuate the predominant surface quality of a painting. For example, in a seascape a few heavy, dense rock forms (painted with opaque pigment) can be used to emphasize the overall iridescence and transparency of the water (painted with nonstaining transparent pigments). When thoughtfully planned, an exciting, expressive painting can be created by combining dissimilar pigment groups.

To be effective, dissimilar pigment groups must be combined following the general principles of design. A harmonious and unified surface quality can be achieved by the repeated use of a single pigment group that matches the general character of the subject. Small amounts of dissimilar pigment can be mixed with this basic pigment for variations in hue and consistency. And small areas of a dissimilar pigment quality can be used for contrast. Here are some examples of combinations you can use in a painting.

TRANSPARENT/OPAQUE

Have you ever noticed how Turner in his marvelously atmospheric watercolors almost always placed an opaque gondola, cow, or tree in the foreground of his design? These small dense accents make his predominantly transparent paintings seem even more vibrant and spacious. In fact, without small areas of opacity, a glazed, transparent painting will look weak and thin.

OPAQUE/TRANSPARENT

You can use small areas of transparency to emphasize the weight and density of an opaque painting. For example, in a predominantly opaque painting of a marsh and muddy riverbank, you might use several light, transparent boat forms for contrast. Because transparent areas are generally more attractive than dense opaque areas, these contrasting accents should be carefully planned and positioned. They'll probably be the focus of the painting.

OPAQUE/STAINING

For contrast in a predominantly opaque painting, you can use small areas of staining pigment. For example, you could convey the weight and texture of a corn crib by using opaque pigments and paint the darker cracks and openings with intense stains.

However, when combining these two pigment groups, you should be aware of the enormous difference in their intensity. If you use stains for contrast, place them on or near areas of primary interest. Or mix and apply them with great restraint.

STAINING/OPAQUE

You can use small areas of more neutral opaque pigment as contrast to the transparent intensity of stains. For example, you could accentuate the blazing intensity of a desert sky by including the opaque silhouette of adobe buildings and dark skyline. Although opaque stains and opaque sedimentary pigments are quite different in intensity, they are similar in consistency. You can combine or intermix these two groups, but you'll find there is little difference in their surface quality.

STAINING/NONSTAINING TRANSPARENT

This is the least effective combination. The difference in intensity between nonstaining transparent pigments and staining pigments limits the possibilities for combining these two groups. The contrast between the subtle, attenuated hues of the nonstaining transparent pigments and the overpowering intensity of stains is more disturbing than effective.

CALIFORNIA WOODS
by Christopher Schink.
Watercolor on Arches 300-lb rough,
21" × 29" (53 × 74 cm).
Collection of the artist.

California Woods was based on sketches I made in the foothills near my home. I was interested in the shapes and patterns and the contrasting surface qualities in a group of large trees. To convey these qualities, I used contrasts in pigment consistency, playing dense, opaque areas against passages of more intense, transparent stains. Areas of non-staining transparent, opaque, and staining pigments can be used in the same painting to create contrasting surface qualities. Here, I've used a triad of opaque pigments for the cool, neutral trunk forms. For the warmer areas of negative space, I used combinations of alizarin crimson, Winsor red, aureolin, and viridian. The weight and density of the tree trunks are accentuated by the more transparent and intense areas of negative space.

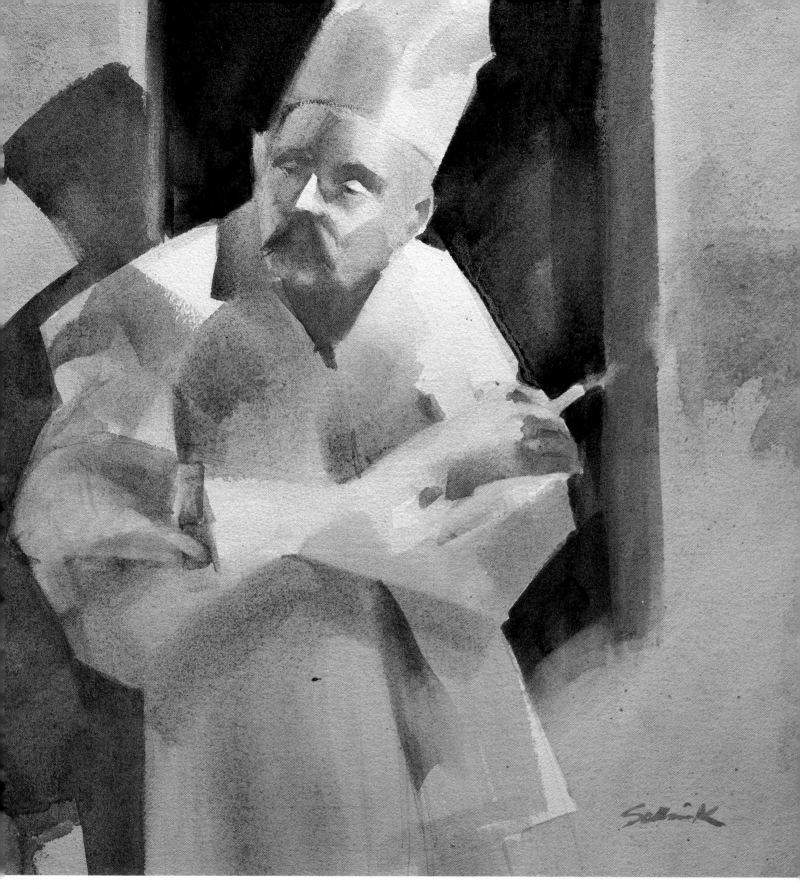

THE CHEF
by Christopher Schink.
Watercolor on Arches 300-lb rough,
21" × 29" (53 × 74 cm).
Collection of John and Nancy Van Natta,
Palo Alto, California.

While waiting at a stoplight, I noticed this cook taking his afternoon break. I was excited by the pattern of his sunlit figure framed in the dark doorway and his relaxed pose, so back in my studio, I made several sketches from memory. To emphasize these qualities in my painting, I used contrasts in value, color, and pigment quality. Small areas of dissimilar pigment consistency can be used to create interest and focus in a unified design. Here, I painted the face and shadows on the figure and wall with non-staining transparent pigments—rose madder genuine, aureolin, cobalt blue, and viridian. For the rest of the painting I used opaque pigments—yellow ochre, Indian red, cerulean blue, French ultramarine, and cadmium red—along with small amounts of alizarin crimson for the dark doorway. The contrast in surface quality between the transparent figure and the opaque background heightens the effect of sunlight and shadow.

APPLYING THESE IDEAS

You must plan contrasts in pigment consistency as you would contrasts in value or color, placing them on or near areas of primary interest. Areas of the predominant and contrasting pigment quality should be designed and apportioned to create a sense of unity, variety, and contrast.

To do this, take a few minutes before painting to identify your subject and the specific qualities that interest you. Ask yourself which pigment group best describes the qualities you wish to convey, and if the use of a dissimilar pigment group would help emphasize these qualities. Then, if you decide to use two different pigment groups, decide which will predominate and where subordinate areas of contrast will occur. Plan these areas carefully. If they're relatively light, transparent or intense, they'll attract the viewer's attention.

For example, if you're excited about the weight and silvery gray texture of the side of an old wooden barn, for the major portion of the painting you could use opaque sedimentary pigments. Then, after you have established a predominant surface quality, you might add a few carefully designed areas of dark staining pigment—suggesting a portion of a window, a crack, or a nailhole—to provide contrast and focus.

But that is not the only way to paint the subject. You might decide instead to take a distant viewpoint of the same rural setting and convey the illusion of light and atmosphere by using glazes of nonstaining transparent pigment. Opaque pigments could then be used for the greatly reduced area of the barn and field. The contrast in pigment consistency would accentuate the general transparency of the painting.

As you can see, there are innumerable possibilities for combining contrasting pigment qualities within the same subject. If they are thoughtfully planned, they can greatly enhance the expressive quality of your painting.

CRITIQUE

Did you plan where and how to use contrasting pigment qualities? Or did you simply match the surface qualities of the various elements in your subject? A painting can contain two (or, on occasion, three) different pigment groups, but the areas of each must be carefully planned and designed. Simply matching the various surface qualities of your subject won't work. For example, the contrast in surface quality of a still life painted with nonstaining transparent pigment for the flowers, intense stains for the leaves, and opaque pigments for the pot will be disturbing. To be effective, dissimilar pigment groups must be combined to create a sense of unity and contrast.

If you have problems organizing dissimilar pigments, plan in your next painting to establish first a predominant surface quality using a single group of pigments. It may not match every element of your subject, but it will create a unified surface into which small areas of contrasting pigment can be effectively introduced.

Do your areas of contrasting pigment quality accentuate or detract from the predominant surface quality of your subject? Areas of contrasting pigment should be carefully apportioned and placed, especially when they are more intense or transparent than the general surface of the painting. Bright or transparent areas are inherently more interesting than neutral or opaque areas. They will immediately attract and focus the viewer's attention. If used for contrast, they should be placed in or near areas of importance, not on the periphery of a painting.

For example, if you wish to accentuate the weight and mass of an old tugboat painted with opaque pigments, don't surround it with a large iridescent sky of glazed, transparent pigments or with a foreground of intense green water made with staining pigment. These contrasting areas will be more detractive than supportive. Instead, use opaque pigments for the major part of your painting and introduce dissimilar pigments in areas of importance—a transparent shadow or window on the boat's cabin or a dark, intense cabin doorway. These contrasting areas should enhance, not detract from, the predominant surface quality of your subject.

COMBINING METHODS

Just as you can achieve different effects and emphasis by using a variety of pigment qualities within the same subject so you can convey the contrasting qualities of a subject by using a combination of methods. For instance, to capture the weight and density of a desert landscape, you might begin your painting using opaque pigments in the wet-in-wet method and complete it with a series of glazes for the shadows and sky. Or you might begin an alpine landscape with atmospheric glazes of transparent pigment and add the soft-edged forms of the mountains using a wet-in-wet method. Different methods can be used in the same painting to create a variety of expressive effects.

As we have seen, there are three basic ways of applying watercolor pigment—the direct or alla prima method, the indirect or glazing method, and the wet-in-wet method. The method or combination of methods you use in a painting is determined by the qualities in your subject you wish to convey and the pigments you select to convey them. Variations or contrasts in surface quality, transparency, and edge can be achieved by combining the three basic painting methods.

Here are several of the many combinations of methods that can be used. Note in the two sketches at right—and in any painting with strong darks, texture, or brush calligraphy—the final stages are applied using the direct method.

GLAZING PLUS WET-IN-WET

To attain a light, atmospheric quality, you can begin a painting with a series

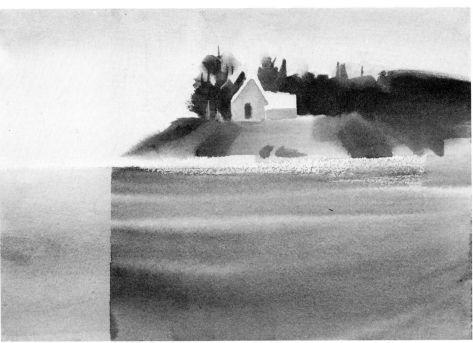

Glazing followed by wet-in-wet.

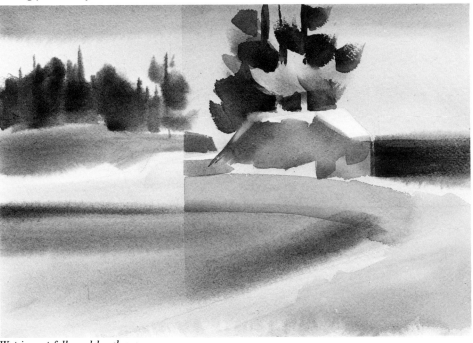

Wet-in-wet followed by glazes.

Glazing Procedure.

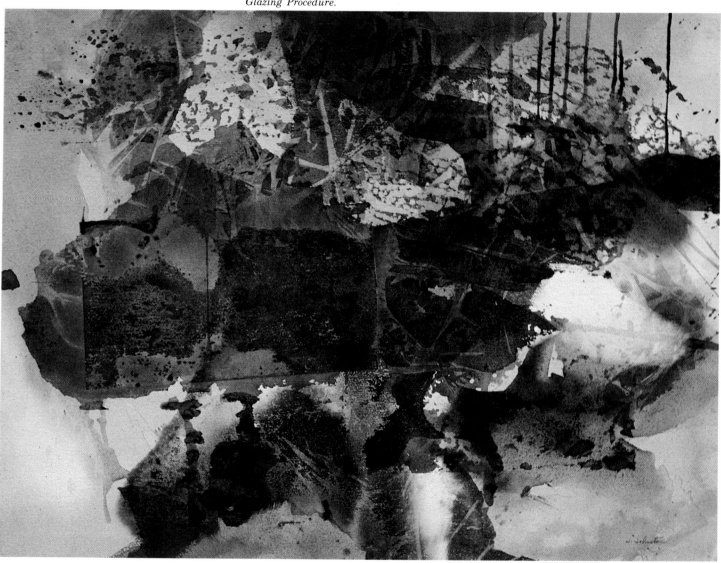

ROCK IMAGES
by June Johnston.
Watercolor on Arches 300-lb cold press paper,
22" × 30" (56 × 76 cm).
Collection of the artist.

June Johnston's creative and adventurous use of watercolor is based on a firm understanding of the medium and an imaginative sense of design. In this painting, she has used a combination of methods—direct and indirect—to create a work that has both a subtlety and spontaneity that reflect her response to the landscape. She began her painting (as shown above in the accompanying illustration) with a series of transparent glazes using aureolin, rose madder genuine, and cobalt blue. Onto this atmospheric background, she applied combinations of staining pigment and burnt sienna using a variety of tools—sponges, glass, mat board, and plastic wrap—to create overlapping, naturalistic forms that appear neither contrived nor gimmicky. With a combination of methods and imaginative means, she has created an expressive and exciting painting.

of glazes using nonstaining transparent pigments. To achieve a soft-edged effect in small areas of middle value or darker (a skyline, reflections in water) you can use the wet-in-wet method, adding moist pigment to the last wash of your glaze.

If your subject requires more extensive use of the wet-in-wet method, you can rewet your paper (when the last glaze has completely dried) by applying clean water with a soft brush or spraying it with an atomizer. You can even dip the painting, board and all, into a tub full of water. After rewetting, be sure you allow the water to soak into your paper before you begin your wet-in-wet painting.

In the first sketch on page 101 I began with a series of glazes (seen on the left) and rewet the paper for middle and middle darks, applied wet-in-wet on the right.

WET-IN-WET PLUS GLAZES
To capture the weight and solidity of a subject, you can begin a painting using opaque pigments in the wet-in-wet method. When your paper has completely dried, you can add glazes of nonstaining transparent pigment to adjust the color and create a more luminous surface quality. For example, glazes could be applied to a wet-in-wet sky or water to create a transparent effect. Glazes can be used to create more sharply defined edges that will be the focus of the viewer's attention. Adding a glaze will not significantly change the value of your

wet-in-wet underpainting, so be sure you have developed at least some areas of middle value before your wet-in-wet wash dries.

I began the second sketch (page 101) on thoroughly wet paper using the wet-in-wet method. Working from light to dark, I suggested the general value, form, and local color of each element (as shown on the left). On the right, I completed the painting with a series of glazes on the sky, field, pond, and rocks. I used the direct method to add the trees' strong darks.

GLAZING OR WET-IN-WET PLUS THE DIRECT METHOD
You'll probably use the direct method in almost every watercolor you do. To complete the last steps of a painting,

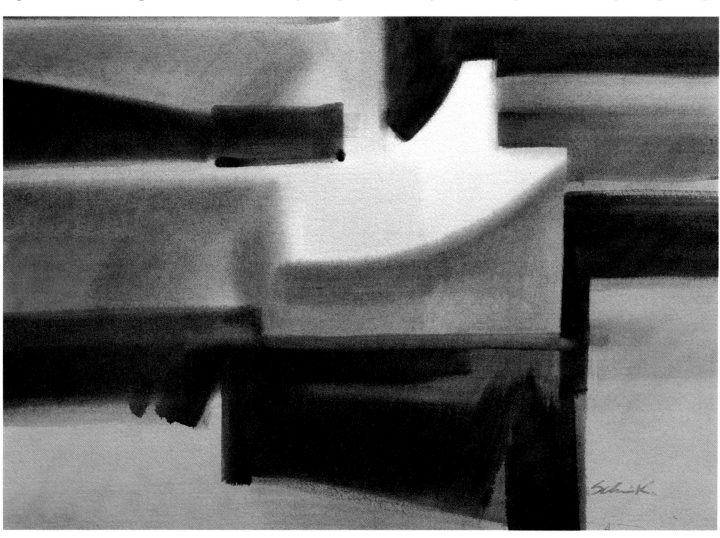

PETE'S HARBOR SERIES NO. 5
by Christopher Schink.
Watercolor on Arches 300-lb rough paper,
21" × 29" (53 × 74 cm).
Collection of Mr. and Mrs. Erik P. Larsen,
Los Altos, California.

In this painting, one of a series I've done based on boat forms, I was interested in the play of light and shadow on a small sailboat framed against a dark pier. To convey the contrast in value and surface quality of my subject, I used a combination of methods. I began the painting wet-in-wet, establishing the simple pattern and forms with opaque pigment and a predominance of yellow ochre. For stronger contrasts in value and edge, I painted the background and reflection in a direct method using a combination of staining and opaque pigments. When dry, the surface of a wet-in-wet or direct painting can appear dull and flat. Here, I added a series of transparent washes in an indirect method (glazing) for greater transparency and luminosity. The method or combination of methods you use in a painting are determined by the qualities you wish to convey and the pigments you select to convey them.

DIRECT METHOD PLUS GLAZING OR WET-IN-WET

You'll find these combinations less useful, especially if you have used stains for your direct painting. As I explained in Lesson Twenty, stains are difficult to control or ineffective when used in a wet-in-wet or glazing method. In the direct method, they're usually so intense that the addition of a transparent glaze will have little effect on them. And if you add opaque pigment wet-in-wet to a direct stain painting the colors usually appear muddy and dull. However, a direct painting done with opaque or non-staining transparent pigments can be modified with small areas done in a glazing or wet-in-wet method.

APPLYING THESE IDEAS

If you haven't had much experience with watercolor, start by trying some of the easier method combinations—for example, glazing, then finishing with direct painting, or working wet-in-wet and then glazing. When you've developed some control and feel comfortable with these techniques, experiment with other combinations.

In any case, before starting a painting, be sure you plan where and how you'll use each method. Determine what the predominant quality of the painting will be and which method will be used first. Decide where contrasts in edge and transparency will be placed to attract the viewer's attention.

At first, plan and employ each technique as a separate procedure to be completed before a second or third method is used. Then later, when you have gained some experience with these simple combinations, you can begin to interpose different methods. For example, in one of the glazes used for the water in an atmospheric harbor scene, you could add opaque pigment in a wet-in-wet method (in other words, while the transparent glaze is still wet) to suggest soft-edged reflections in the water. Then, you could continue glazing and complete the painting with some direct painting. By combining methods you can produce a multitude of effects that will enhance the expressive qualities of your painting.

you can add detail, small accents of dark, texture, and brush calligraphy with the direct method. You can also add more extensive areas of direct painting to underpaintings done wet-in-wet or with glazes. For example, to capture the light and atmosphere of sailboats in a sunny harbor, you can begin your painting with a series of glazes and, when they have dried, add the middle to middle-dark buildings and docks using the direct method. The contrast in surface quality and edge between the more atmospheric glazed areas or the softer forms of a wet-in-wet and the more sharply defined areas of direct painting will focus the viewer's attention.

CRITIQUE

Did you use a combination of techniques as part of a preconceived plan or simply as an attempt to salvage a failing painting? Watercolor is a difficult medium to control and results are often unpredictable. On occasion you may have to resort to a combination of methods to save a failing painting—for example, adding direct painting to a wet-in-wet that has dried too light or softening the disturbing edges of a glaze by superimposing softer forms painted wet-in-wet. Sometimes it works, but for a combination of methods to be truly effective, the contrasting qualities of each technique must be planned before a painting is begun.

Do you have difficulty integrating areas painted with different methods? If your glazes seem to separate and float above your wet-in-wet underpainting, or if wet-in-wet additions seem dull and muddy, you're more likely to be misjudging values than to be mishandling a technique. If you're using the wet-in-wet method first, be sure you have established some areas of middle and middle-dark value in your underpainting before adding a glaze or doing any direct painting. These darker areas will support any transparent additions. On the other hand, if you're using a series of glazes for your underpainting, when you add areas of opaque pigment using the wet-in-wet method, be sure that they are darker in value. Light, opaque paint on a transparent background will seem dull and muddy.

LESSON TWENTY-THREE
MIXING VARIATIONS

You don't need to buy a tube of every new or exotic pigment that comes on the market to have varied and distinguished color in your painting. With practice, you can mix an almost unlimited assortment of hues using just the primary pigments (triads) of each pigment group on the basic palette to reproduce almost any hue found in nature or in a tube.

There are several advantages in using primary pigments to mix the light to middle-value hues of your painting: (1) You can reproduce the exact hues of your subject with greater accuracy. (2) You can combine pigments to match not only the hue of

your subject, but also the surface quality. (3) You can increase as well as reduce the intensity of a mixed hue.

Any one of the triads of the three basic pigment groups (nonstaining transparent, opaque, and staining) can be used to mix a variety of hues. The primary pigments in each triad are equally matched in consistency and intensity and so when mixed, one pigment will not overpower another. Also, each triad will produce hues with distinctly different surface qualities that can be matched to the general characteristics of a subject—light and atmospheric, heavy and dense, or intense and powerful.

The following examples illustrate how each triad can be used to mix variations in hue. To suggest the approximate proportions of each mixture, the ingredients have been painted in varying sizes in the accompanying diagrams. Just a brief reminder: Secondary hues (orange, green, and purple) are made by mixing any two primaries in equal proportions. Tertiaries—red-orange, red-purple, yellow-green, yellow-orange, blue-green, and blue-purple—are made by mixing a secondary hue with its neighboring primary or by mixing two primaries in unequal proportions.

TRANSPARENT NONSTAINING TRIAD MIXTURES

The triad of rose madder genuine, aureolin, and cobalt blue is by far the most useful. These pigments are not only nonstaining and transparent, but more important, they are close in hue to the true primaries on the color wheel. They can be mixed to produce the widest variety of intense, transparent light to middle-value hues. Their principal limitation, however, is their value, which ranges only from light to middle tones.

Mixing any two of these primaries in unequal amounts makes intense, transparent tertiaries. In the first row there is a blue-purple, a red-purple, and a yellow-orange; and in the second row, a red-orange, a yellow-green, and a blue-green have been mixed. The hue of any of these tertiaries could be subtly shifted by increasing the amount of one of the primaries. By varying the proportions of all three primaries, you can also mix a large assortment of distinctive and subtle hues to match the slightly grayed hues found in nature. In the third row hues have been created by using all three of the transparent triad pigments.

OPAQUE TRIAD MIXTURES

Because of the low intensity of the opaque primary pigments—yellow ochre, cerulean blue, and Indian red—this triad will produce only a limited number of moderately bright hues.

Row 1. Mixing tertiaries with the transparent triad.

Row 2. Making more tertiaries with the transparent triad.

Row 3. Mixing neutrals with the transparent triad.

However, many of the grayed earth-like colors made with this triad are useful in landscape painting. The opaque triad can make grayed, opaque secondaries (see the fourth row of mixtures). But because these pigments are essentially neutral, the possibilities for mixing intense variations are limited. Even when mixed in unequal amounts, combinations using all three primaries will be relatively gray.

STAINING TRIAD MIXTURES
A fairly large number of variations in hue can be produced with the staining triad—Winsor yellow, Winsor blue, and Winsor red. And, with the exception of purple hues, mixtures in a full range of intensities can be attained with these pigments.

In the fifth row secondary hues have been mixed using the staining triad of Winsor blue, Winsor red, and Winsor yellow. Because Winsor red and Winsor blue are slightly on the yellow side, they will not make an intense purple. But they can be combined with Winsor yellow to make an assortment of intense oranges and greens. In the sixth row, all three of these staining primaries have been combined to produce grayed hues. If the amounts of the hues are carefully apportioned, this triad also will produce a useful assortment of rich, slightly opaque browns and greens or intense darks.

Row 4. Creating grayed secondaries with the opaque triad.

Row 5. Mixing grayed secondaries with the staining triad.

Row 6. Making neutral hues with the staining triad.

APPLYING THESE IDEAS

If you have come to rely on a group of premixed tube colors such as sap green or burnt umber for color variations in your paintings, you'll find that mixing hues with just primaries will require some practice.

Start by experimenting on a practice sheet—a scrap of watercolor paper or the back of an old painting will do—and mix simple combinations of two of the nonstaining transparent primaries. To begin with, combine them in equal amounts and try a brushstroke on your practice sheet. Label each mixture for future reference. Then, gradually increase the amount of one of the pigments and test it on your practice sheet. Reverse the dominance of the two pigments and test the results. Repeat this process with different combinations of two of the three transparent primaries.

For greater variation, try combinations of all three transparent primaries. Mix them in unequal amounts with one primary dominant. Also try combinations with two dominant primaries. Then repeat this process with the other two triads. Be sure to label each combination on your practice sheet. You can use it as a guide for mixing possibilities when painting on location.

CRITIQUE

Are you unable to mix the exact hue you want using just primaries? Although a great many of the hues you'll use in a painting can be mixed with a single triad, some hues will require other pigments. To mix these you can use any of the pigments on your palette or even intermix different triads. Just be sure that the resulting mixture is compatible with the general consistency and intensity of your painting.

When you mix hues using the three primaries of a triad do you invariably get a gray? If you seem to get a gray every time you try to mix a subtle hue, it's probably because you're combining all three primaries in equal amounts. Remember: adding even a small amount of its complement to a hue will gray it. Combining equal amounts of a matched triad will produce a completely neutral gray.

Next time you need a slightly neutral hue, start by mixing an intense secondary or tertiary, then add a small amount of the third primary to modify its hue and intensity. For example, if you want an earthy brown, start by mixing an intense orange, then add small amounts of blue to gray it.

LESSON TWENTY-FOUR

MIXING GRAYS

While mixing variations in hue, you may have discovered that an attractive and varied assortment of gray and neutral hues can be made by combining nearly equal amounts of all three primaries in a triad. Each triad—nonstaining transparent, opaque, and staining—will produce mixtures with distinctly different pigment qualities that can be matched to the surface quality of a subject or be used as a design element in a painting to accentuate the intensity of brighter hues.

PREMIXED GRAYS

There are a number of grays and neutral hues available in premixed tube form that are popular with watercolorists. For an experienced painter, they offer no advantage other than convenience. With the exception of Davy's gray (which can be closely duplicated with opaque pigments), each is simply a manufactured combination of standard pigments darkened with lamp black. For example, Payne's gray is made by combining alizarin crimson, Prussian blue, ultramarine, and lamp black. Sepia is a mixture of burnt sienna and lamp black. Neutral tint and indigo are combinations of alizarin crimson, Winsor blue, and lamp black. The presence of lamp black limits the usefulness of these manufactured combinations. Lamp black not only sullies other pigments in a mixture, but also produces a dull, sooty surface quality when it dries.

MIXING GRAYS WITH TRIADS

Although it's possible to duplicate any of the popular premixed grays with the pigments in the basic palette (and lamp black), a more varied and luminous assortment of neutral hues can be made by combining any of the three triads. Each triad is comprised of three primary pigments that are similar in consistency and intensity. Combined in equal amounts, these pigments make a totally neutral gray. But by varying the proportions of one or two of the pigments, they will produce an assortment of distinctive neutral hues.

MUD VERSUS NEUTRAL HUES

Even the mention of "mud" strikes fear into the hearts of some inexperienced watercolorists! To avoid any possibility of mixing the dreaded stuff, they rely entirely on premixed grays for the neutral hues in their paintings. Their anxiety probably is based on a misunderstanding of what makes mud.

The only difference between mud and a neutral hue is how each is used in a painting. What painters describe as mud is simply a large area of unrelieved, opaque neutral hue usually middle to middle-dark in value. Whether mixed on a palette or applied directly from a tube, any large area of neutral hue will seem unattractive and monotonous without some areas of contrasting value, intensity, or transparency. When carefully designed and apportioned, areas of neutral hue (or, if you prefer, "mud") can be used to capture subtle and expressive effects or to accentuate more intense or transparent hues.

The following hues are examples of some of the grays and neutral hues that can be mixed with the three triads. Entirely different hues could be produced by varying the proportions of any of these mixtures.

MIXING NEUTRALS WITH THE NONSTAINING TRIAD

In the first two rows of the mixtures illustrated in this lesson, aureolin, rose madder genuine, and cobalt blue have been mixed to produce a series of transparent neutral hues. I began by combining all three primaries in equal amounts, and then, for variations in hue and intensity, I altered the proportions. Grays made with these pigments have great transparency and luminosity. They can be used as glazes to create atmospheric effects or to modify underlying colors.

The exact hue of a gray and its effect in a painting are difficult to judge on the palette but must be seen in relation to other colors on the painting. Small areas of intense complementary color have been added in these examples to illustrate how neutral hues—mixtures you might normally discard as muddy or dirty—can be used in a painting to accentuate brighter hues by contrast.

MIXING NEUTRALS WITH THE OPAQUE TRIAD

The three primaries of the opaque triad—yellow ochre, cerulean blue, and Indian red—are already somewhat neutral and therefore require little mixing to become totally gray. Neutral hues made with the opaque triad have a rich consistency that is especially useful in landscape painting. I added a small area of intense color to the last sample in the third row for contrast.

Row 1. Mixing neutrals with the nonstaining triad.

Row 2. Altering the triad proportions for variety.

Row 3. Mixing neutrals with the opaque triad.

Since a large unrelieved area of neutral hue painted with opaque pigments can appear monotonous and muddy, in the fourth row the opaque triad has been used to create subtle variations within each neutral hue. In the first example on the fourth row, interest has been created through a slight gradation of the hue. In the second example, a granulated effect was achieved by gently rocking the board while my wash was still wet. In the last two examples on the row,

more abrupt shifts in hue were made to suggest the surface variations found in natural elements of the landscape.

MIXING NEUTRALS WITH THE STAINING TRIAD

Because each of the staining pigments actually stains the other, the staining primaries—Winsor yellow, Winsor red, and Winsor blue—can be easily mixed to gray, as shown in the fifth row. It is difficult to judge the value

of neutral hues made with stains when they're wet because they dry lighter and less intense than when first applied.

The staining triad can also be used to make a variety of grays and neutral hues in the middle and middle-dark value range. The sixth row of examples shows several neutrals mixed with the staining triad that are similar to popular premixed colors: Payne's gray, sepia, and neutral tint, respectively. A large assortment of

Row 4. Creating subtle variations of neutrals.

Row 5. Mixing neutrals with the staining triad.

Row 6: Making popular neutral colors with stains.

useful dark grays can also be produced by combining this triad with small amounts of other pigments from your palette.

APPLYING THESE IDEAS

If you've had any experience with watercolor, you'll know that mixing grays is easy. After fifteen minutes of painting, your palette is covered with them! But learning to mix them to the desired hue and consistency takes practice. So before you begin painting, try mixing variations of gray and neutral hues on a practice sheet—such as the back of an old painting or a piece of sketch paper.

The procedure for mixing them is relatively simple. To mix a perfectly neutral hue, select one of the three triads (the opaque and staining triads are easiest to mix) and combine the three primaries undiluted and in approximately equal amounts. To judge its hue and intensity, add a small amount of water to the edge of this mixture and try a brushstroke on your practice sheet. It will probably be slightly off neutral, with one (or two) of the primaries predominating. To neutralize the predominant hue,

add a small amount of complementary hue. For example, if the mixture appears greenish, add a small amount of red. Then test it again. Several adjustments may be necessary before you achieve a perfectly neutral gray.

You can now use this perfectly neutral gray as the basic component of a color and add small amounts of one or two of the primaries to it as desired to vary its hue and intensity. To control its value, just vary the amount of water you use to dilute each mixture.

Now repeat this process with the other two triads. When these grayed hues have dried, try painting some areas of intense complementary color next to them. Observe how hues of contrasting intensity interact in a painting. For examples of how grays or neutral hues can be used in paintings, see *Prospect Harbor* (Lesson One) and *Gray Harbor* (Lesson Seventeen).

CRITIQUE

Do you use Payne's gray, sepia, or neutral tint because they're conveniently packaged? The convenience and uniformity of the popular premixed grays are, in a sense, a disadvantage. If you automatically reach for your

tube of Payne's gray whenever you need to paint a cloudy sky, gray barn, or distant mountain, the color in your painting will probably be undistinguished and predictable. Until you've gained some experience, mixing grays with primary pigments will take more time, but the hues you produce will be more varied and expressive than any gray you squeeze from a tube.

Do you have a favorite combination of complements you use for all your grays? There are several combinations of complementary pigments that can be used to make grays: French ultramarine and burnt sienna, Winsor red and Winsor green, cadmium red and Winsor blue. They're quick and simple to mix, but the possibilities for variation in hue, intensity, and consistency with these mixture is limited. Grays made with a set formula of complements can be discordant or monotonous. Don't rely on a single combination for all your grays. Try to mix your neutral hues to match the hue and consistency of your subject, or use them to accentuate the expressive qualities of your design.

LESSON TWENTY-FIVE

MIXING DARKS

Darks are not simply inky blue accents you add at the end of a painting. They are an important part of a painting's color scheme and should be as distinctive and varied as any light or middle-value hue. A large assortment of deep darks can be made by combining two or three of the darkest pigments on the basic palette. The pigment consistency as well as the hue, value, and intensity of a dark mixture can be adjusted to match the character of the subject or to accentuate the hue or surface quality of lighter areas.

JUDGING DARKS

It is harder to identify the exact hue of a dark area than that of a light or middle-value one. This is because the *amount* of light reflected from a dark is limited, and therefore the *type* of light (hue) it reflects is less easily distinguished. To an untrained eye, all darks will appear gray and neutral, but they're not. Actually the darks observed in nature are almost as varied in hue and intensity as light or middle-value areas. Here are several simple tricks to help you distinguish the hue and intensity of a dark:

1. Before trying to judge the color of an area, rest your eyes. Then look quickly at your subject and note your first impression. The color rods in your eye are quickly fatigued, so the longer you stare, the less color you'll be able to see.

2. If you're still having trouble identifying the hue of a dark area, hold something perfectly neutral (like the black handle of a brush) against your subject and make a comparison. You'll soon see that darks are not all neutral gray or black. They're filled with color.

SELECTING THE RIGHT PIGMENTS

In order to produce a dark mixture, you have to use at least one dark pigment as an ingredient. Combining two middle-value complements (for example, cadmium red and cobalt blue) will produce a hue that is low in intensity but not in *value*. Don't confuse grays (intensity) with darks (value). To make a dark, you need dark pigment.

Winsor blue and Winsor green are the two darkest pigments on the basic palette. Alizarin crimson, burnt sienna, French ultramarine are slightly lighter and cadmium red, viridian, and Winsor red are middle-value hues. Any of these pigments can be intermixed or combined with lighter hues to make a wide variety of middle darks and darks.

I painted the following examples to illustrate how dark pigments can be combined in a variety of mixtures. They are not intended as formulas (to be used in place of Payne's gray or neutral tint and applied in every painting), but only as examples of the many darks that can be mixed with the pigments from the basic palette.

USING STAINS

The deepest darks are produced by combining Winsor blue, Winsor green, and alizarin crimson. A limited number of extremely dark hues can be made by mixing any two of these pigments in unequal proportions—a red or blue purple, a dark green or red, a green-blue or blue-green (see the first row of mixtures on page 114). Undiluted, these mixtures will appear to be almost black. They are less effective when lightened or diluted because of their low intensity and lack of warmth.

USING STAINS AND OTHER DARKS

A greater variety of dark hues can be made by combining alizarin crimson, Winsor blue, or Winsor green with other dark pigments on the basic palette. In the second row alizarin crimson has been combined with French ultramarine to make a dark purple, the dark green is a combination of Winsor green and burnt sienna, and the opaque warm dark has been made by combining Winsor blue and Winsor red.

USING DARK AND MIDDLE-VALUE PIGMENTS

Variations in hue and consistency can be achieved by mixing dark stains with middle-value pigments. In the third row alizarin crimson has been combined with burnt sienna and a small amount of Winsor green to produce a warm, dark transparent brown. The more opaque blue-green was made with Winsor blue, Indian red, and a small amount of Winsor green, and a dense, warm green has been made by combining Winsor green, cadmium red, and a small amount of alizarin crimson.

DISTINGUISHING DARKS FROM NEUTRALS

A common mistake in mixing darks is to think of them as being neutral (or, at best, an inky blue-gray). They're not. Darks can be filled with saturated color that repeats or accentuates the lighter hues in a painting, but because they are low in value, their exact hue and intensity is difficult to judge. For example, in the fourth row, two dark squares have been painted—one totally neutral and one fairly in-

tense. On your palette they might appear similar, but when used in a painting, their effect on other colors would be quite different. To illustrate how an intense dark can be used to accentuate a light hue, two areas of light yellow have been painted in the middle of two squares, one a neutral and the other an intense dark. Because of the contrasting color of its background, the yellow on the right seems more luminous and vibrant.

USING COMPLEMENTARY DARKS

By mixing dark hues that are the complement of lighter areas (for example, a dark red on a light green) you can widely separate areas, creating the illusion of deep space. Complementary darks will also accentuate the hue, intensity, and value of lighter areas (see Lesson 27).

Complementary darks are particularly useful in landscape painting—for example, a dark green doorway in a red barn, deep purple

Row 1. Mixing darks using stains.

Row 2. Making darks with stains and other dark pigments.

Row 3. Creating darks with dark and middle-value pigments.

cracks in warm, yellow rocks, or the deep brown interior of a cool gray shack. In the fifth row, the background of each of these designs has been painted with a complementary dark that accentuates the lighter hue of the naturalistic form.

USING ANALOGOUS DARKS

By using darks that are closely related (or analogous) in hue to the lighter areas they surround or adjoin, you can create a shallower sense of space and greater unity of color. Analogous darks will fuse with lighter areas to suggest a more solid form. They can be used to create a sense of unity rather than contrast.

Analogous darks have many uses in landscape painting—for example, the dark cracks on the side of a weathered barn, the knotholes and recesses in an old tree trunk, or the dark foliage of a tree in shadow. In the sixth row of examples, closely related hues have been used for the dark design in each of these illustrations. The dark green is Winsor green and alizarin crimson. The dark red is alizarin crimson, burnt sienna, and Winsor green. The dark yellow (which is really *brown*, since a "dark yellow" can't be made with pigments) is made with alizarin crimson, burnt sienna, French ultramarine, and aureolin. Finally the dark blue is a combination of French ultramarine, Winsor blue, and burnt sienna.

Row 4. Distinguishing darks from neutrals.

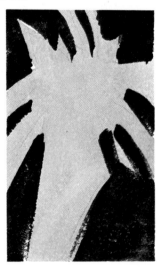

Row 5. Using complementary darks.

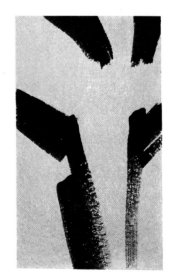

Row 6. Using analogous darks.

APPLYING THESE IDEAS

Before attempting to use any of these darks in a painting, practice this simple mixing procedure using the back of an old painting to test mixtures. Start with a clean, dry palette (even a small amount of water or light opaque pigment will dilute or muddy a dark) and plenty of fresh, soft pigment. Use a brush that doesn't hold much water—an Aquarelle or 1″ (25 mm) varnish brush works well—and shake it out before mixing your pigment.

For the deepest darks, mix combinations of the staining pigments, using just enough water to make your mixture fluid, and apply it to dry paper. For middle darks and variations in hue, combine any of the darker staining pigments with burnt sienna, viridian, French ultramarine, and Winsor red or cadmium red. If more warmth is needed in a mixture, include a small amount of aureolin. Avoid adding light opaque pigments such as yellow ochre, cadmium yellow, or cerulean blue. They'll make your dark mixture muddy.

Don't settle on one combination, but instead try for a variety of dark hues. With practice you can learn to mix darks that are as varied and distinctive as any of the lighter hues in your paintings.

CRITIQUE

Do your darks always seem to be too light or washed out? If you have trouble attaining deep darks even with the pigments I've suggested, it's probably because of your method of mixing and application. Weak or thin darks are usually caused by one of the following errors: (1) Too much water in your brush or on your palette. To avoid this, mix and apply darks with the minimum amount of dilution. (2) Too hard a pigment. You can't make a strong dark if your paints are rock hard, so start with plenty of soft, fresh pigment. (3) Too wet a surface. Make sure your paper is dry before adding strong darks because even the darkest pigments will dry light and thin if applied to wet or saturated paper.

Do you rely on a black or neutral mixture for all your darks? You may occasionally want to use a black or neutral mixture in your painting, particularly if you're working in a flat, abstract style. But for most paintings, neutral darks have one great disadvantage: they're neutral. Because of this, they will neither harmonize with nor accentuate the lighter hues in a painting. Therefore, in your next painting, try to make your darks as intense as possible. They can always be modified later with a wash of a complementary stain.

LESSON TWENTY-SIX

MIXING GREENS

If you have spent any time painting outdoors, you know that mixing greens that approximate those found in nature is an essential but difficult part of landscape painting. Although it is impossible to duplicate with pigments the infinite variety of greens found in nature, you can make a wide assortment of naturalistic greens by combining either viridian or Winsor green with any of the yellows, reds, or oranges on the basic palette in different combinations and varying proportions.

ANALYZING LANDSCAPE GREENS

The greens found in nature are not made simply with a combination of yellow and blue. Their colors vary enormously, but most contain far more warmth (yellow and red) than many painters realize. The varying colors of stems, branches, and trunks and the warm glow of reflected sunlight may all affect the actual hue you observe. Also, smooth-textured vegetation may reflect the cool, blue-violet cast of the sky. Then, some foliage may be light and transparent in quality, while other foliage may appear dense and opaque. Observing and analyzing these subtle differences in hue, value, intensity, and consistency is the first step in reproducing naturalistic greens.

SELECTING THE RIGHT PIGMENTS

By starting with pure green pigment—viridian or Winsor green—and adding varying amounts of primary colors to it, you can mix a full range of greens—from light to dark, warm to cool, intense to neutral—that approximate those seen in nature.

Viridian serves as an excellent basis for making naturalistic greens. In its pure state, it is an intense, cold green (more toward blue than yellow) with an unnatural appearance. It is relatively transparent, nonstaining, and middle dark in value. It can be modified with varying amounts of red, yellow, or orange to produce a great number of useful greens.

Winsor green can also serve as the basic component for a variety of greens, but its staining action and extreme intensity limit its usefulness. It can be used in small amounts to intensify greens made with viridian or as the major component in darker greens. Using viridian or Winsor green, I've mixed a number of naturalistic greens to illustrate how these two pigments can be combined with other pigments on the basic palette.

MIXING TRANSPARENT GREENS WITH VIRIDIAN

Unless your subject is a 1947 Studebaker, you'll find little use for viridian in its pure state (shown in the first row on the left). However, it can be warmed with varying amounts of aureolin and rose madder genuine to produce more naturalistic, transparent hues. The three mixtures to the right of it were made by combining viridian and aureolin. In the first example, mostly aureolin was used. The amount of viridian was gradually increased in the following two examples. The resulting mixtures have a glowing transparency that could be used to suggest fresh vegetation or sunlit foliage.

The second row of greens was mixed with viridian, aureolin, and a small amount of rose madder genuine. These are just four examples of the wide assortment of greens that can be made with these three pigments. By varying the proportions of these pigments, you can produce mixtures that range in hue from a light orangish green to a cool blue-green and in intensities ranging from brilliant to neutral. You can use variations of these mixtures to describe darker vegetation or fall foliage. By adding cobalt blue, you can also obtain a wide assortment of transparent violets, oranges, and browns with a naturalistic appearance (see Lesson Twenty-three).

MIXING OPAQUE GREENS WITH VIRIDIAN

Viridian also can be used as the basic ingredient in a large assortment of opaque greens. When combined with any of the warmer opaque pigments on the basic palette, viridian will produce mixtures of great weight and density. In the third row viridian has been combined with cadmium yellow, yellow ochre, cadmium orange, and cadmium red to produce four examples of the many opaque hues that can be made with it. You can use these greens to describe the density of a lush meadow or field, the weight of foliage on an oak, or the rich warm hues of an evergreen forest.

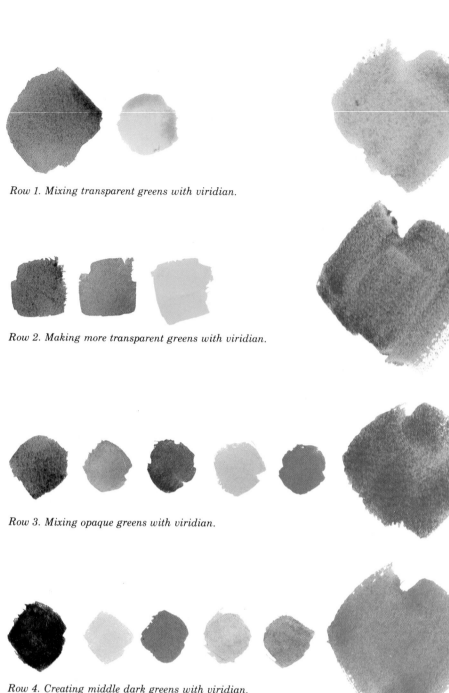

Row 1. Mixing transparent greens with viridian.

Row 2. Making more transparent greens with viridian.

Row 3. Mixing opaque greens with viridian.

Row 4. Creating middle dark greens with viridian.

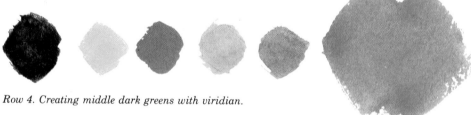

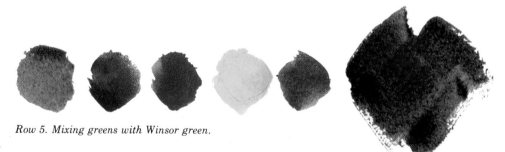

Row 5. Mixing greens with Winsor green.

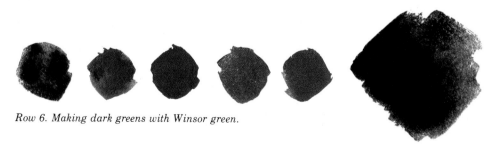

Row 6. Making dark greens with Winsor green.

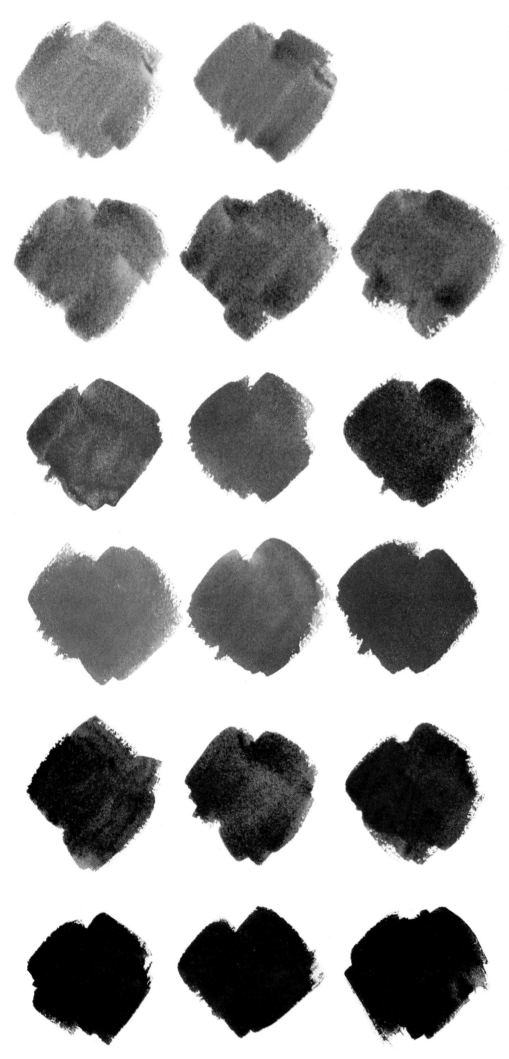

MIXING MIDDLE-DARK GREENS WITH VIRIDIAN

A variety of middle-dark greens, both transparent and opaque, can be made by combining viridian with any of the orange-reds or reds on the basic palette. In the fourth row I've mixed a few greens by adding Indian red, burnt sienna, and cadmium red to viridian. In the first example (viridian and Indian red) a small amount of aureolin was added for warmth and intensity. The proportions in the last two examples (viridian and cadmium red) were reversed to create a cool and warm green. You can use variations of these combinations for darker foliage, trees in shadow, or the warm interior of a woods.

MIXING GREENS WITH WINSOR GREEN

Winsor green is a cold, dark, transparent green with enormous intensity. For realistic landscape painting, it can be modified by adding large amounts of any of the warmer pigments on the basic palette. In the fifth row a small amount of Winsor green was combined with large amounts of (left to right) aureolin, cadmium yellow, yellow ochre, and cadmium orange, respectively. The resulting mixtures are examples of the light-middle and middle-value greens that can be made with this staining pigment. You can use greens such as these to describe the intensity of lush spring foliage or a sunlit meadow or marsh, but be sure they're compatible in intensity and surface quality with the rest of your painting.

MIXING DARK GREENS WITH WINSOR GREEN

The darkest greens are obtained by mixing Winsor green with any of the orange-reds or reds on the basic palette. In the sixth row, Indian red, burnt sienna, cadmium red, and alizarin crimson were added to this staining pigment. You can also make an almost-black green by combining alizarin crimson and Winsor green using a minimum amount of dilution. But be careful to reserve these dark-green mixtures for only the darkest shadows in foliage or for small accent areas because when diluted they'll appear cold and gray. For lighter variations of these hues, add small amounts of aureolin for warmth.

APPLYING THESE IDEAS

As an exercise, spend part of an afternoon outdoors on location practicing reproducing greens. Choose an area that has a variety of vegetation. Don't be concerned about finding a subject or composing a painting. The object of the exercise is to duplicate some of the greens found in nature.

Start with a clean palette and plenty of fresh pigment. Leave your tubes of Hooker's green dark, sap green, olive green, and the like at home. This is only an exercise, so use a scrap of watercolor paper or the back of an old painting.

Pick a small uniform area of green—for example, the sunlit part of a tree or field—and take a few seconds to analyze its hue, value, intensity, and consistency. Is it warm or cool, intense or neutral, dark or light, transparent or opaque? Try reproducing the color with combinations of the pigments I've suggested. Paint a small area of the mixture on your paper and hold it up to the green you're trying to match. Is it warm enough? Dark enough? Does it have the same consistency? Keep adjusting the mixture until you're satisfied. If the mixture becomes neutral or muddy, wash it off and start again. Then pick other elements—a bush, a shrub or a dark shadow—and repeat this process until you've filled the sheet with greens.

Remember: this is only an exercise to develop your skills in color mixing. In a painting, it's neither necessary nor even desirable to slavishly duplicate every color of your subject. However, capturing the characteristic colors of important elements can help reinforce the expressive quality of the work.

CRITIQUE

Do you make all your greens by combining primaries–yellows and blues? You may have been taught to make all your greens from scratch, by combining just primaries. And in theory, you should be able to produce a full range of greens by mixing blue, yellow, and small amounts of red. However, each of the blue pigments available has some disadvantages. Cerulean and cobalt blue are too light to produce dark mixtures. Winsor blue, because of its extreme intensity and staining action, makes greens that are often out of tune with the rest of a painting. French ultramarine, although relatively dark and nonstaining, is too opaque and purple to be used for naturalistic greens. Therefore, the most effective method of mixing a full range of greens is to start with a pure middle to dark secondary—viridian or Winsor green—and then add varying amounts of other hues to it.

Do your greens seem dull and cold when they dry? If your painting is filled with dull, cold greens—mixtures that looked all right on your palette, but then dried to the color of an old sofa—the explanation is simple: as a hue dries or is diluted, it becomes lighter and, consequently, less intense and colder. Therefore, to retain the warmth and intensity of a mixture, try using less water. Instead, lighten your greens by adding light, warm pigments—yellows and oranges.

JUDGING COLOR IN CONTEXT

No matter how attractive or unappealing a color may seem on your palette, its effectiveness in a painting can't be judged until it's actually applied. The appearance of a color—its hue, value, and intensity—is relative and is therefore affected by its surroundings. For example, a red barn in snow will not seem as warm and intense as the same red barn surrounded by bright green, but it will seem darker. This illusion—the modification of one color by another—is called *simultaneous contrast*. The fundamental principle of simultaneous contrast is that colors are modified in appearance by their proximity to other colors. To use color effectively in a painting, you should understand how this phenomenon works.

MODIFYING VALUE

A hue can be made to appear lighter or darker simply by changing the area that adjoins or surrounds it. For instance, in the sketch below I've painted a strong dark around the white boat form and have gradated and softened the edges away from the boat. Because of the difference in contrast, the white of the boat form appears to be lighter than the white on the edges of the illustration. In a painting you can use this simple illusion to accentuate light hues, thereby drawing attention to important areas.

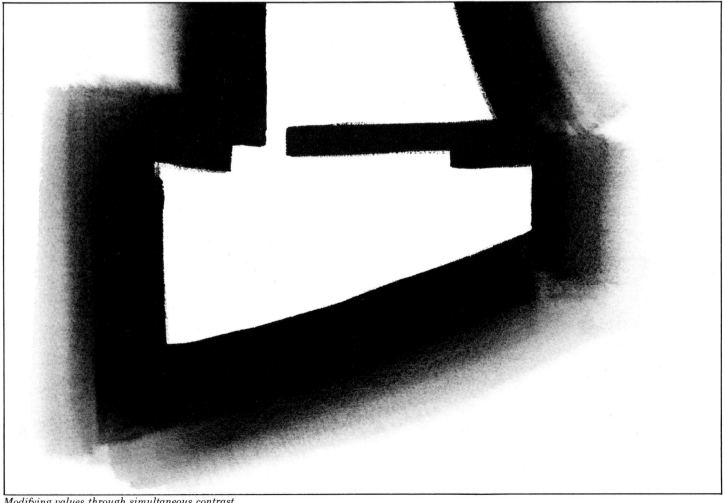

Modifying values through simultaneous contrast.

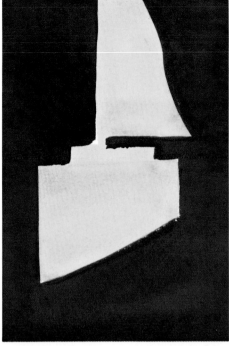

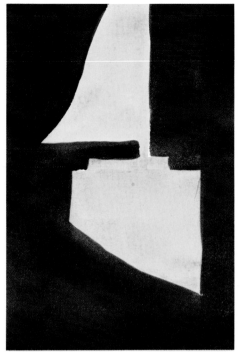

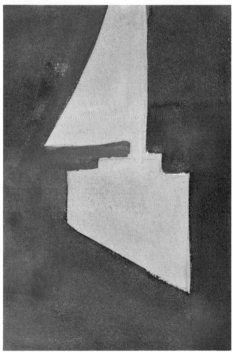

Modifying intensity through simultaneous contrast.

Modifying hue through simultaneous contrast.

MODIFYING INTENSITY

When complementary colors are placed side by side, they accentuate and enhance each other. A hue will appear to be more intense if it is adjoined or surrounded by its complement. For example, in the second sketch I've used the same yellow for both boats, but one is surrounded by a neutral gray background and the other by an intense purple—the complement of yellow. The contrast created by the complementary background makes the yellow boat on the right seem brighter.

MODIFYING HUE

Adjacent colors influence each other, causing each to appear to subtly shift in hue toward the complement of the other. For example, a gray shadow on a bright yellow object will appear to be violet. To illustrate this shift, in the third example I've painted these two boat forms with the same almost neutral gray, but used entirely different hues for their backgrounds. Compare the two gray boats. Each boat appears to be slightly different in hue. The blue background makes the boat on the left seem slightly warmer (moving in hue toward the complement of blue-orange) and lighter than the boat on the right. The other boat appears to be cooler (leaning toward blue) and darker because of its background.

APPLYING THESE IDEAS

When you're on location and facing an old barn and a blank sheet of paper, you probably won't spend much time thinking about the effects of simultaneous contrast. However, you can use the idea in this fundamental concept when painting to enhance or modify the color in your design. Here are a few simple applications.

JUDGING VALUES

Accurately judging the value of a mixture—how dark or light it will seem in your completed painting—is a skill you acquire with practice, but understanding the effects of simultaneous contrast will help. Remember: the value of a hue is affected by its background. That is, the same hue will appear darker on a light background and lighter on a dark background. In a painting, your initial washes may appear to be the right value when compared to the white of the paper, but when middle values and darks are added your first

LOG PILINGS NO. 2
by Christopher Schink.
Watercolor on Arches 300-lb rough paper,
22" × 30" (56 × 76 cm).
Collection of the artist.

I created this simple design (taken from an old sketch) to illustrate how the appearance of a color—its hue, value, or intensity—is altered by the colors surrounding or adjoining it. By "keying" colors—juxtaposing two contrasting or complementary colors—you can enhance the effect of both. For instance, here I've accentuated the warmth and intensity of the log ends by making the large nearby areas a cool, neutral gray and have used a deep brown for the dark interior that emphasizes by contrast the hue or value of the lighter areas. I placed small areas of blue-green in the log ends to make them seem more intense and warmer. Colors that, by themselves, might seem undistinguished or dull have been combined to create a forceful and vibrant color scheme.

values may seem too light. By anticipating this change in appearance and overstating the value of your first washes, you can more accurately reproduce the final values of your design.

MODIFYING LIGHTS AND DARKS

You can use the effects of simultaneous contrast in a painting as a device to modify misjudged values. By adding a small area of contrasting value, you can change the appearance of an area that is too light or too dark. For instance, if the barn you've painted seems too dark and dull, you can make it appear lighter and more luminous by adding several strong, dark windows. Or if the barn seems too light in your finished painting, you can make it seem darker by "lifting out" several rather light windows.

CREATING COLOR CONTRAST

Many painters use the term "keying a color" to describe the effects of simultaneous contrast. By introducing small areas of contrasting or complementary color, you can accentuate the hue and intensity of a predominant color. For example, you can make your painting of a lush, green forest seem even greener by adding a few reddish-brown tree trunks. Or you can accentuate the warmth of a dark brown interior by framing it with a cool gray doorway. Also, dull, monotonous areas can be animated by introducing small areas of contrasting color. For example, the unrelieved cool gray of a large barn can be enlivened by adding a few dark brown doorways and windows. In short, "keying colors"—playing complementary or warm and cool colors off each other—is an effective way of animating the color scheme of a painting.

CRITIQUE

Do you reject a mixture if it looks unattractive on your palette? There are times when a mixture—a garish red or a muddy gray—will seem unattractive on your palette but prove highly effective when used with other colors in a painting. A color can't be judged out of context. Before you wash away what you think is an unappealing color, paint a small area of it on a piece of scrap paper and hold it up to your painting. It may provide just the contrast your painting needed.

Have you tried to make the color in your painting more exciting by using a whole array of intense hues? Simply filling a sheet with bright colors won't produce an exciting painting. The results will more than likely be disturbing or chaotic. For color to be effective, it must be planned with areas of contrast—light against dark, warm against cool, intense against neutral—carefully designed to accentuate the important elements in the painting.

LESSON TWENTY-EIGHT

CREATING SPACE WITH COLOR

As an object recedes in space, it is viewed through an increasing amount of atmosphere, and so its hue, value, and intensity are altered. By reproducing these color changes—the effects of aerial perspective—in your painting, you can convey a sense of depth and distance.

To create the illusion of three-dimensional space in a realistic painting, you can mix and modify color following the rules of aerial perspective. Or, in an abstract or non-realistic work, you can reverse these rules to retain the inherent flatness of your paper and emphasize the two-dimensionality of your design. In either case, you should know and understand how distance and atmosphere modify the color of an object.

AERIAL PERSPECTIVE

I'm sure you're already aware of the general effects of aerial perspective. While painting on location, you certainly will have observed the difference in color between distant hills and trees and those directly in front of you. With a good "eye" and some experience in color mixing, you can duplicate these differences. Knowing precisely how color is modified by distance and atmosphere will help.

The atmosphere through which we view the landscape is filled with particles of dust and water vapor. Even over a short distance, these minute particles will alter the appearance of an object. For example, an apple ten feet away will not seem as warm, intense, or as round as an apple ten inches away. Over a greater distance or through denser atmosphere, such as fog and haze, these differences can easily be discerned. For example, distant mountains may be covered with the same warm green trees as those directly in front of you, but they will appear to be almost a neutral gray.

The rule of aerial perspective is as follows: As an object recedes in space and is viewed through an increasing amount of atmosphere, its appearance is altered in three ways:

1. Its *hue* becomes cooler, shifting (at great distance) to blue.

2. The *value contrasts* on it diminish, shifting (at great distance) to a uniform, middle value.

3. Its *intensity* decreases, shifting (at great distance) to an almost neutral hue.

Understanding the rules of aerial perspective will help you either emphasize or diminish the illusion of deep space in your painting.

CREATING THE ILLUSION OF DEEP SPACE

I've painted a simple seascape (page 126) to illustrate aerial perspective and how it can be applied in a realistic painting. The subject is three similar boats: one in the immediate foreground, one in the middleground, and one in the distant background. All three sit on a smooth, flat plane. As the boats and water recede in space, I've modified their hue, value, and intensity to emphasize their relative position in space.

For the boat in the foreground, I've used a full range of values, from black to white, and warm, intense color. (Warm, bright colors advance and cool, dull colors recede.)

For the middleground boat, I used a more limited value range—from off-white to middle gray. Compare the lights on it to those on the foreground boat; they're slightly darker. And to reinforce the illusion of distance, I used cooler and grayer colors.

I painted the most distant boat a uniform blue gray and eliminated all detail on it. This is because the color of an object seen at great distance or through dense atmosphere will shift to a cool, neutral middle-value hue. Also, because of the absence of contrast—dark to light, warm to cool, bright to dull—all detail is lost.

CREATING SHALLOW OR FLAT SPACE

It is difficult to paint a flat, two-dimensional design in watercolor. When applied in layers, the medium has a transparency and luminosity that immediately suggest distance and atmosphere. However, you can create a painting with limited or shallow space by consciously reversing the rules of aerial perspective.

If you want to work in a flatter, less realistic style, here are several ways you can modify color to limit the pictorial space in your painting:

1. Restrict your color to variations of a single hue (for example, warm and cool greens) or two analogous hues (say, blue and green). It's difficult to achieve a two-dimensional effect with a wide or full range of hues because, regardless of the design, warm hues will advance and cool hues will recede. (See Phil Dike's painting in Lesson Two.)

2. Reverse the normal color relationships. Instead of painting warm, positive elements surrounded by a cool, neutral negative space, "push" background areas forward with warm intense hues and "pull" foreground areas back with cool, neutral hues to create a sense of spatial ambiguity. (See Keith Crown's painting in Lesson Nineteen and my painting, *Pete's Harbor* in Lesson Nine.)

3. Limit your value range to two or at the most three value steps and work with flat, simple patterns. Avoid abrupt value changes. Strong value contrasts in a design suggest distance and space. Strong value contrasts on a single element suggest volume and mass.

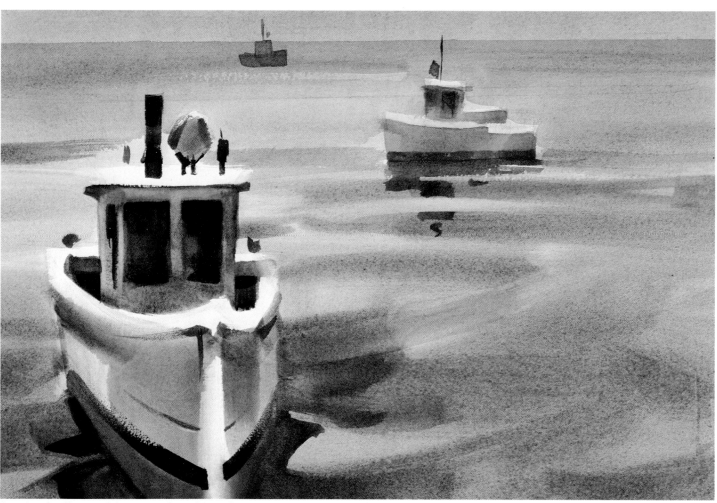

Creating the illusion of deep space through aerial perspective.

ROCK MASS
by Christopher Schink.
Watercolor on Arches 140-lb rough paper,
24" × 38" (61 × 97 cm).
Collection of Prof. and Mrs. James H. Dewson, III,
Palo Alto, California.

The subject of *Rock Mass* was one of the large rock outcroppings that line the shore at Rangemark, Maine. I painted it in a more realistic style than I normally use to convey the volume and form of these massive rocks as they recede in space. Applying the principles of aerial perspective, I modified the color of the rock forms to create the illusion of depth and recession. Note, for example, how the foreground rocks are warmer and more intense in color than those in the middleground. As objects recede in space and are viewed through increasing amounts of atmosphere, their hue, value, and intensity are altered. By observing and reproducing these changes in color, you can achieve an illusion of real space and distance.

APPLYING THESE IDEAS

Even with an understanding of aerial perspective, you may find it difficult to organize color to create consistent and convincing pictorial space. Here is a simple procedure that will help you judge how effectively you've used color to create a sense of space: At regular intervals or after applying a new value step, turn your painting upside down and stand back from it. A different perspective will free you from any preconceptions and allow you to assess how your color is working to create the illusion of space. Is the red of your barn sitting on your green field? Or is it floating in space? Does your green field seem to go back in space? Adjust the hue, value, and intensity of each area to reinforce the illusion of space.

CRITIQUE

Have you left any unpainted areas that may destroy the illusion of deep space? It's easy when working in a direct method to leave little areas of unpainted white paper scattered around in your painting. But if these areas appear in the middleground or background, they will destroy the illusion of depth and distance. Remember: as an object or area recedes in space, its lights become darker (shifting toward middle gray). Distant lights (with the exception of direct reflections of light such as on a window or in snow) are darker than those in the foreground. Even small areas of pure white in the background will be disturbing or confusing. To prevent this, if you enjoy drybrushing or working in a direct method, try first toning your background with a cool wash that gradually lightens to white in the foreground.

Have you used detail throughout your painting to make it seem more realistic? Finely rendered detail will not make a painting seem more realistic if it's used in the wrong places. If you finish every painting by adding minute detail to background areas—little houses with little windows on distant hills—you're reducing rather than reinforcing the illusion of real space. Detail can only be seen when there are strong contrasts in the hues, values, and intensity of an object. All objects and areas seen at great distance normally shift to a uniform, cool gray. They should be painted with a simple, flat wash. Detail should be reserved for closer elements, where interest is needed.

CREATING VOLUME WITH COLOR

We all think of an apple as being red. But to paint a realistic image of an apple (or of any three-dimensional object), you must use more than a single, unvaried hue. The color of an object changes when seen in light and shadow. There are variations not only in its value (from light to dark) but also in its hue and intensity. By reproducing these variations with pigment, you can create a convincing illusion of three-dimensionality, one that conveys the volume and mass of your subject.

USING VALUE TO SUGGEST VOLUME
The simplest way to convey the illusion of the volume of an object is to vary the values of its color from light to dark. The greater the range of variation, the stronger the illusion of three-dimensionality. For example, a painting of an apple that contains values ranging from the white of the paper to almost black will seem more three-dimensional than one with a narrower range of value—say, light to middle.

The range of value on an object and the degree of contrast from light to shadow depends on the direction and intensity of the light source. The lighting that best reveals the form and volume of an object is a strong, bright light from a single source (such as the sun) that illuminates the object from one side.

VALUE CHANGES IN LIGHT AND SHADOW
To the untrained eye, an object in the sunlight and shadow, such as a barn or tree trunk, appears to have only two values: dark and light. However, after careful observation you'll discover there are four (or in the case of a round object, five) different value steps that occur in the lighted and shaded areas of an object. Let's look at the values, from light to dark, on two basic forms—a white cube and a white sphere—as shown below:

1. *Highlight.* This is the lightest value on a smooth or reflective surface.

2. *Light.* This is the area on an object lit directly by sunlight.

3. *Half-light (or halftone).* This is the area of gradual transition between the light and shadow areas on a round object only. This is where the texture of the object is most apparent.

4. *Shadow.* This is the darkest area on a sunlit object.

5. *Reflected Light.* This is a slightly lighter area in a shadow created by reflections of the sky or sunlit surfaces. The reflected light is always darker than the half-light.

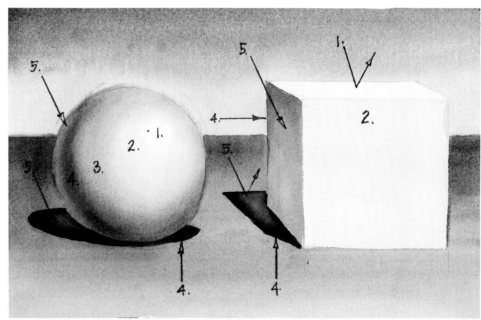

Value changes in light and shadow.

COLOR CHANGES ON SUNLIT OBJECTS
The color of an object in sunlight changes not only in value but also in hue and intensity. By reproducing these changes—through a subtle alternation of color temperature and intensity—you can convey the form and volume of your subject.

The color of the lighted and shaded areas on an object is determined by the color temperature of the light source and by the effects of simultaneous contrast. In normal sunlight, the lighted areas are predominantly warm, their local color being tinted by the slightly yellowish cast of the sun. On the other hand, the shadows are predominantly cool, appearing by contrast to be violet or blue (the complement of the warm light source).

To illustrate these alternations in color temperature, let's look at the example below, where a white cube and white sphere are lighted from one side by the sun (and overall, by skylight). (For purposes of reproduction, I've slightly exaggerated the color.) In the predominantly *warm* lighted area, color variations occur in the following order:

1. *Cool Highlight.* This is the lightest area of a smooth or reflective surface. It is cool because it reflects the color of the sky. Here it is found on the top of the cube and the lightest part of the sphere, and I've painted both with the faintest tint of blue.

2. *Warm Light.* This is found on the area lighted directly by the sun—the front of the cube and the larger light area on the sphere—and is obtained with a light wash of yellow.

In the predominantly *cool* shaded area, color variations occur in the following order:

3. *Cool Half-light.* This is on the area where a rounded object turns away from the light and shadow begins It is cooler than the shadow. (There is no half-light on a square object; the changes in plane there are sudden and abrupt.) Here I've painted the half-light area of the sphere a blue gray.

4. *Warm Shadow.* This is the darkest part of the shadow area, and it is warmer than the areas of half-light or reflected light. In the diagram this is

shown as a gray violet for the shadow core of the sphere, the side of the cube, and the shadows on the ground.

5. *Cool Reflected Light.* This is the outer, lighter edge of the shadow on a round object and the inner areas of cast shadows that face the sky. It will be cooler in color than the rest of the shadow and cast shadow areas. But there is warm reflected light on shaded areas facing downward or away from the sky because these areas reflect the color of brightly illuminated surfaces nearby; these reflections are usually warm. In the diagram this is shown as a slightly lighter blue on the edge of the sphere, in the middle of the cast shadows, and in the inner area of the shadow on the cube where the skylight is reflected. On the other hand, the shadow under the sphere, which does not reflect the skylight, is warmed instead with a small amount of yellow.

VARIATIONS IN LIGHT SOURCES
The second diagram was lit with warm afternoon sunlight. With variations in the color of the light source, however, the color of lighted and

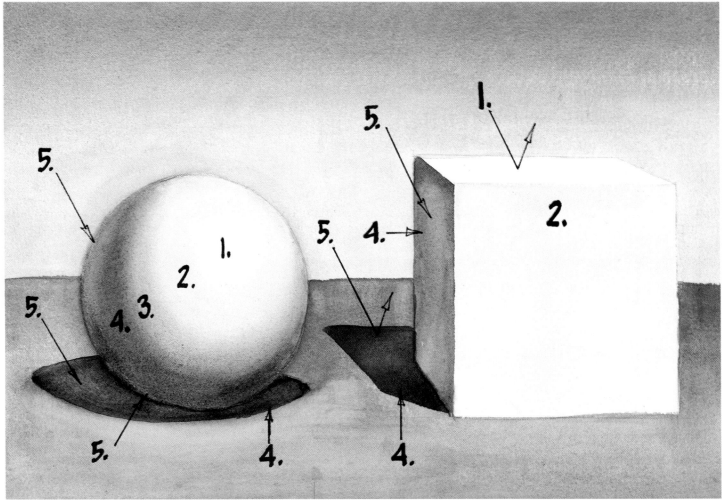

Color changes on sunlit objects.

BIKER
by Christopher Schink.
Watercolor on Arches 300-lb cold press paper,
14" × 21" (36 × 53 cm).
Courtesy RJK Gallery, Atlanta, Georgia.

Biker was painted from a model who posed for one of my watercolor workshops. It illustrates how the color of an object in light and shadow can be modified to create a convincing illusion of volume and mass. There are variations not only in value—from light to dark—but also in hue and intensity. By reproducing these alternations in color temperature and intensity—cool highlight, warm light, cool half-light, and so forth— you can convey the three-dimensionality of an object, whether it's a figure, a barn, a boat, or a tree trunk. Here, I've emphasized these changes in color (and exaggerated the warmth of reflected light around the eyes and under the nose) in order to create a convincing and expressive portrait. (Other examples of color used to create an illusion of three-dimensionality can be seen in *69 Pounds* (Lesson Nineteen), *The Chef* (Lesson Twenty-One), and *Rock Mass* (Lesson Twenty-Eight).

shaded areas changes, even though there is still an alternation of warm and cool. For example, on a foggy or gray day, when the light is much cooler than sunlight, the shadows would be much warmer (complementary in hue). Under the almost white light on a desert, on the other hand, the shadows may appear to be almost black. Under moonlight, which is very cool and dim, the shadows at night are quite warm and solid, containing no reflected light.

APPLYING THESE IDEAS

Spend a little time studying the illustrations in this chapter. Don't be put off by all those little numbers and arrows. The basic ideas are fairly simple and immediately applicable to landscape painting. Here are a few examples you might observe or reproduce when out painting on location:

1. *Cool Highlight.* Note the cool, almost blue, highlight on the surface of a wet rock or the top of someone's nose or on the deck of a white sailboat. Painting these lightest areas with a subtle blue tint will make the sunlit areas of your painting look even warmer.

2. *Warm Light.* Notice how sunlight warms the side of a barn or sailboat, or an outcropping of rocks. You can emphasize this warmth by adding a light wash of yellow to the local color of your subject.

3. *Cool Half-Light.* Observe how

the edge of the shadow on rounded forms such as a tree trunk, a silo, or the pilings of a dock or the side of a sailboat appear cooler than the core of the shadow itself. Emphasizing this temperature change in your painting will make an object look rounder.

4. *Warm Shadow.* Notice how the darkest part of a shadow on a rounded form—a silo, a tree trunk or a rock—will seem warmer than the area of half-light. Reproducing this change in color temperature will make the shaded part of a round object seem more three-dimensional.

5. *Cool and Warm Reflected Light.* Observe how the color temperature of a shadow becomes cooler and lighter on the edge of a rounded form such as a tree trunk or rock. Notice how a cast shadow from a barn or trees will appear cooler in the center. Adding these color changes in your painting will make your shadow seem more open and transparent. Also note how shaded surfaces facing away from the sky reflect brightly illuminated surfaces nearby. For example, the green of a field is reflected on the underside of a tree and the warm light of a field is reflected into the shadow under the eaves of a barn. In a painting these subtle changes in hue help animate the color of your design.

CRITIQUE

Have you left any unpainted areas on the edge of the object you're modeling? In order to prevent washes from accidentally running together, you may

have developed a habit of separating the various elements in your painting with a narrow band of unpainted white paper. If so, you'll have difficulty creating a convincing illusion of volume and space. No matter how small, these incongruous areas of light will have a disturbing effect, making the three-dimensional elements of your subject appear to be detached (as if cut from paper) or concave. Remember: No value on the shadow side of an object is as light as the values on the light side. The next time you're modeling an object, avoid leaving a fringe of light or unpainted paper. Paint the adjoining area right up to its edge. And if it is a round object, soften it. A soft edge on a round object will make it seem more three-dimensional.

Are the value relationships in your painting consistent? If your normal procedure is to paint each element of your subject separately, modeling one part completely before starting on the next area, you may have trouble maintaining consistent value relationships. When the contrast between the light and shadow areas of elements is dissimilar, the illusion of volume and space is less convincing. To achieve the illusion of realistic space and volume, you should systematically develop the overall value relationships of your subject, working from light to dark throughout your painting. Don't paint "things"—individual elements— one at a time.

LESSON THIRTY

ORGANIZING COLOR

To produce an effective painting—one that clearly communicates your thoughts and feelings—you must carefully select and organize the colors for use in its design. Therefore, the color mixtures you choose and their arrangement in your paintings are decisions that should be made before you begin to paint.

Accurately duplicating the colors of your subject or creating a convincing illusion of volume and space does require some skill, but it doesn't necessarily produce a profound or expressive work of art. That is to say, for all its verisimilitude, the accurate reproduction of a purple barn, blue tractor, orange sunset, and green field may not make an appealing painting.

USING COLOR EXPRESSIVELY

The colors you select for a painting, for the most part, are a matter of personal taste, and based on your own interpretation of the visual world. Even in a highly realistic painting, the colors you choose should reflect your personal response to the subject and should be organized to reinforce the expressive qualities you wish to convey. Here are several examples of how color can be used in a painting:

1. *To Create the Illusion of Space and Volume.* If your primary interest is in conveying the space and expanse of a subject, you can organize your color following the principles described in the last two lessons. By picking colors that emphasize the effects of aerial perspective and the alternation of color temperature on three-dimensional objects, you can heighten the illusion of space and volume. Examples of color used in this way can be seen in *Last of the Season* (page 74) and *69 Pounds* (page 90).

2. *To Create Flat, Decorative Patterns.* If your primary interest is in conveying the flat, decorative qualities of your subject—for example, the colorful tents and banners of a circus or the variegated hues of a floral bouquet—you can organize the color of your subject using only carefully chosen *local* color. By eliminating the effects of light and shadow and aerial perspective and emphasizing the interplay of unmodified local color, you can create an effective flat, two-dimensional design. Examples of color used in this way can be seen in *Night Canyon* (page 42) and *Taos Pueblo* (page 91).

3. *To Create Movement within a Design.* You can create a sense of movement that will lead the viewer's eye through a painting by arranging color in a systematic progression from warm to cool or from intense to neutral. For example, you arrange the local color of a group of sailboats in sequential hues—green, green-blue, blue, and blue-violet—that would move through the painting and animate its design. Example of color used in this way can be seen in *Milcumbre* (page 82).

4. *To Convey an Emotional Response.* If your response to your subject is primarily emotional, you can choose any color that you feel suggests the expressive qualities of your subject. You might, for example, convey the excitement you feel about a winter snow scene with colors totally unrelated to your subject, such as yellows and oranges because, with subjective color, you can make a highly personal statement. Examples of color used in this way can be seen in *Wintershore* (page 38) and *Taos Pueblo* (page 91).

The various systems of color composition, although certainly worth studying, are far too complicated and theoretical to be of any immediate use. For now, the simplest way to organize the elements of color in your painting is by following the general principles of design described in Lesson Five.

THE ELEMENTS OF COLOR

By repeating, varying, and contrasting the elements of color—value, hue, intensity, and temperature—you can create a harmonious and interesting design. To review the four elements of color and illustrate how they can be used to create contrast or unity in a painting, in the example below there are four versions of the same simple design, each emphasizing differences in value, hue intensity, and temperature.

1. *Value.* By using the same hue (green, in this case) in a wide range of values, you can create contrast. Emphasizing contrasts in value is a simple way to organize the color in a design.

2. *Hue.* A wide range of hues can also create contrast. But even though strong contrast in hue is exciting, it is more difficult to organize than contrasts in value of a single hue.

3. *Intensity.* To create contrast, you can also vary the intensity of closely related hues such as reds and oranges. Warmer, more intense hues are usually used for important, positive elements.

4. *Color Temperature.* You can also create interest and variety by contrasting or alternating warm and cool hues.

VALUE

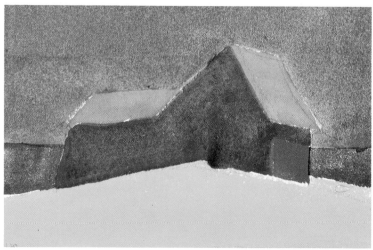

HUE

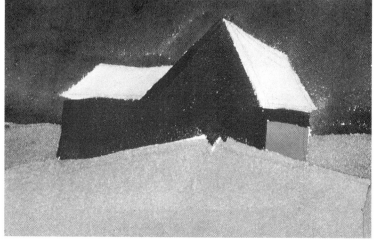

INTENSITY

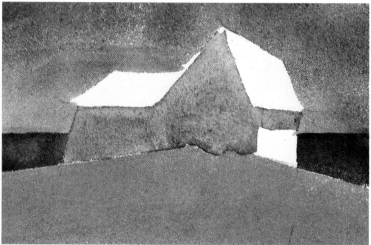

COLOR TEMPERATURE

The elements of color.

134

UNIFYING THE COLOR SCHEME

Unity can be achieved by repeating some visual element; that is, by using colors that are closely related in either value, hue, intensity, or temperature. For example, by painting the landscape in the second illustration the same hue (green), the same temperature (cool), and the same general intensity (slightly gray), I've created a unified painting. Variety and contrast here are created entirely by differences in value. The design, however, is rather static.

VARYING THE COLOR SCHEME

By introducing visual elements that are related or only slightly dissimilar to the predominant quality of a design—using color slightly different in hue, value, intensity, or temperature—you can produce more variety within a unified color scheme.
In the third illustration I have used the same value plan and predominant hue as the basis for my painting, but widened the range of hue (extending it from green-blue to yellow-green), intensity (from medium bright to almost neutral), and color temperature (alternating warm and cool greens). The result is greater variety and a more interesting—though still unified—design.

CREATING CONTRAST
IN THE COLOR SCHEME

Contrast is created by introducing visual elements that are different or that complement the predominant quality of a design. Small areas of color that widely differ in hue, value, intensity, or temperature will accentuate the predominant colors in a design and focus interest. For example, in the fourth illustration, I've painted a more dynamic version of the same design using contrasting colors. I've used differences in hue (a complementary orange-red) and intensity (placing a small area of intense red under the eaves) to draw attention to my primary interest—the building. The degree of contrast and the size and number of contrasting areas depend on the expressive quality to be conveyed. For example, the first version, done with a single hue, has a quieter, more peaceful quality than the other two. To convey the feeling of a busy, active farmyard, you would require an even greater range of contrast.

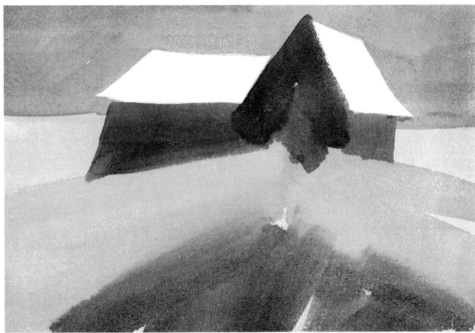

Unifying a color scheme.

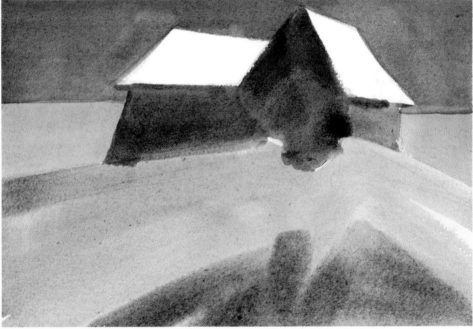

Varying a color scheme.

Creating contrast in a color scheme.

135

APPLYING THESE IDEAS

Visualizing and organizing a color scheme in your head is difficult. A far easier approach is to make several quick color sketches employing the general principles of design and based on your value plan.

Start by determining what quality you want to convey in your painting—for example, a sense of space, excitement, or calm. Then select one or two of the colors in your subject that you think describe these qualities. But don't feel you have to use the exact hues of your subject. Pick a group of related colors whose range of contrast in hue, intensity, and value reflects the expressive quality you wish to convey, and distribute them in your sketch to establish a color dominance. Don't try to make a small painting. Just apply the paint in simple rough washes. Now add small areas of contrasting or complementary color to this harmonious arrangement and analyze the result: How does your color scheme work? Is the contrast too great or too isolated? Does it occur in areas of interest? Does the color convey your feelings about the subject? Try adjusting or changing the color. If your areas of contrast seem too isolated, repeat contrasting colors in smaller amounts. If the design seems too static, aim for greater variety in the predominant color scheme. Don't be afraid to experiment. A green boat may be more effective than a red one and just as believable.

You may have to do several sketches before you're satisfied, especially if your subject or interpretation contains a wide variety of hues. But a well-designed color and value plan will enable you to convey your response to your subject with confidence and directness.

CRITIQUE

Do you feel your use of color is generally uninspired or pedestrian? The skill to use color expressively and creatively takes experience and practice. Even the most skilled colorists began by turning out works with color that was drab or conventional. If you're interested in developing greater skill in the use of color, spend time studying and analyzing the work of artists you admire. Observe how they have used color to reinforce the expressive qualities of their interpretation of a subject. Note how they have developed a sense of unity, variety, and contrast.

For a better understanding of how color can be organized, try "borrowing" the color scheme of a painting you find particularly appealing. Using your own subject and value plan (they should be similar to your model's), try reproducing the color of the original. Although not entirely creative, this exercise will increase your skill in color mixing and broaden your understanding of how color can be used expressively.

Do your color schemes seem chaotic and discordant? You may be excited by subjects filled with a wide assortment of hues, but find it difficult to organize them in a painting. The simplest way to organize a multicolored subject is to select from it a group of analogous hues—for example, yellows, oranges, orange-reds, and reds—and repeat them with variations throughout your design. For contrast you can introduce small amounts of dissimilar or complementary color—in this case, greens or violets. You'll find it far easier to enliven a color scheme that is harmonious but dull, than to unify one that is chaotic or discordant.

Does the color in your finished painting seem less exciting than you thought it would be? If the color you thought would be exciting and vibrant seems dull and lifeless when you stand back and view your finished painting, its weakness may be the result of aerial perspective. This is because color appears less intense and cooler when viewed from a distance than it does when seen from one or two feet away (the normal working distance when painting). To overcome this effect, in your next painting try to exaggerate the intensity, warmth, and value range of your color. "Project" your color (as an actor on stage projects his voice) so it will seem exciting or believable from twenty feet away. And when painting, stand back at regular intervals to view the results.

FINAL CRITIQUE

Throughout this book I have emphasized the importance of planning and organizing the color and design of your painting. To do this effectively you must acquire, along with your knowledge and skill, an ability to analyze and judge your own work. This last section deals with the analytical process—how you combine feeling and thinking, your intuition and intellect, in the planning and execution of a watercolor, and how you can objectively assess the finished results.

The physical part of painting—mixing and applying pigment—doesn't take much time or energy. With fresh paint and a large brush, you could probably cover a full sheet of paper in less than a minute. What does require long and often exhausting effort is the thinking and feeling part of painting—the analytical process. Every painting involves innumerable decisions that are resolved not by technique, but by intuition and intellect.

THE ANALYTICAL PROCESS

Occasionally you'll do a watercolor that seems almost to paint itself, with every element falling effortlessly into place. Unfortunately such magical moments are rare. Most paintings require hard work—planning, analysis, and adjustment—and numerous decisions: what color to use, how a shape will work, where to place a dark. When you are learning to paint, many of your choices are made intellectually. But the more you paint, the more intuitive your decisions become. You sense rather than intellectualize what to do.

Although your most creative work probably is done by intuition during periods of inspiration, these rarely last long enough to sustain an entire painting. Most paintings are produced through a combination of intuition and intellect—feeling and thinking. Learning when to stop moving your arm and start thinking is an important part of the creative process.

SETTING A GOAL

The thinking part of painting should begin even before you put brush to paper. You should decide not only what you want to paint and why, but also *how*—the approach you'll use to interpret your subject. You should set a goal for yourself, a personal challenge to go beyond mere technical competence, to create a painting that is uniquely and personally yours. Thoughtlessly whacking out one more barn scene may impress your friends and neighbors, but it won't (or shouldn't) bring you much satisfaction.

Knowing at the outset of a painting what you want to express and how you hope to express it will provide you with the criteria to judge the progress and ultimate success of your work.

RETAINING YOUR CONCEPT

When you have selected a concept—your approach to a subject—you should try to retain it throughout the development of your painting. A painting that starts as an intimate, realistic landscape and ends as a wild abstract will probably be unsuccess-

ful, or at best, unconvincing. But watercolor is an unpredictable medium and your painting can change direction by accident or impulse, even when you have a strong concept clearly in mind. Deciding whether to respond to or ignore a change in direction is part of the analytical process.

ACCIDENT AND IMPULSE

I like to make a distinction between accident and impulse. No matter how careful or skillful you are, accidents in watercolor are inevitable. Drips, runs, and backwashes are an inherent part of the process of painting. In small amounts, they add a feeling of spontaneity and immediacy but, for the most part, they detract more than they add. You may be tempted to save or even emphasize some unique intermingling of pigment, but if it significantly changes the concept or expressive quality of your painting, you are better off correcting or removing it.

On the other hand, impulses are not accidental. In the excitement of painting you may impulsively add a color or shape that was not part of your original plan or concept. For example, you might instinctively paint a desert sky bright orange rather than light blue. This added element or alteration is not the result of an accident but rather stems from a creative impulse—your unconscious response to the expressive qualities of your subject. Yet this change may entirely shift the direction of your painting, forcing you to redesign or

PETE'S HARBOR SERIES NO. 10
by Christopher Schink.
Watercolor on Arches 300-lb rough paper,
28" × 20" (71 × 51 cm).
Collection of the artist.

I did this painting in two stages, starting it on location and completing it in the studio several days later. I did the major portion of the painting on location, but reached a point where I was unsure of how to proceed. Rather than ruin a good start with a half-hearted finish, I waited to complete the painting until a later time when I had a chance to study and analyze the design from a fresh perspective.

In most paintings you encounter a variety of problems that call for a few minutes of thought and analysis—a normal part of the creative process. But you can also reach a point (usually after several hours of painting) where your ability to reason or sense is exhausted and any further work would be unproductive. Learning to stop painting *before* your energy or inspiration has run out will save you from ruining a satisfying and effective painting with a half hour of disinterested painting.

SAIL PATTERNS NO. 5
by Christopher Schink.
Watercolor on Arches 140-lb rough paper,
24" × 38" (61 × 97 cm).
Collection of the artist.

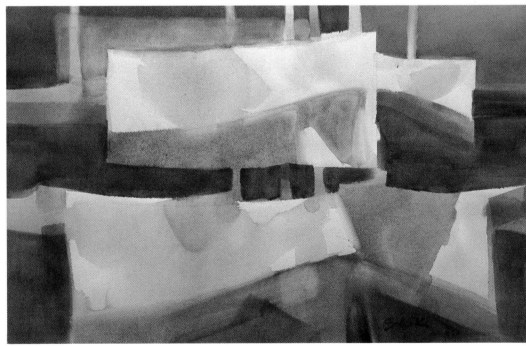

This is one of a series of watercolors I've done based on the shapes and patterns of sails and sail covers. Although I'm generally pleased with the completed work, I must confess it was not achieved in thirty minutes of inspired painting but was the result of several false starts and many revisions that occurred over the course of several days.

Contrary to popular belief, most successful paintings are not produced in a flurry of creativity and frenzied brushwork. They're the result of thoughtful planning, analysis, and review combined with periods of adventurous, intuitive painting. Knowing when to paint and when to think, when to use your intellect and knowledge and when to trust your intuition, is part of the creative process.

modify your original plan and concept. Before you decide whether to keep it or eliminate it, you should spend a few minutes studying its effect and ask yourself a few questions. Does it reinforce the expressive qualities you wanted to convey? Or does it suggest other qualities you hadn't seen before? Can you save it *and* the painting?

I find these instinctive additions are usually worth the effort of redesigning and the risk of losing a painting. Painting by impulse is an important part of the creative process. By alternating periods of adventurous painting with periods of study and analysis, you can produce an imaginative work of art.

REVIEWING YOUR PROGRESS
When teaching workshops, I'm continually amazed at how strong even the beginning painter's sense of design is. And how *infrequently* he uses it! A creative painting involves more than just two steps: planning and execution. It requires constant review—regular periods of study, analysis, and adjustment. Learning to stop painting and look at your work is as important a skill as learning to accurately mix color or manipulate a brush.

If you have had the experience of setting a recently completed painting up for class critique or on your couch at home and noticing for the first time some disorganized or discordant element in its design, you need to learn when and how to judge the progress of your painting. To begin with, concentrate on developing the habit of standing back from your work at regular intervals or whenever you add a new color or complete a value step. If you forget, write yourself a note on the top of your board saying "Stand back! Look!" Also try viewing your painting from a different perspective. Turn it upside down or sideways. A fresh viewpoint may reveal an out-of-tune color or a disturbing shape. By constant review, you can immediately identify and correct problems that would otherwise ruin your painting.

WHEN TO STOP PAINTING
Painting can be an exhausting business. After a while, even the most experienced or motivated painter will reach a point where his concentration and intuition fail. Since painting is not knitting, mindlessly moving your arm will never produce a creative work of art. Thus, learning to *stop* painting before your energy and inspiration have run out is as important as learning how and when to start.

Recognizing when to stop painting isn't always easy. In most paintings you encounter a variety of minor problems that call for a few minutes of thought and analysis—a normal part of the creative process. But you can also reach a point (usually after several hours of painting) where your ability to reason or sense is exhausted and any further painting would be unproductive. Remember, many good paintings are ruined in the last thirty minutes by a half-hearted attempt to finish.

If you find after painting for several hours that you can no longer think or sense what to do, stop! Take a break and get away from your painting. If after ten minutes rest, you're still uncertain as to how to proceed, pack up and head for home. You don't have to complete a painting in two hours or even in the same day. If you have a good idea or good start, don't ruin it with a half hour of indifferent painting. Problems can be resolved and finishing touches added at a later time when your energy and inspiration have returned.

STUDYING AND REVISING YOUR PAINTING
A painting is usually completed by adding small areas of accents of contrasting color, value, texture, and detail as well as by making subtle adjustments of hue and value. Before adding these finishing touches you should spend some time studying and analyzing your design. I often wait several days or even weeks before I complete a painting.

I've found waiting to complete a painting has several advantages: (1) After a few hours or days away from a painting, you see it with a fresh perspective. (2) Away from your subject (and all the annoying distractions that accompany painting on location) you are better able to concentrate on the design relationships and expressive qualities of your painting. (3) Back in the studio you can experiment with and test different ways to revise and modify or complete the painting. However, there are also several disadvantages to delaying the completion of a painting: It's sometimes hard to revive the mood or excitement you originally felt for your subject and your finishing touches may be tentative or out-of-tune. And if it's a painting you particularly like, you may feel it's too precious to take chances with.

Here are a number of devices I use that may help you finish a painting with greater confidence: (1) Before applying a glaze over a large area of discordant color (for example, a blue sky that is too intense), I try out several different combinations on the edge of my painting that will be hidden by the mat. (2) Before repainting an area or adding an accent, I often cut two or three pieces from a discarded painting in colors and shapes I think might work. I move these around on my painting until I know exactly where an accent (a dark window, a tree trunk, or a distant figure) or a repainted form will work best. (3) Before adding a strong dark (for example, cracks in a rock), Barse Miller would try out different possibilities using pieces of black electrical tape.

By using these devices, you can judge exactly the effect of any addition or modification needed to complete your painting. Knowing, for example, the position, shape, value, and color of a dark doorway will allow you to add that finishing touch with confidence and apparent spontaneity.

FINAL JUDGMENT

To me, watercolor is a medium of broken promises and surprise endings. A painting that seemed so exciting and imaginative the day before may prove to be disappointing and dull on later inspection. And a painting that seemed unsuccessful may turn out to be the best thing you've done in years.

It's difficult to judge the success of your own work and dangerous to rely on the opinions of others—your friends, fellow-artists, or instructors. The ultimate decision as to whether to save and exhibit, to revise and repaint, or to discard a finished work is yours—and yours alone.

Here are some questions you should ask yourself when making that decision:

"Does my painting clearly convey the ideas, interests, and feelings I wanted to express?"

"Have I expressed these in an imaginative and inventive way that is personally and recognizably mine?"

"Does my use of color, design, and the medium reinforce the expressive qualities I wished to convey?"

"Have I used my knowledge of color, design, and technique to produce a painting that is more than conventional, competent, or technically facile?"

"Have I created an expressive and creative work of art?"

It was my hope in writing this book that you would gain from it a better understanding of how color, design, and technique are used in watercolor. But, remember, these are only tools—the means to an end. Your ultimate goal when painting should be the expression of your own interests, ideas, and feelings.

SUGGESTED READING

Betts, Edward. *Master Class in Watercolor*. New York: Watson-Guptill, 1975.

——. *Creative Landscape Painting*. New York: Watson-Guptill, 1978.

Brandt, Rex. *Watercolor Techniques and Methods*. New York: Van Nostrand Reinhold, 1977.

Chomicky, Yar G. *Watercolor Painting*. Englewood Cliffs, New Jersey: Prentice-Hall, 1968.

Goldsmith, Lawrence C. *Watercolor Bold and Free*. New York: Watson-Guptill, 1980.

Itten, Johannes. *The Art of Color*. New York: Van Nostrand Reinhold, 1961.

Loran, Erle. *Cézanne's Composition*. Berkeley and Los Angeles: University of California Press, 1943.

Reep, Edward. *The Content of Watercolor*. New York: Reinhold Publishing Co., 1969.

Wood, Robert E. and Nelson, Mary Carroll. *Watercolor Workshop*. New York: Watson-Guptill, 1974.

INDEX

Edited by Bonnie Silverstein
Designed by Bob Fillie
Graphic production by Hector Campbell
Set in 10-point Century Schoolbook